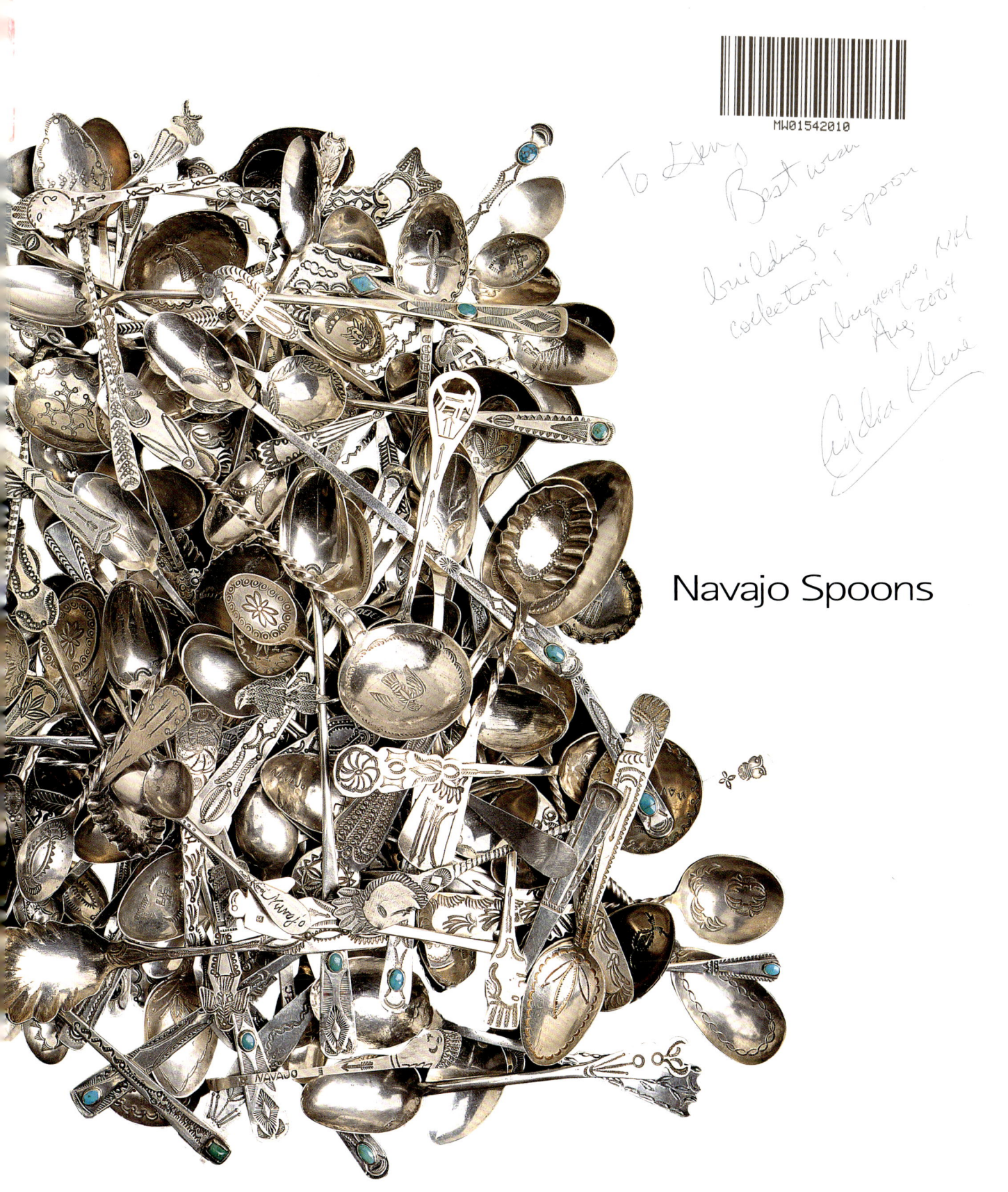

Navajo Spoons

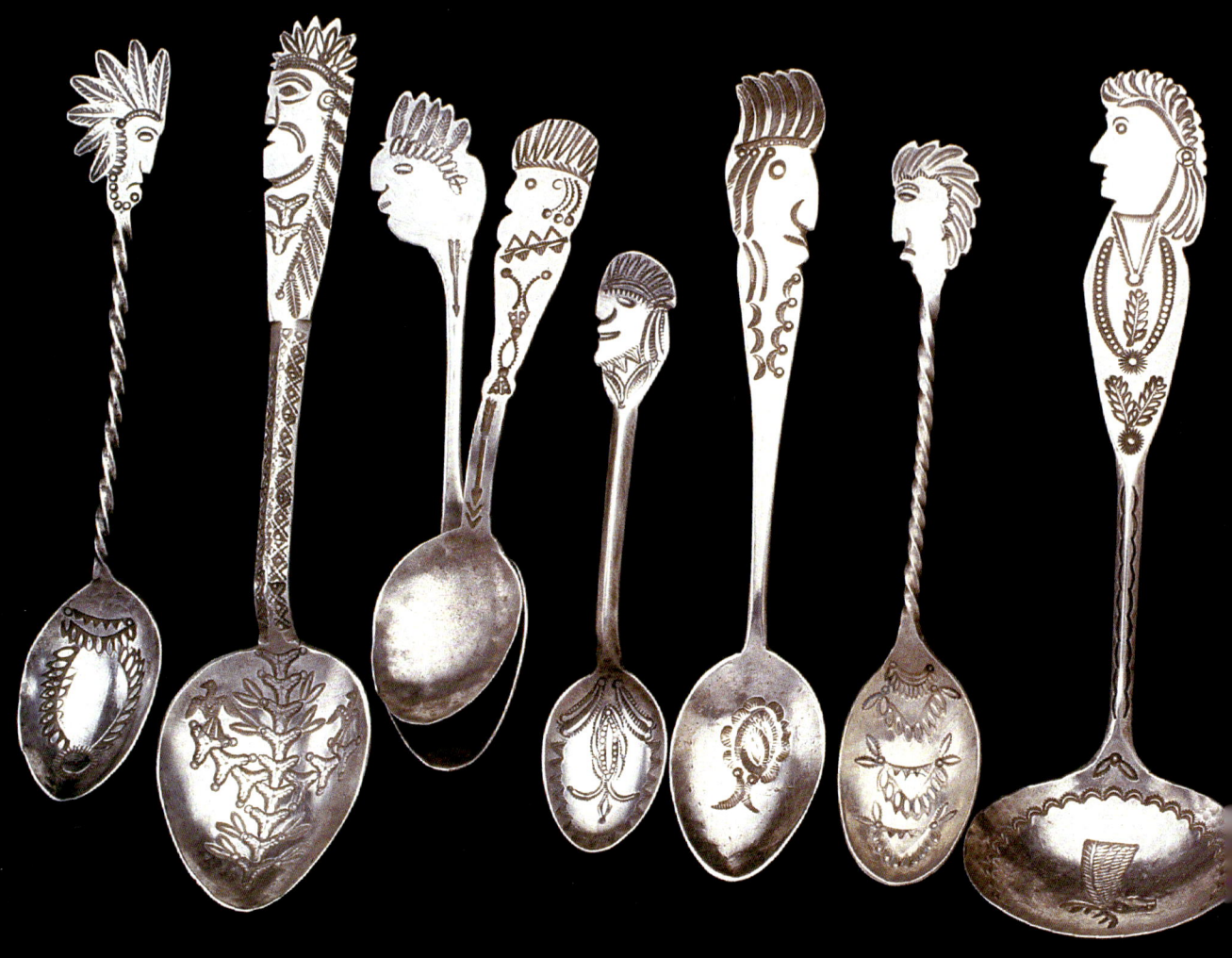

Photography by Kyle A. Castle and Blair Clark

Museum of New Mexico Press • Santa Fe

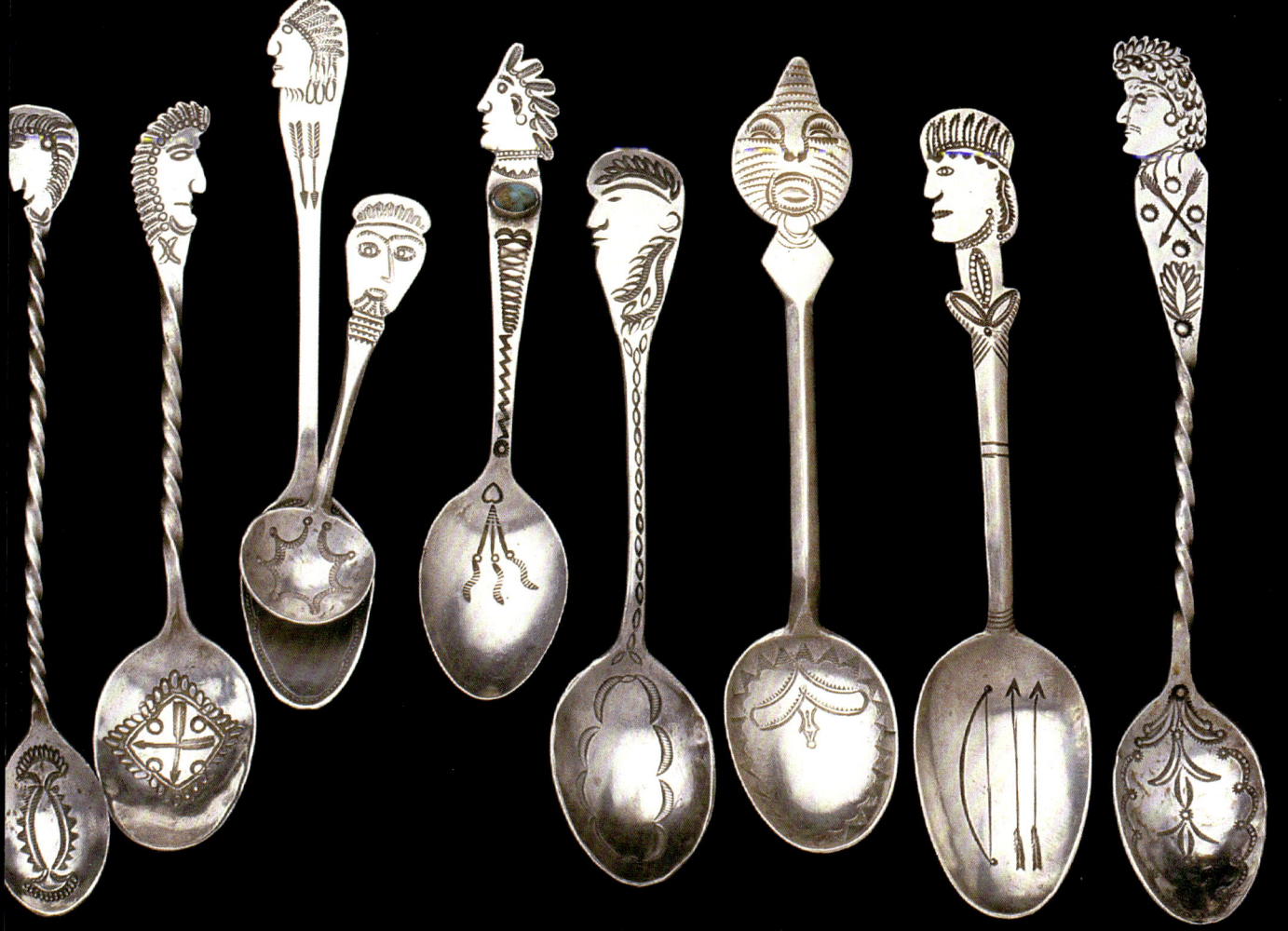

Navajo Spoons

Indian Artistry and the Souvenir Trade, 1880s–1940s

By Cindra Kline

Copyright © 2001 Museum of New Mexico Press.
Text © Cindra Kline. All rights reserved. No part of this
book may be reproduced in any form, with the exception
of brief passages embodied in critical reviews, without
the express written consent of the publisher.

Project editor: Mary Wachs
Design and production: David Skolkin
Photography: Kyle A. Castle Photographic Design and Blair Clark
Cover Photography: Kyle A. Castle
Photo Styling: Cindra Kline
Printed in Hong Kong
Composition: Set in Goudy with Rotis San Serif Light display

10 9 8 7 6 5 4 3 2 1

Library of Congress Cataloging Data Available

ISBN: 0-89013-391-3

Museum of New Mexico Press
Post Office Box 2087
Santa Fe, New Mexico 87504

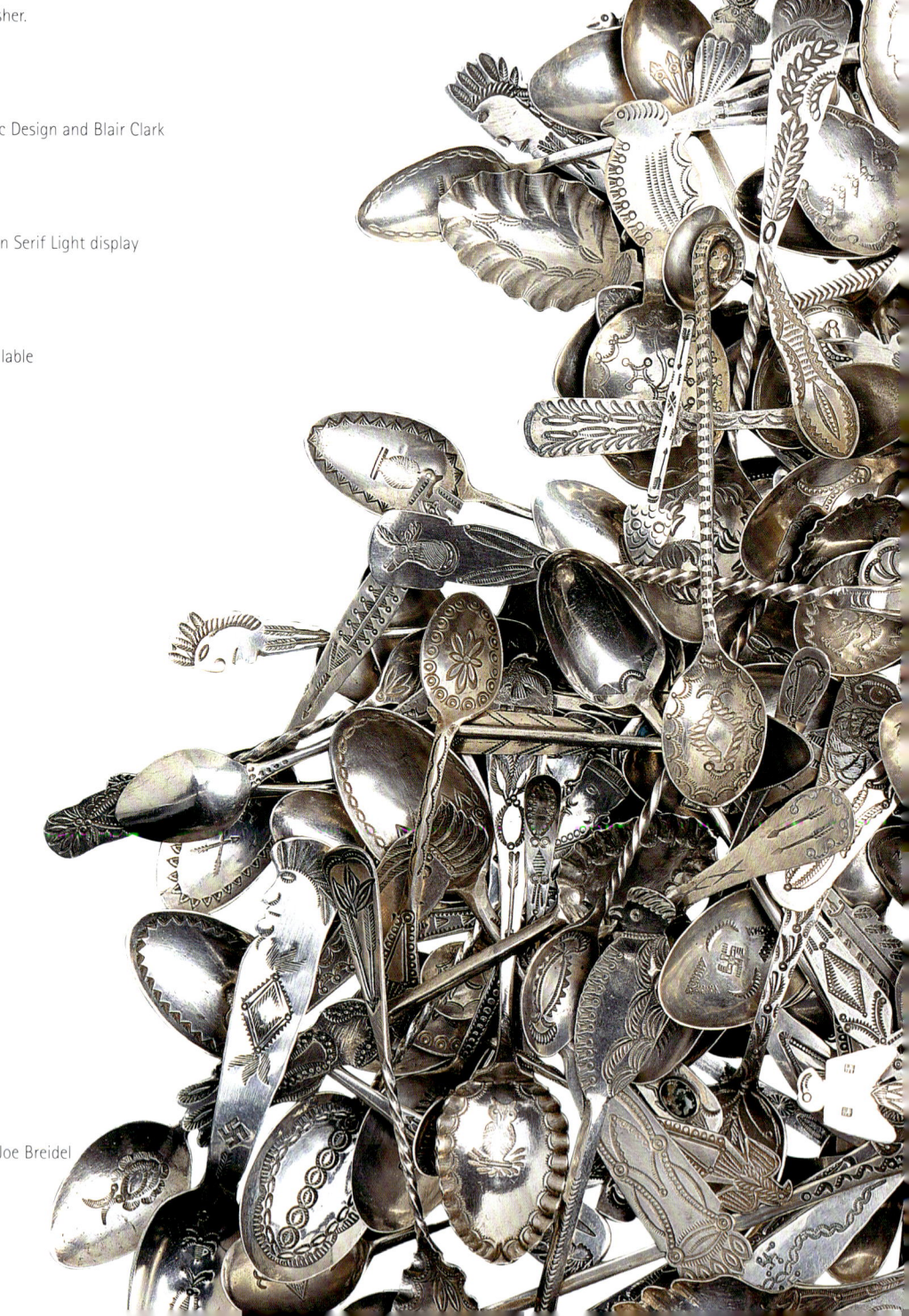

Cover and pages i, iv–v spoons courtesy Joe Breidel

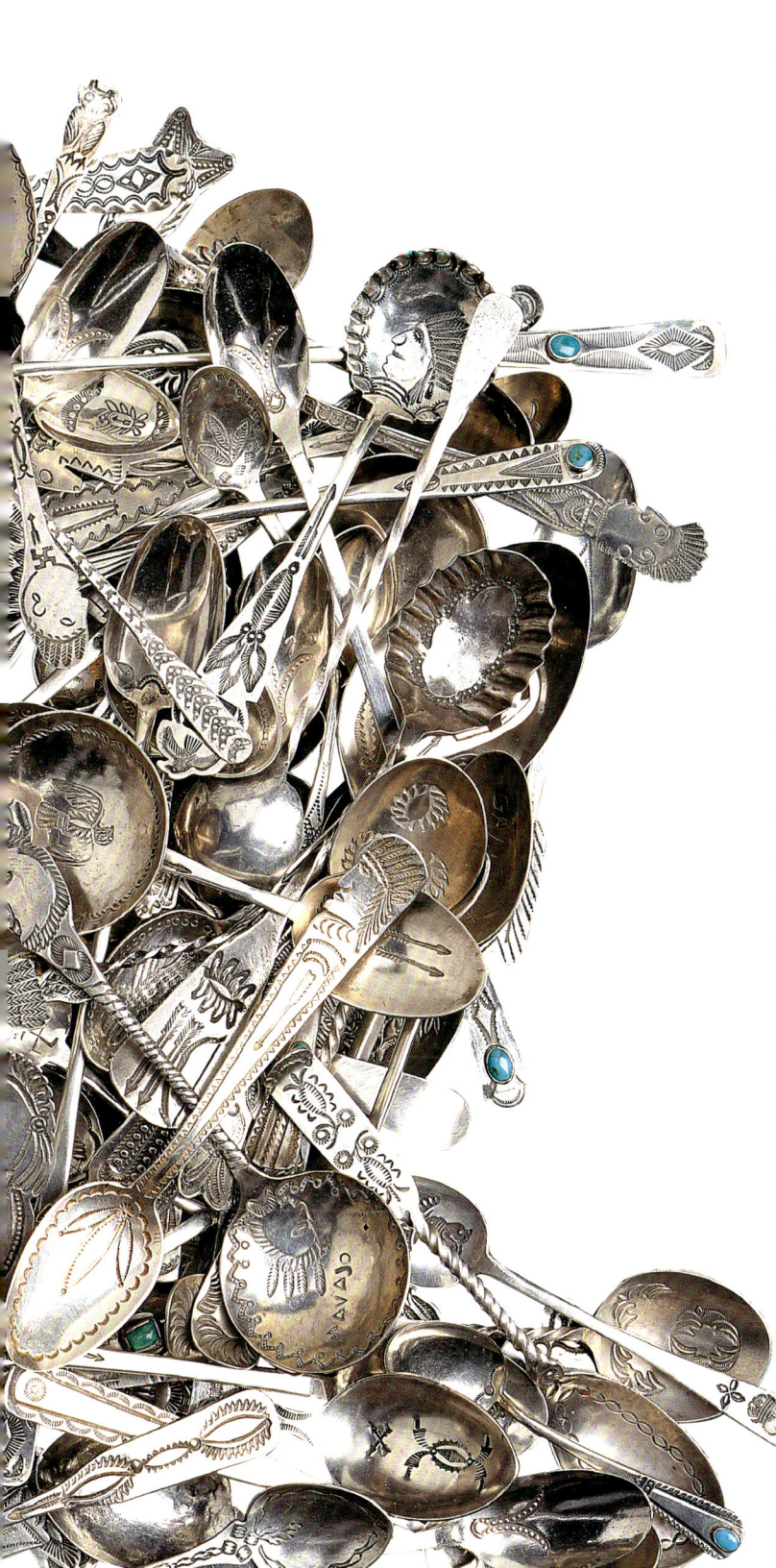

contents

acknowledgments 7

Introduction 11

Prologue 17

1 Stirring Up Tourism 19

2 Navajo Silver Comes of Age 37

3 Traders, Trains, and Teaspoons 43

4 Silver Words and Thunderbirds 59

5 The Making of a Navajo Spoon 75

6 End of a Phenomenon 91

7 Epilogue 103

notes 110
appendix 111
selected references 112
index 115

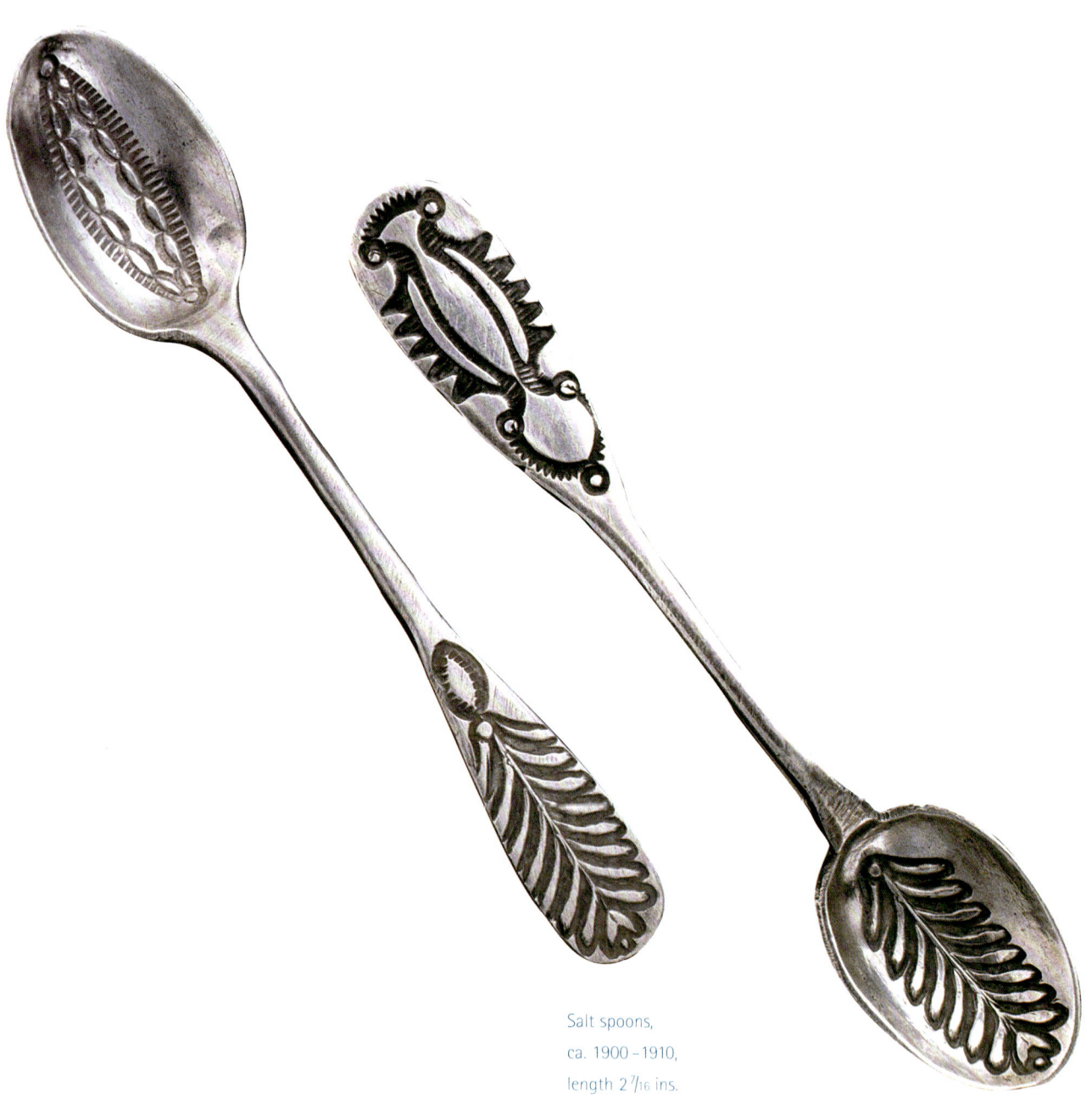

Salt spoons,
ca. 1900–1910,
length 2 7/16 ins.

acknowledgments

THIS BOOK WOULD HAVE BEEN impossible without the collectors and dealers who provided their spoons for research and photos. Many, many thanks to the faces behind these spoons: Bob Sinclair; Joe Breidel; Teal McKibben (owner of La Bodega in Santa Fe); the late Carl Lewis Druckman (courtesy of his mother, Susan Laventhol); David Stock; Paul Parker; Lynn D. Trusdell (owner of Crown and Eagle Antiques in New Hope, Pennsylvania); Murdoch Finlayson; Robert Bauver; Merill Domas; Bob Gallegos; Jay Evetts; John Kania and Joe Ferrin (owners of Kania-Ferrin Gallery in Santa Fe); Jeanie M. Harlan; Marcia Spark; Wayne Bednersh; Skip Gentry; C. Douglas and Marilyn Guske; Martha Hopkins Struever; Lane Coulter; Christopher Radke (owner of Dancing Bear Gallery in Evanston, Illinois); Bob and Marianne Kapoun (owners of Rainbow Man in Santa Fe); Peggy Nugent; Kevin Spray; Rick Rosenthal (owner of Morning Star Traders in Tucson, Arizona); and John Krena (owner of Four Winds Gallery in Pittsburgh, Pennsylvania).

I must also thank the many individuals who helped along the way, in many ways, including: John Kania, for saying a lifetime ago, "I know a collector with a lot of spoons . . ."; Sue Siegel; Fred Roberts; Jonathan Batkin, for his support and rare catalog information; Kathy Howard; Sina Brush; Skip Gentry, consummate Fred Harvey enthusiast, for trusting me; Mary Mackie; Marilyn Cosentino and Greg Simon; Melissa Katsimpalis and Laura Sandell (ISIS); Greg Eich and Pam Small; Kim Walters; David and Linda Cook; Norm Anderson; Cheri Falkenstien Doyle; Catherine Hollander Purse; Jan Brooks;

Mark Hooper; Jon Bowman; Jamie Kahn; Mark Sublette; Diana Pardue; Wayne Bednersh; Kathryn Dieruf; Jim Farrell, for handing me the truck keys; LaRee Bates; Sandy Stewart; Ralph and Tam and Ojas; Richard Tritt; Mike McKissick; Al Anthony; Bob Vandenberg; Charles and Debra Ruling Hissun; my editor Mary B. Wachs, for granting twenty minutes to a complete stranger and "getting the spoon thing"; David Skolkin, for pulling it together so beautifully; Gay Sinclair; Dorothy Rainwater; Sandra Bump (Mom); Yvette Ackerman; Deborah Westcott; Dr. Crystal Askew; Gordon Bronitsky; the Kapouns, for uncountable kindnesses; Mary Katherine Ellis; Dr. Tom Pixley; foot goddess Lucy Hyatt; Carol Stertz; my husband, Bruce, and my daughters, Sierra and Kelsie.

Thank you to The Wheelwright Museum of the American Indian, in Santa Fe, for providing the secure space for Blair Clark's studio photography. Cheri and Mary Katherine: Your gracious tolerance of my week's intrusion upon your collections room was most appreciated.

Special thanks to Jay Evetts, a man of few words, for giving me many; the late Carl Lewis Druckman—I hope this book touches upon the dream you had, which Fate so unfairly prevented you from realizing; Kyle "not a problem" Castle, of Kyle A. Castle Photographic Design, Fort Collins, Colorado, for his patience and talent; and lastly, but most importantly, Joe Breidel, who started everything.

Opposite: Victorian tea caddy spoons

For anyone who ever wondered.

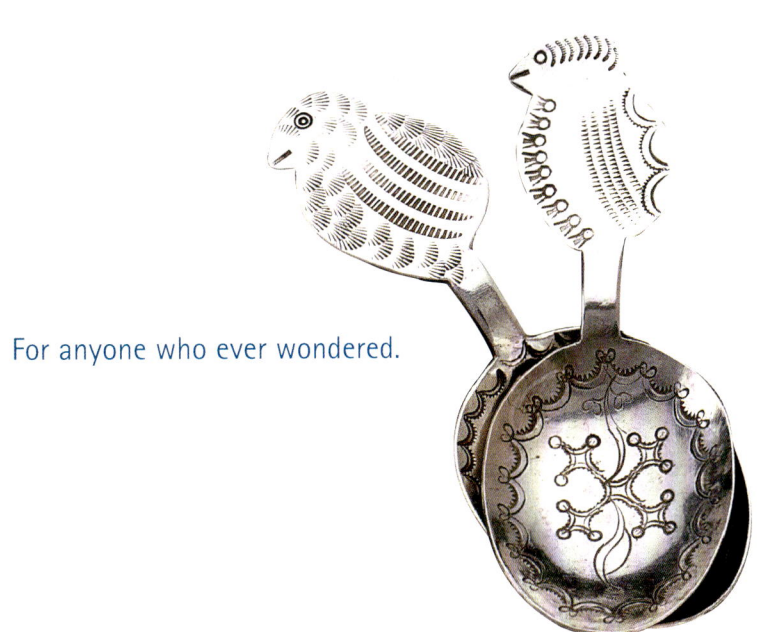

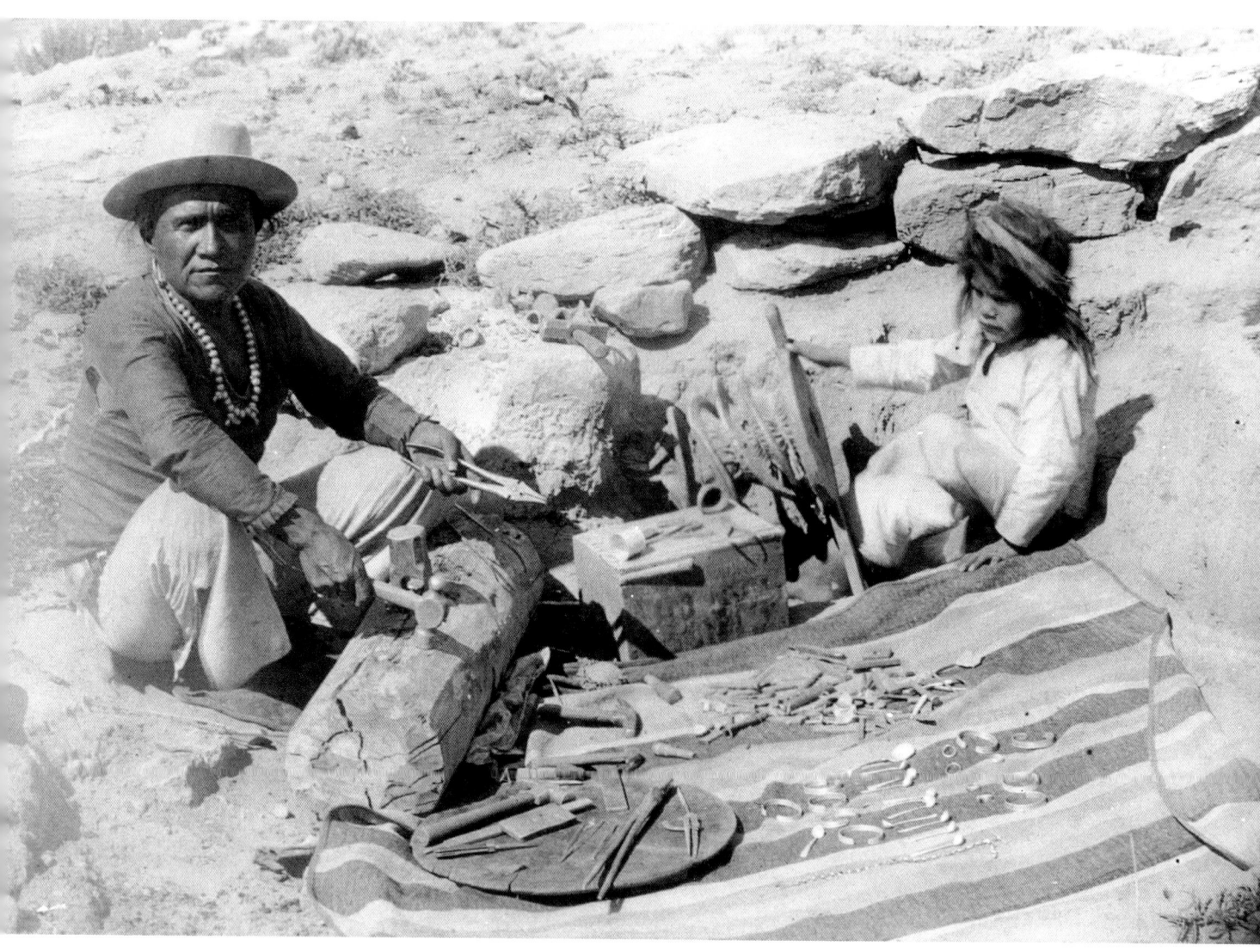

This photograph by Charles Goodman was taken ca. 1895–1900 in Bluff, Utah. Note the many spoons on this Navajo silversmith's blanket. Museum of New Mexico 9188

Introduction

I RECALL MY FIRST ENCOUNTER with a Navajo spoon, in the bottom of a glass case in a rather junky little "antiques and collectibles" mall in central Illinois. Contained in a plastic sandwich baggie, it caught my attention because of the stampwork and charming horse head atop the handle. "Folk art spoon—sterling (?), $4.50" read the gummed label.

"Oh, I have some of those," said friend and fellow antique dealer Joe Breidel when I showed him the spoon, "but I haven't been able to find any information about them." If Joe, the most voracious reader I've ever met, hadn't found any information on Navajo spoons, I knew the digging would be deep. My quest began.

Truly, I had no idea what I'd gotten myself into. Papers and notes and spoon pictures would follow me, in cardboard boxes, through two states and four houses and a nasty three-car collision (mine being the unfortunate middle car) during one of many book-related trips to Santa Fe. Photocopies of Navajo spoons, mailed to me by collectors across the country, covered the kitchen table and living room couch, were stacked on my dresser top and stuck on the refrigerator with magnets. Navajo spoons became my mission. Or obsession, friends and family would say.

What really began to motivate me was the "1920s to 1940s" period attributed to most Navajo-made souvenir spoons and flatware by dealers, on the rare occasion that they were selling any. Many seemed earlier, but even I would be

Horse head, ca. 1920

surprised by how much earlier. Prior to this book, Navajo spoons were not considered objects of the nineteenth century, and I'm proud that my research thrusts their origins back into the "First Phase" decade in which they belong: the 1880s.

While gathering information for this book, Navajo spoons proved difficult to explain to people because of the lack of published data. No one knew what I was talking about. I learned early on not to ask about Navajo spoons per se—asking a museum curator or a library archivist if he or she had any photographs of "Navajo spoons" only led to a perplexed look and a quick "no." Asking instead for old shots of silversmiths or of the interiors of curio stores—and armed with a magnifying glass and resigned patience—led to discoveries of spoons that had gone unnoticed, in some instances for more than a century.

"Well, what do you know," they'd say as they wheeled their carts full of prints and negatives back to climate-controlled storage rooms. "I never saw those spoons in there before."

I also learned not to bother asking general antiques dealers if they had any Navajo spoons. Inevitably, they'd bring forth a pile of commercial spoons featuring Indians on the handles. Better to ask if they had any "handmade silver" or "Arts and Crafts" flatware. "Here you go," dealers would say, cautioning me that the spoons probably weren't silver because they weren't marked "sterling" or .925, indicating silver content.

Because I've been a writer far longer than I've been an Indian jewelry dealer (and a very part time dealer at that), I myself own only a handful of Navajo spoons. In desperation, however, I resorted to tucking them into my purse so I could have them handy to help explain what I was researching. Reactions were remarkable, so much so that I grew to anticipate the excitement when I pulled out my spoons for examination. It became a predictable sequence: Initial surprise, then an outstretched hand and request to "hold one" as people studied the spoons, turned them over—*fondled* them, even.

When I began to put words to paper, of the "five w's," it seemed "what" (Navajo spoons) and "where" (the Southwest) were obvious while "who" (Navajo smiths and, occasionally, Pueblo smiths) was at least answerable on the surface. "When" and "why," however, loomed large.

"Why," the question I found myself most often asked by others, would become the most difficult to answer. Why did Indian silversmiths in the mid-1880s begin fashioning spoons? Understanding why required a plethora of related study, including this country's Victorian obsession with table settings; origins of train and automobile travel; stacks of texts about silversmithing in the Southwest; the Great Depression; World War II; the background of the swastika

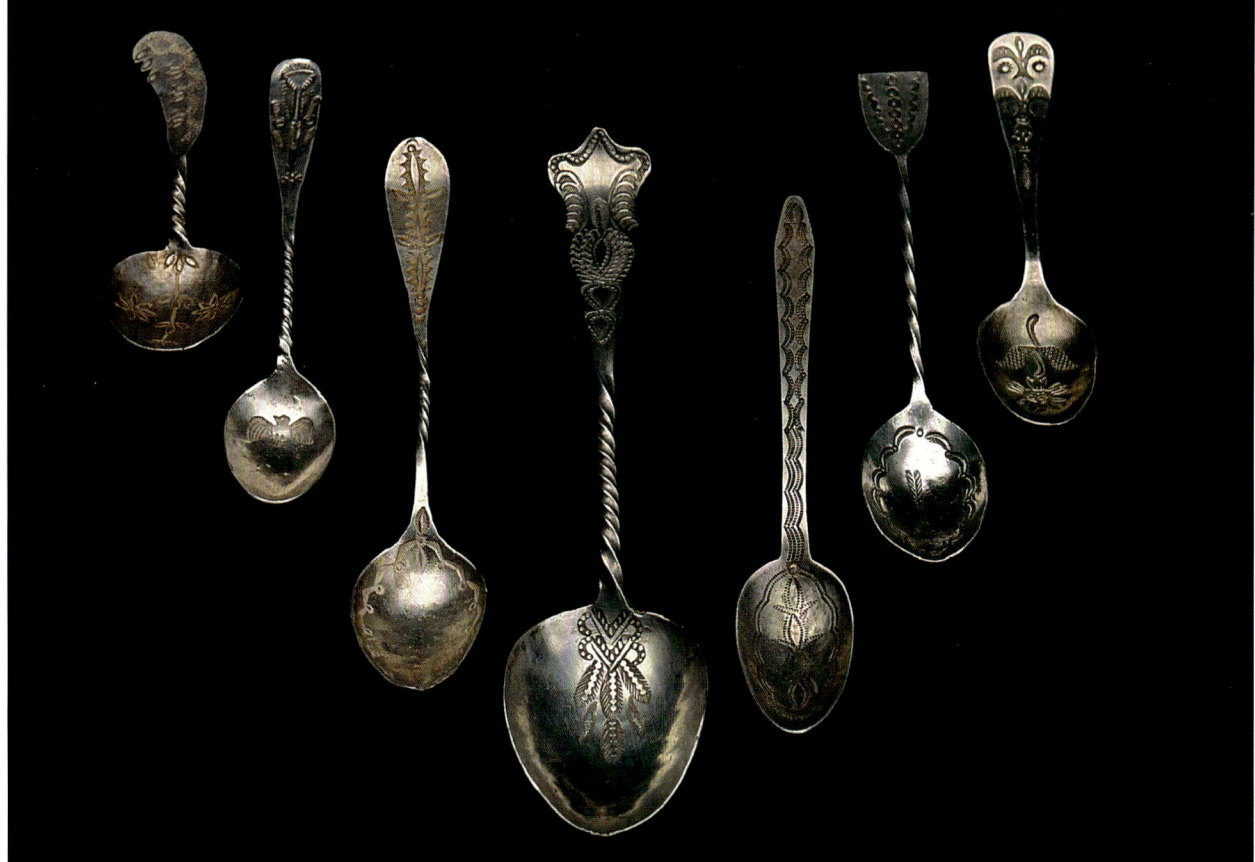

Late 19th-century utilitarian spoons often have twisted handles and were made in a variety of shapes and sizes.

(whirling log) motif; Indian traders; lithography; jewelry engraving practices; world's fairs and expositions; the histories of minted coins; dedication dates of historical sites and states; Navajo lore and mythology; Tiffany and Company; commercial flatware designs, patents, catalogs, and advertisements; Bosque Redondo; Plains silverwork; thunderbirds; archival photos; curio catalogs; and, finally, and most importantly, investigation into the "souvenir spoon movement." Once I fully understood the scope and duration of that little-known phenomenon, things started to get exciting.

It was a grand moment when I learned of an early Navajo silversmith named Chit-Chi and his spoon making in a newspaper article pasted into Charles F. Lummis's personal scrapbooks, housed at the Southwest Museum in Los Angeles.[1] Information in that article allowed me to date the first Navajo-made spoon to before 1885, correcting the historical record that had previously placed them at the turn of the twentieth century. This revision of the timeline helps to explain the advent of curiously Victorian types of flatware, such as sugar shells, bonbon spoons, and even pickle forks, that Navajo smiths were producing alongside the purely souvenir types.

Lummis, writing on January 10, 1885, discusses Chit-Chi circuitously in his description of the Navajo chief Manuelito's two brothers: "Klah (left-handed) the elder, would command respectful attention in any crowd, with his large, well-shaped head, strong face and herculean frame. The younger, whose name I forgot, is cast in a smaller mold, but an equally good one. He is an expert silversmith . . . and some of his work—though of semi-barbaric design—is wonderfully well done" (Byrkit 1989, 230).

Whose name I forgot.

Fortunately, by 1888, Lummis, the inveterate traveler and traveloguer, had befriended this expert silversmith, and his scrapbook article provides indisputable name clarification for Chit-Chi. Written in 1888 while at Acoma Pueblo in New Mexico and published in the *San Francisco Chronicle* (Lummis 1888, 41–45), the piece discusses Chit-Chi at length, cites the details of a sugar spoon made by Chit-Chi per Lummis's specifications, and includes an ink sketch Lummis made of his cherished new spoon. For all the questions I was able to answer about Chit-Chi's place in the history of the first documented Navajo-made spoon, however,

ca. 1920

other questions remained illusive. As a result, some of the material presented here is meant not to be definitive but to stimulate further exploration.

This is the first book devoted to Navajo spoons featuring items culled from major private collections across the country. Animals and life-forms uncommon on Navajo silverwork are nonetheless common on Navajo spoons, and the two separate elements of handle and bowl often invited different but complementary designs—a shocked cat atop a handle peering down to find a chicken in his spoon bowl, for instance. There's a real sense of artistic play in many Navajo spoons, and not unlike Navajo pictorial weavings, most anything that captured a silversmith's attention could appear stamped onto a handle or into the bowl of a spoon, including motifs taken directly from the coins the smiths were melting down. Spoons have been found stamped with the eagle-and-snake motif found on Mexican pesos and with the "liberty shield" taken from American coins.[2]

Most books on Navajo silverwork focus on Southwest history, but the story behind Navajo spoons is a national one. My strong belief that fully explaining Navajo spoons required placing them into the larger con-

text of what was happening in the world led me to read most anything mentioning spoons as a topic. After reading an essay on tea caddy spoons in the October 1965 issue of *Antiques* magazine, I took a moment to flip through the rest of the articles and paused on a page wherein editor Alice Winchester praised M. Ada Young for an article she had submitted. Mrs. Young and her husband purchased a New England maple secretary in the late 1950s, and curiosity about the new piece of furniture started her on an exhaustive five-year investigation into Massachusetts' cabinetmakers.

Young had attached a note to her manuscript that the editor deemed worthy of printing: "It is our sincere hope that others who have never started on such a project will undertake one that interests them, regardless of 'experts' who may discourage them, intentionally or otherwise. It has been our experience that it is often the amateur who, with wholehearted enthusiasm and ignorance, will dare to use avenues of research that the expert would scorn to employ, in order to accomplish what the expert thinks impossible" (Young 1965, 477).

The editor then added her thoughts: "We couldn't agree more heartily. Some of the most important research in the field of antiques has been done by amateurs. . . . In virtually every issue we present the findings of at least one nonprofessional enthusiast whose curiosity has led him into thorough and fruitful investigation of some aspect of antiques. He may not presume to call his quest research, or to think of himself as a scholar, but nonetheless he makes a scholarly contribution, even if it is not presented with all the *cfs.* and *ibids.* of academic tradition. Every expert was an amateur once" (Winchester 1965, 477).

There were days when I took great inspiration from M. Ada Young: Days of unanswered phone calls and emails from potentially important information sources. Longer days of wondering what had made me think I could pull this off with no grant or funding or museum affiliation or "Navajo spoon experts" to call with my questions. This book was born of simple curiosity, with the steadfast conviction that it was an important topic and with great sacrifice from my household budget. I traded styling work with photographer Kyle A. Castle to cover a portion of the photography expenses, and when I couldn't afford to buy research books, I packed a sandwich and headed for the nearest library.

Trying to figure things out all alone from photocopies of spoons often was frustrating. It was just me and the goldfish on my desk. (Actually, through the course of this project, there were several goldfish, but all were equally supportive.) For a few years in the 1980s, I wrote Jell-O gelatin commercials at Young and Rubicam in New York— hardly the "proper credentials" to pen a text

for a museum press on Navajo spoons, although I do enjoy pointing out that Jell-O is *eaten* with a spoon. Having by now looked at close to two thousand spoons, however, I've learned with my eyes what words could never have taught me. So whether it's a New England maple secretary or a silver horse spoon in a plastic baggie or some other subject matter, it is my hope that this book will serve as an inspiration for others. How nice it is to know that an inquisitive nature and "wholehearted enthusiasm" can, even today, sometimes be more of an asset than a Ph.D.

A most rewarding aspect of this endeavor has been seeing Navajo spoons reunited and connections made from collections in far-flung locations. The progression grouping featured on page 23, for example, is comprised of the key transition pieces culled from seventeen spoons owned by collectors in Minnesota, Massachusetts, California, and Arizona, and it was figured out from photocopies mailed to me by their owners.

With the exception of the photograph provided by the Heard Museum on page 75, and the Tiffany spoons in the Autry Museum (page 28), all the Navajo spoons in this book belong to individuals, not institutions. Museums have paid no attention to Navajo spoons. This required, at times, a tremendous trust in me by a lot of people, some for whom I was no more than an unknown voice over the telephone. It also means that every spoon pictured in this book has a face, not a building, behind it.

It has been rewarding to meet the people who have long loved these special objects, who have continued to collect them despite not knowing much about them, and who to this day tuck their Navajo spoons into sugar bowls or use them to eat their daily breakfast cereal. They indeed are living with and *enjoying* Navajo spoons. Whereas museum-quality Indian art typically requires careful storage and display, Navajo spoons invite handling and use. It's one of their most endearing qualities. To apply a twenty-first-century term to late-nineteenth-century objects, Navajo spoons are "user-friendly."

Go ahead—stir your morning coffee with one.

Prologue

When the thinking man appreciates that the collecting of individual spoons as souvenirs . . . has become a broad fashion the first question he asks within himself is, Why should a spoon be chosen in preference to all other articles? There is no positive answer to this question; the commercial reason that a spoon admits of a combination of beauty and design and utility, and is not costly, may sustain the demand, but the demand must first be created. The very love of the spoon, which is innate in all hearts, may account for the selection.
— *The Jewelers' Circular*, 1891

THE INNATE LOVE OF SPOONS is rooted in childhood. Holding them tight in our baby fists, we lift our arm and aim the spoon at that place on our face where we know the food goes in, and the spoon goes in, and we swallow and we smile. Even though time has tucked that smile too far into the recesses of our adult psyche to actually remember, we know that we smiled. And so it is that spoons get into that deepest of all places in our hearts, where we know that we love them even without being able to remember first loving them.

In the latter years of the nineteenth century, a peculiar national passion for commemorative spoons and for setting Victorian tables with fussy flatware came head-to-head with what would be called the "classic period" in Navajo silver making. The engine that stirred this confluence was tourism.

The railroad reached the United States territory of New Mexico in 1879, thus ushering in and promoting the era of tourism,

Whimsical animal ingot spoons.

with its attendant cravings for Indian-made curio crafts. On the Navajo reservation to the west, traders beginning in the 1870s had discovered and were exploiting the Navajos' skill in weaving and silver working, but the infusion of travelers into the region sealed the conversion of economics on the reservations from herding and farming to the production of arts and crafts.

The merging of Victorian tastes with travel in the West, made possible by the extension of the railroad across the country, was well met by Navajo silversmiths in the 1880s and 1890s. These two decades saw the refinement of tools and techniques, the availability of high-quality silver, and the production of masterworks in both silver jewelry and utilitarian items. The result was to lift the souvenir spoon to a level of artistry equal with the best Navajo-made silverwork of the period.

The first U.S. patent issued in 1881 for a commercially produced souvenir spoon celebrated the suspension bridge at Niagara Falls. By 1890, with the release of a commercial design called "The Witch Spoon," the craze for souvenir spoons reached full throttle. Designed by Massachusetts silversmith Daniel Low to honor his hometown of Salem, the Witch cast its spell on the American public. In the following eighteen months, its staggering popularity generated more than twenty-two hundred different commercial souvenir spoon designs

Souvenir spoons were often intended for actual use. This ad, from *Scribner's* July 1891 magazine, offers the popular Witch design as an orange spoon, bonbon spoon, and almond scoop.

(Bednersh 1998, 9). An 1891 souvenir spoon ad has, as its opening sentence: "An interesting mania, yet one having its useful side as well, is the collecting of odd silver spoons" (Author's papers, DL, 1891).

1 Stirring up Tourism

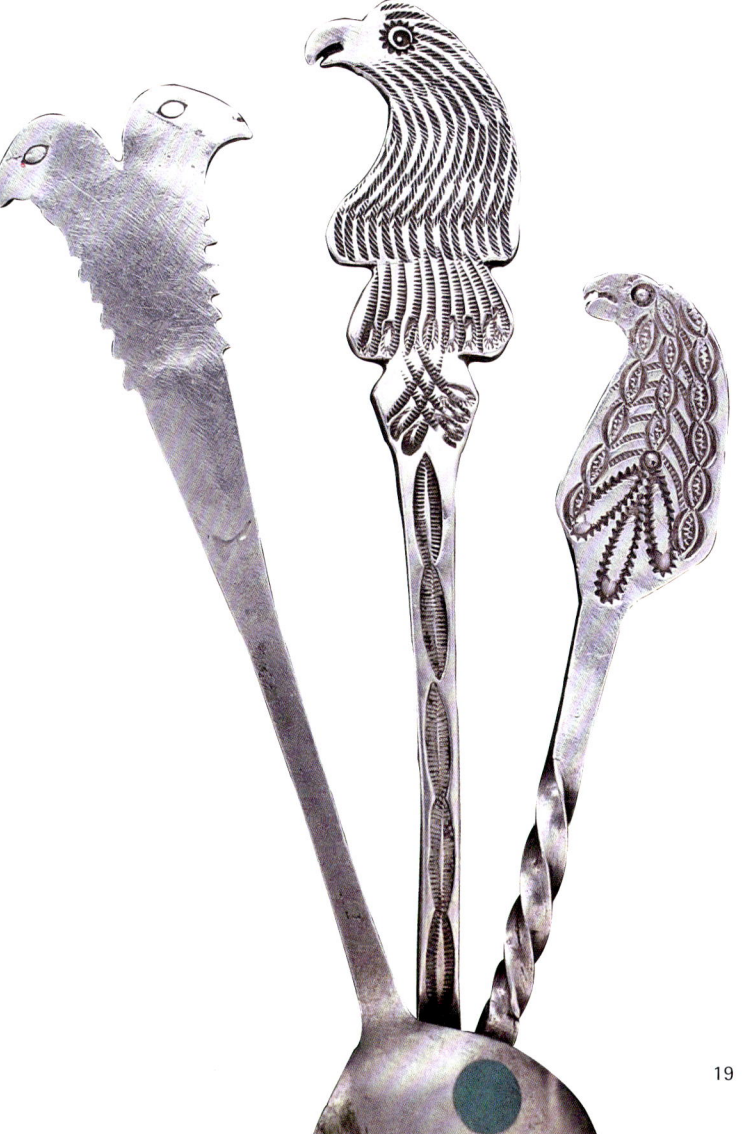

Turn-of-the-century bird handles. The double-headed spoon, fully stamped on the front, has the addition of eye outlines on the backside.

SPOONS WERE IDEAL SOUVENIRS in the era of train travel. Second only to the desire to go somewhere is the desire to bring something back, and bags and trunks packed tight with necessities for lengthy adventures by rail did not leave much room to bring back weighty or breakable purchases. When trying to decide between a fragile pot, sizable textiles, or a half-dozen spoons, spoons were the souvenirs of choice. Better still, spoons could be displayed or even used upon the return home, and commercial designs typically were decorated with figurative details of sights and cities. Part of the fun was that compilations of spoons could, at a glance,

opposite page

TOP

The shape of this spoon is nearly identical to the sugar spoon Chit-Chi made for Charles F. Lummis. The addition of fluting on the bowl was popular on buttons around 1900, and a "profile" has been added for tourist appeal.

BOTTOM

Lummis photographed the 1888 sugar spoon that he commissioned of Chit-Chi, alongside other silver items. Courtesy the Southwest Museum, Los Angeles, Photo N.506/43019

remind you of all of your adventures. Collected one by one, they assembled a visual travelogue easily expanded with each new experience.

Seventy thousand miles of railroad track inched their way across the United States between 1880 and 1890. The Atchison, Topeka and Santa Fe Railway arrived in New Mexico late in 1879 and was steaming into New Mexico's major cities a mere two years later. The Southern Pacific and the Atlantic and Pacific reached the Southwest in 1881 and 1883, respectively, soon to be joined by the Denver and Rio Grande and numerous other lines. Trains so altered daily life, through both personal travel and transportation of goods, that it necessitated the adoption of Standard Railway Time in 1883. Hours were no longer marked locally, by the passing of the sun across the sky, but nationally by the passing of trains across the countryside.

Trains and tourists go hand in hand, and once the Navajo began accepting tourist dollars for their work, their work changed. Charles F. Lummis observed in the late 1880s that "the universal rule with the Pueblo and Navajo smiths is to charge as much for the work as for the silver. For instance, if you give them a silver dollar as the material for a bracelet, you will have to give another silver dollar for their labor, and so on up" (Lummis 1888, 45). Traditionally, Navajo crafts had included pottery, basketry, and ironwork, but textiles and jewelry constituted the bulk of trade items for the growing American markets.

Items were made to order, either for visitors with handfuls of coins or for traders seeking quantities of items to sell. A Native smith's work no longer necessarily reflected his own aesthetics, particularly if he was creating an item from a sketch or copying an item supplied by the would-be purchaser. Navajo silverwork split into two types: personal adornment and designs that would sell readily. Each new item added to the list of what a smith knew how to make, and, by the early 1880s, to the list of previously historically documented buttons, bridles, bracelets, tweezers, bells, concha belts, and tobacco canteens can be added flatware and spoons.

On January 10, 1885, in a colorful but convoluted tale about breaking his arm and pulling off a handsome trade for a meerschaum pipe, Lummis, at the time a reporter for an Ohio newspaper, wrote that he felt "rich as a hog with two mouths" for having acquired the following Navajo items while on a stopover in New Mexico en route to California: a large "bed-blanket," a saddle blanket, and a grouping of silver jewelry of "semi-barbaric beauty" that included two bracelets, two earrings, several wrist and leg ornaments, a "rude, heavy ring," and "about 25 buttons made from dimes, quarters and halves. . . . All the jewelry by the way was made by the skillful brother of old Manuelito [Chit-Chi]—the leading silversmith of the Navajos" (Byrkit 1989, 231).

Later in the same musings, Lummis states that a station agent "... showed me a very beautiful set of table silver which Manuelito's brother [Chit-Chi] had made for him. I would vastly prefer it to any American set that ever was fashioned" (Byrkit 1989, 233). Lummis goes on to mention that the table silver was hammered from American silver dollars.

Navajo table silver rivaling commercially produced flatware? At the very start of the year 1885? The fact that Lummis waxes poetic about the table silver but refers to Chit-Chi's other jewelry items as "semibarbaric" and "rude" powerfully suggests that Navajo spoons and flatware were being produced, at least by Chit-Chi, well before 1885. Table silver *must have* included spoons.

The thought of any Navajo silversmith hammering out silver teaspoons, sugar shells, and complete sets of flatware in the early 1800s is a revelation. On the rare occasion that Navajo spoons are even mentioned in historical jewelry texts, their origins have been placed in the twentieth century: "After the turn of the century, silversmiths produced . . . new items such as

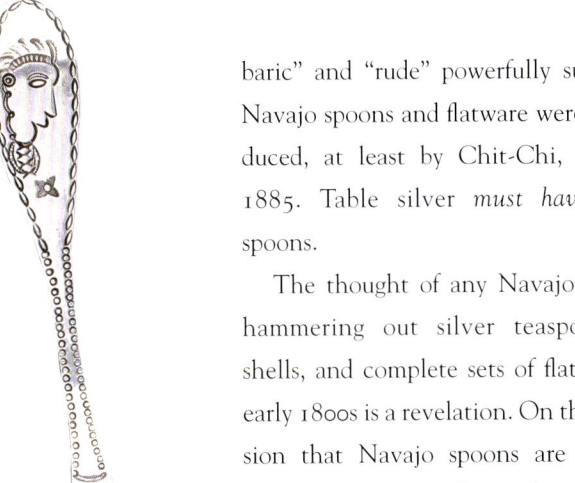

NAVAJO SILVER WORK.

eardrops, belt buckles, tie clasps, and watchbands, meat forks, gravy ladles, spoons, sugar shells, . . ." cites one standard on the subject (Bailey and Bailey 1986, 154). Researcher and photographer John Adair's classic text, *The Navajo and Pueblo Silversmiths*, published in 1944, lays claim that "in the past forty years the traders and the curio dealers have encouraged the Navajo smiths to make souvenirs for tourists. . . . Boxes, ash trays, forks and spoons . . ." (Adair 1944, 53), also placing spoon origins at the turn of the twentieth century.

We know from Lummis, however, that Navajo spoon making actually began approximately twenty years prior. Examination of the characteristics of the earliest spoons found in private collections supports this timeframe, and the earliest dated Navajo spoon yet found, engraved by

The mastering of a spoon: Shown front and back, in sequence of age, this grouping shows one silversmith's development between ca. 1885 and 1891. Note that the faces have the same oval eyes, and the owls have consistently rendered feet and round eyes. *At far left*, thin spoon with one twist in the handle features rocker-engraving and a "corn" motif similar to Lummis's sugar spoon ca. 1888. The spoon *third from left* has documentation that it was made from a silver quarter (hence, its smaller size), and is signed "Navajo" in rough script. Rather than twisting the handle, the smith chose to decorate it with a series of punchings with a small die. *Spoon four* is heavier with a rounded handle. *Spoon five* continues this new handle treatment. *Second from right*, the handle is thicker and the form more skillfully done. The *final spoon* ties it all together: the owl and profile, found individually on the earlier spoons, appear together on this spoon. The smith-engraved date of 1891 left no room for the smith to write his usual "Navajo," however. An ornate, Anglo-engraved "A" fills the bowl.

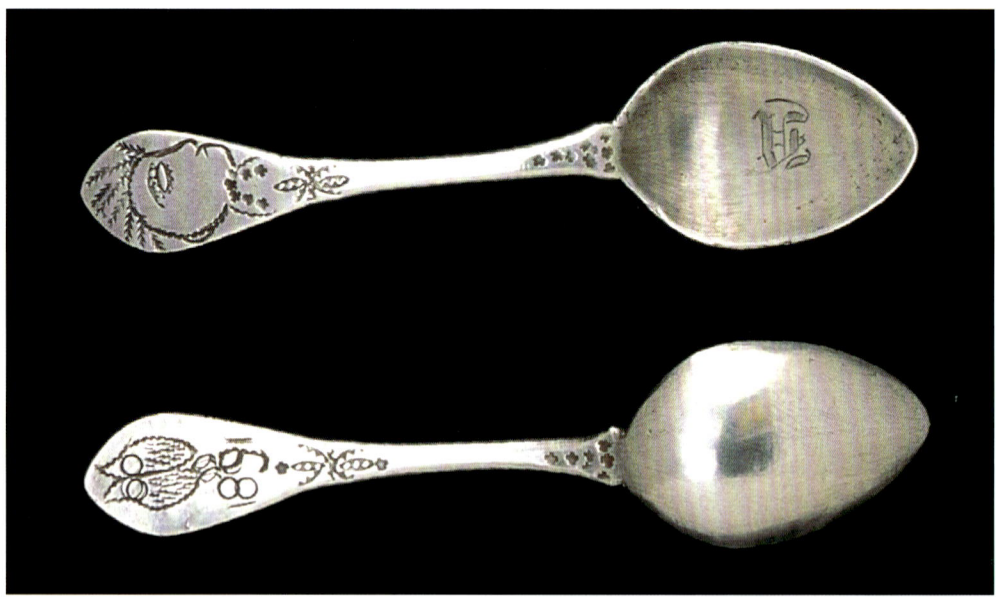

the Navajo smith with a date of 1891, corresponds to the year that souvenir spoon collecting became a national pastime.

And spoons would soon, if not already, include souvenir spoons. Even before the release of the Witch spoon in 1890, some designs enjoyed sales in the thousands, including twisted-handle spoons manufactured in Washington, D.C., with profiles of George and Martha Washington. Spoons became coveted as remembrances of trips, places, renowned individuals, and events, and it was rare that a traveler did not board a train for home without at least one souvenir spoon.

By the turn of the century, nearly 185,000 miles of railway laced the country, approximating the entire rest of the world combined. This, and a vibrant economy, enabled many Americans to travel for pleasure, a luxury previously reserved for the very wealthy. Assortments of souvenir spoons became the preferred gift-memento for the newly mobile middle class.

America's new mobility did not correspond with a growing worldliness, however. *Baedeker's United States: Handbook for Travelers*, published in 1899, still cautioned prospective tourists that North America "had not quite yet . . . brought civilized society to its western half" (Lockwood 1999, 84). The great expositions of the late nineteenth and early twentieth centuries, such as The Panama-California Exposition that San Diego hosted in 1915–16, were

A likely souvenir of Buffalo's 1901 Pan-American Exposition, this spoon may predate 1901 if crafted in the Southwest and shipped to the exposition. Profile spoons of this style first appeared in Indian trader J. L. Hubbell's 1902 pamphlet.

opposite page
TOP
By 1892, souvenir spoon collecting was sweeping the country. Note that the Witch spoon is promoted as being "The most celebrated of the Souvenir Spoons."

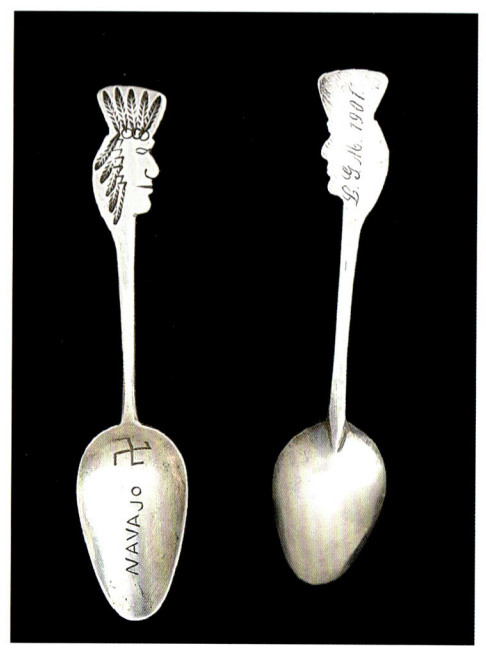

designed in part to introduce cautiously curious new tourists to the more exotic aspects of an America as yet unexplored and wholly misunderstood. Financially underwritten by the railroad interests whose chief concern was the development of tourism in the West, these expositions featured anthropology and ethnographic exhibits, often involving living people, that perpetuated EuroAmerican superiority while romanticizing the "primitive" (Rushing 1995, 7).

An Anglo-engraved profile, or Indian-head, spoon, inscribed "L.G.M. 1901" may be attributable to the Pan-American Exposition held that year in Buffalo, New York. Many Indian-themed commercial souvenir spoons were patented for these expositions. The 1893 Chicago World's Columbian Exposition took souvenir spoons

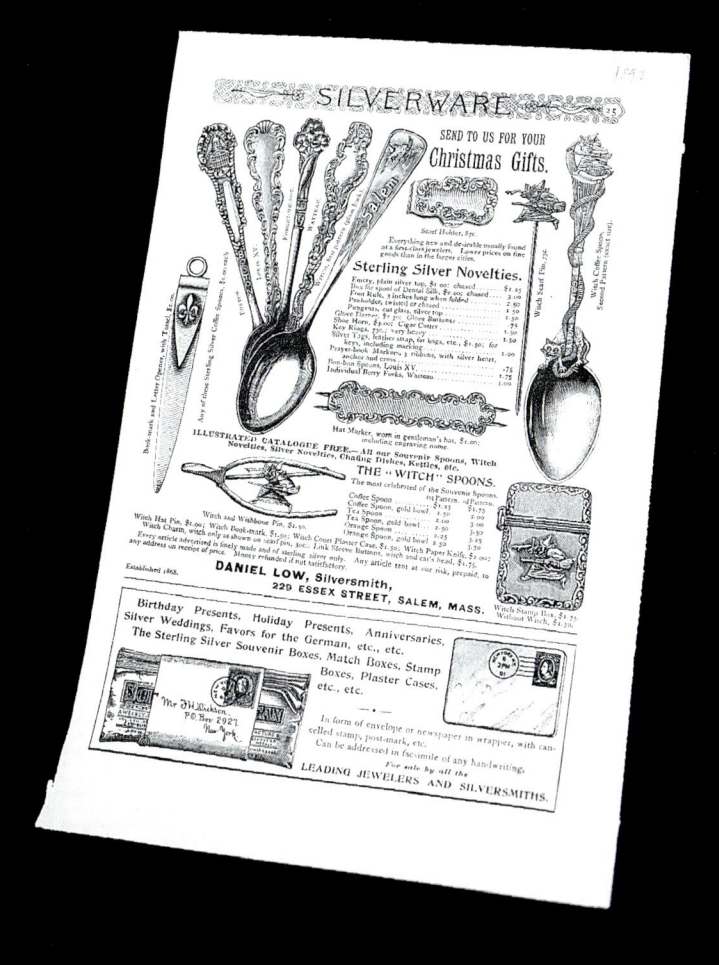

national, as more spoons were produced for that exposition than for any other event in history (Rainwater and Felger 1968, 225).

Being handmade by Native silversmiths and unique to the region, Navajo spoons were ideal souvenirs of the Southwest, and the Charles M. Robbins Company in Attleboro, Massachusetts, took notice. A company founded in 1892 primarily for the manufacture of political campaign buttons, Robbins produced four collectible whirling logs, or swastika, spoons, two with twisted handles, and deemed the designs "Navajo Spoons." Sold with the sentence: "These spoons are fashioned after the style of those made by the Navajo Indians" (Rainwater and Felger 1968, 194), an undated Robbins catalog proclaims the designs took "Highest awards at the St. Louis Exposition, 1904."

Robbins's "Navajo Spoons" provide a time-marker for genuine Navajo spoons because they must have been popular well before 1904, with identifiable styles, in order for an East Coast manufacturer to produce commercial interpretations for the 1904 St. Louis Exposition. Indeed, many pre-1900 Navajo spoons have twisted handles.

Twisted handles were so popular in commercial spoon designs of the 1880s and 1890s that they were one of the features of

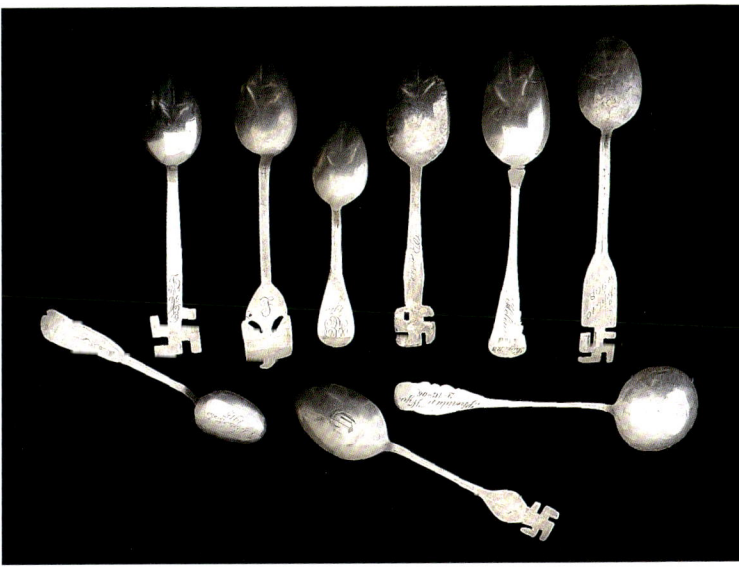

This grouping shows the assorted ornate engraving styles used at the turn of the twentieth century.

Stirring up Tourism 25

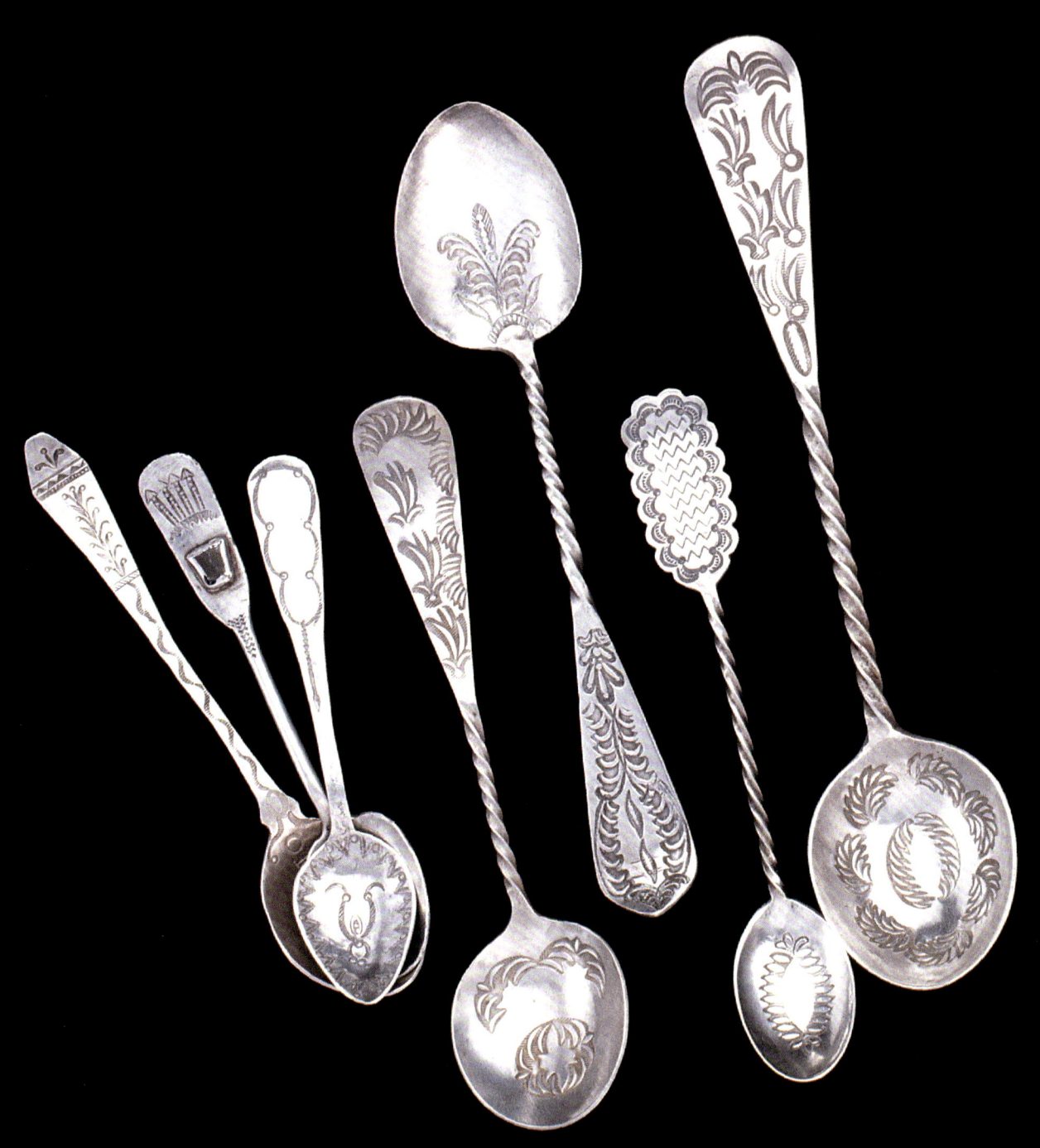

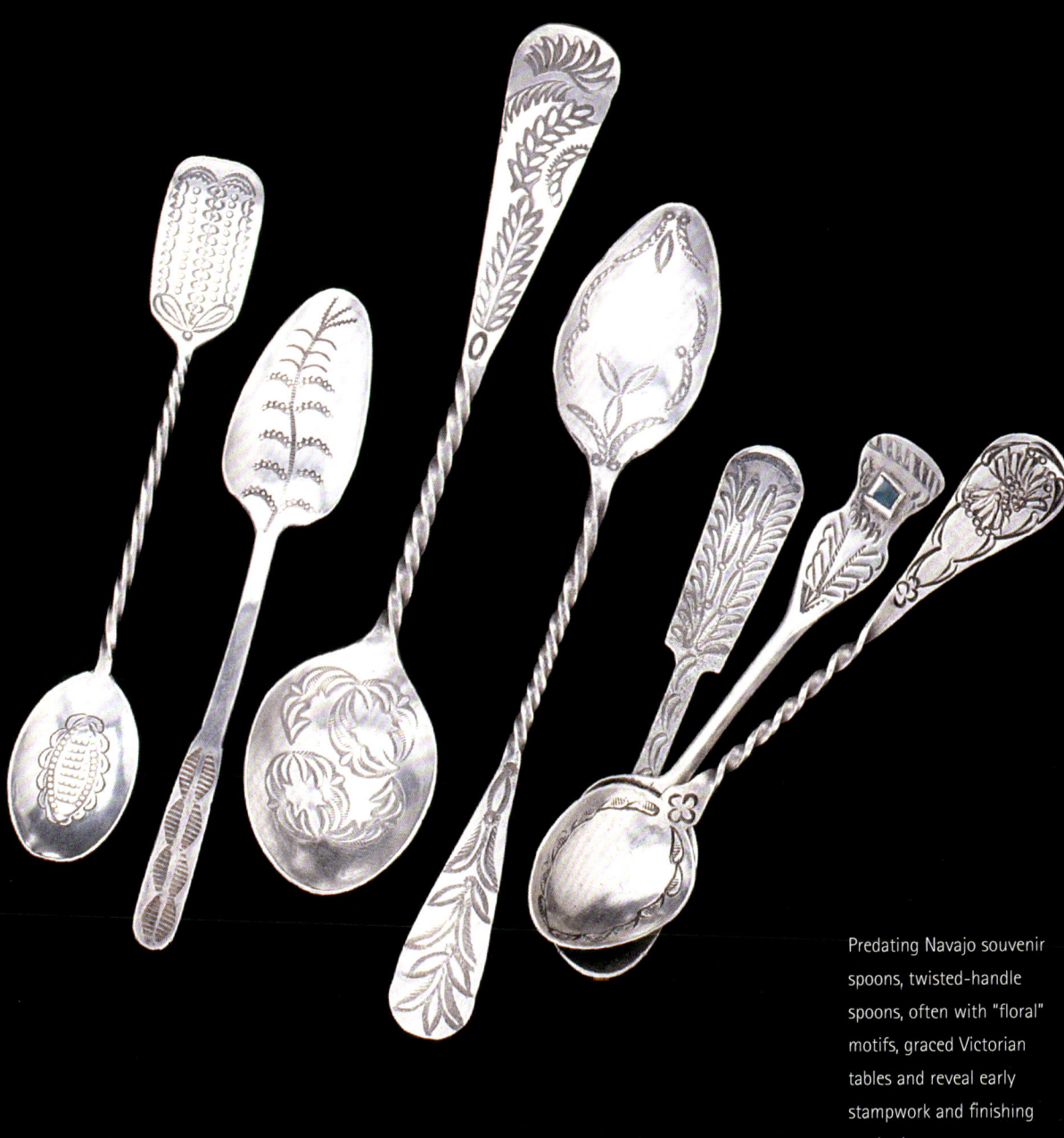

Predating Navajo souvenir spoons, twisted-handle spoons, often with "floral" motifs, graced Victorian tables and reveal early stampwork and finishing methods.

Tiffany & Co. often used Indian motifs as inspiration for its own designs. This soup spoon and ice cream server, made by Tiffany & Co. ca.1893, are from an extensive line designed by Charles T. Grossjean, patented in 1885. Purchased at auction from the estate of William Randolph Hearst. Photo courtesy the Autry Museum of Western Heritage, Los Angeles.

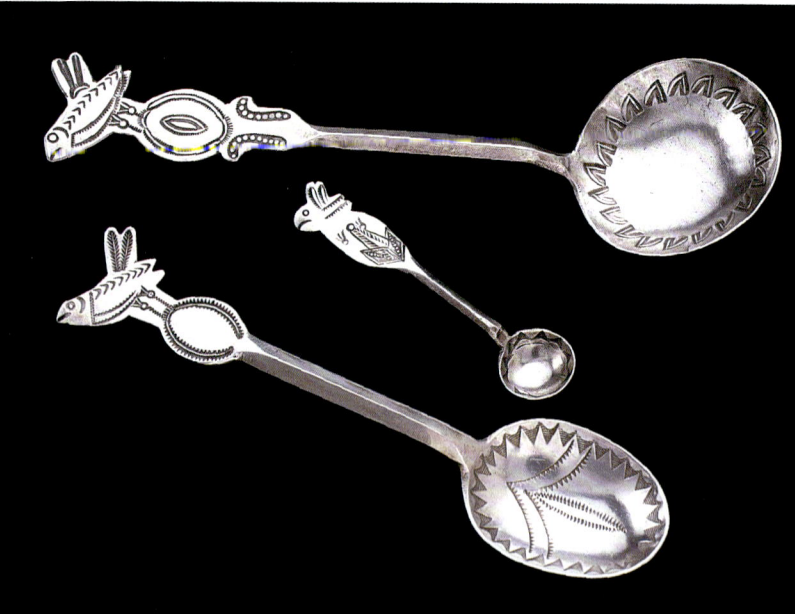

the Robbins Company's 1904 commercial "Navajo Spoons" and were offered in Indian trader catalogs as late as 1906. Trader J. B. Moore promoted twisted handles as providing "extra strength." In addition, the end result was quite pretty.

In 1885, Tiffany and Company released an elaborate line of spoons depicting "Indian dances." Tiffany's interest in Native arts is well documented, and many fine examples of Navajo silverwork purchased by the company were displayed at the 1893 Chicago World's Columbian Exposition (Frank 1990, 27).

While souvenir spoons purchased today are solely decorative, it originally was popular to offer commercial souvenir spoon designs in a variety of sizes for a variety of uses. Advertisements often subcategorized souvenir spoons as "coffee spoons" or "orange spoons." The notion of a spoon having an assigned use was a Victorian one. Late-nineteenth-century silver companies manufactured more than 150 different types of serving pieces since the opulent table settings of the day required the proper utensil for everything from oysters to asparagus, not to mention the fact that a Victorian meal could have ten courses.

Because commercial spoons were offered in a variety of sizes, Navajo smiths sometimes followed suit, as shown.

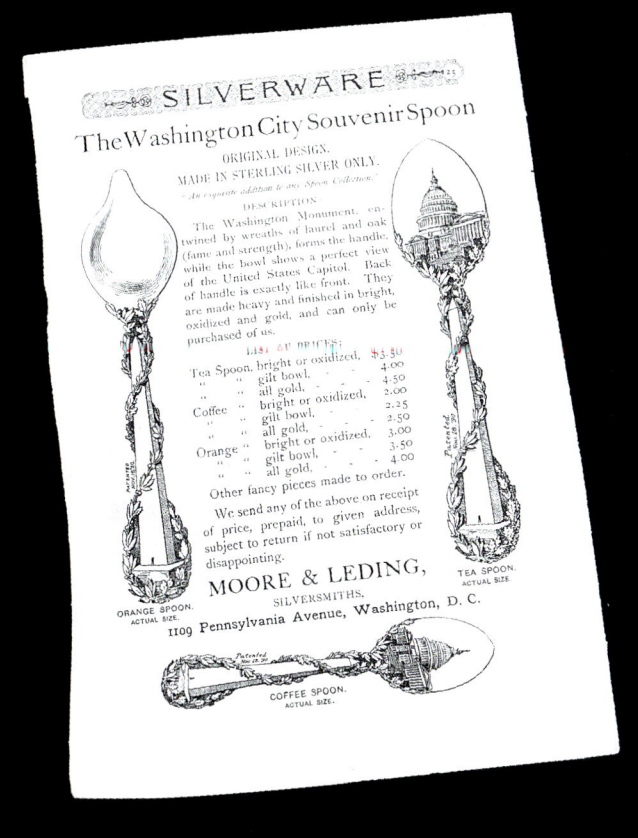

These orange and tea "souvenir spoons," as this advertisement from 1891 demonstrates, would be "An exquisite addition to any Spoon Collection."

Additional shapes and sizes typical of the turn of the twentieth century: The letter opener *second from top* has notable wear on the blade. The squared bowl *fourth from left* is a cheese scoop used for serving Stilton or other soft cheeses.

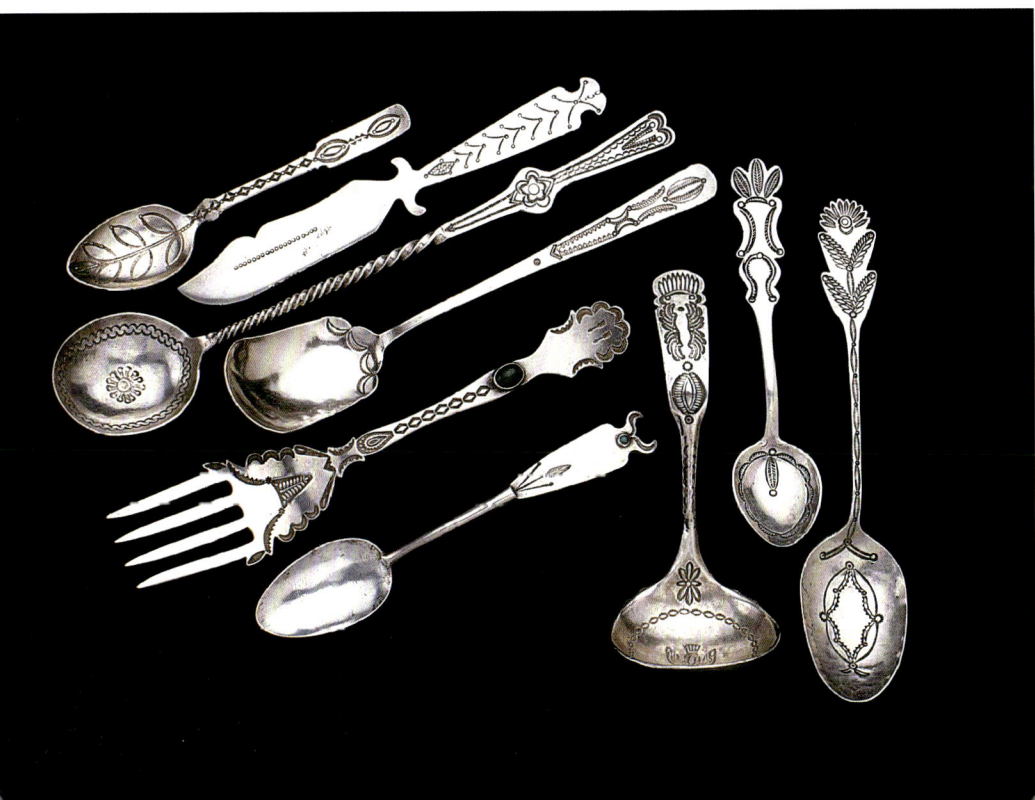

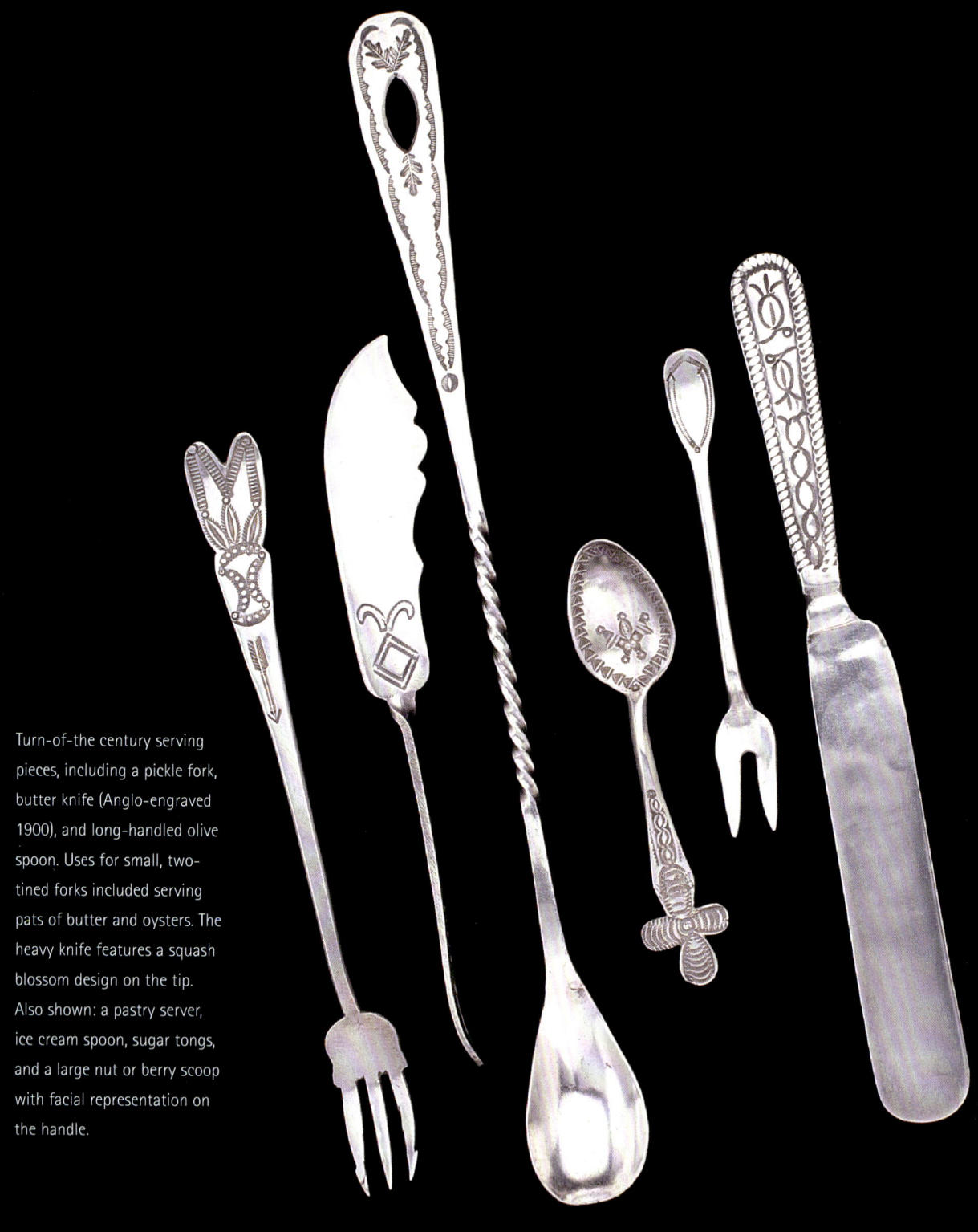

Turn-of-the century serving pieces, including a pickle fork, butter knife (Anglo-engraved 1900), and long-handled olive spoon. Uses for small, two-tined forks included serving pats of butter and oysters. The heavy knife features a squash blossom design on the tip. Also shown: a pastry server, ice cream spoon, sugar tongs, and a large nut or berry scoop with facial representation on the handle.

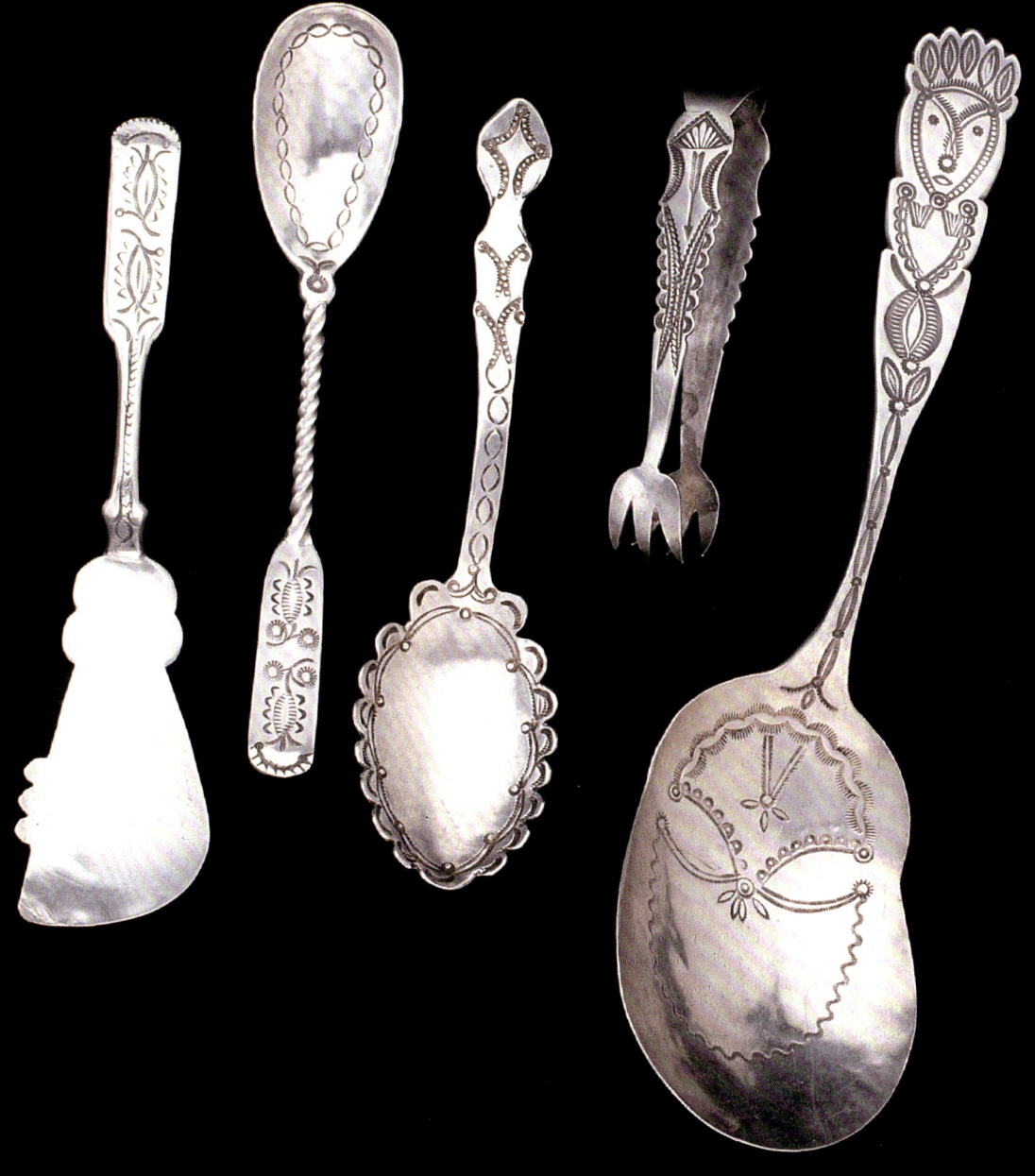

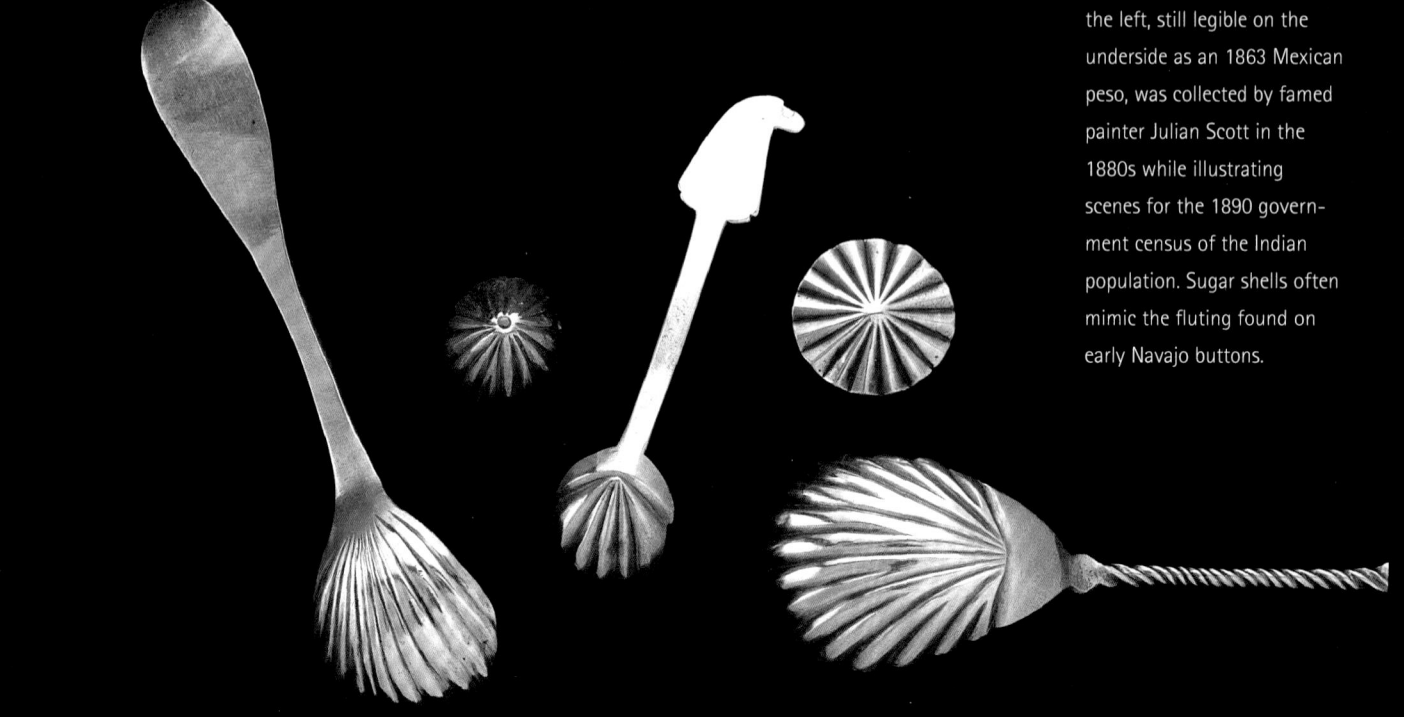

the left, still legible on the underside as an 1863 Mexican peso, was collected by famed painter Julian Scott in the 1880s while illustrating scenes for the 1890 government census of the Indian population. Sugar shells often mimic the fluting found on early Navajo buttons.

Historically, spoons were already the most prevalent item of flatware, but it was not until the Victorian era that spoons were elevated much beyond common teaspoons and tablespoons. More spoons and spoon uses were created for the elegant tables of the Gilded Age than at any time before or since, including ice cream spoons, berry spoons, salt spoons, cream and gravy ladles, nut spoons, soup spoons, Stilton cheese scoops, long-handled olive spoons, pierced tomato servers, bonbon spoons (sometimes referred to as bonbonieres), mustard spoons, and even spoon "rests"—decorative shapes in crystal or silver that provided your spoon a stylish respite. Covered sugar bowls, called "spooners," featured little brackets around the outer edge for no other reason than the decorative dangling of pretty sugar spoons, and pampered infants ate from elegant sterling feeding spoons, which led to the phrase "He was born with a silver spoon in his mouth" (alluding to family prosperity).

Although Chit-Chi's sugar spoon has a smooth bowl, sugar spoons often were called sugar shells because of their scalloped bowls resembling seashells. They were a favorite of the Victorians and a favorite of Navajo smiths to make—the fluting (deeply ridged surfaces) so popular on late-nineteenth-century Navajo buttons transferred perfectly to the crafting of sugar shells. In fact, Navajo spoons incorporate many of the decorative effects found on buttons, one of the most

commonly produced items of early smiths. Navajos loved to adorn themselves with buttons, not as Anglos use them, with buttonholes, but instead sewn all over their clothing for ornamentation.

Lummis commented that "the results of a mixture of native workmanship with American ideas are sometimes curious" (Lummis 1888, 45), and nothing exemplifies that observation more vividly than the Navajo spoons made for Victorian tables. When commercial designs from different manufacturers are compared, there's often no distinction between one manufacturer's "bonbon spoon" and another's "berry spoon" and so on, and this presents a challenge when trying to match Navajo spoons with commercial counterparts. Some Navajo spoons are real head-scratchers, and even when they're seemingly obvious—soup spoons, for example—one glance at a late-nineteenth-century flatware guide brings the realization that soup spoons had separate designations, such as "cream soup spoons" and "bouillon spoons."

Souvenir spoons belong to a thirty-year period of popularity, but for a much longer period table silver was regarded as fine jew-

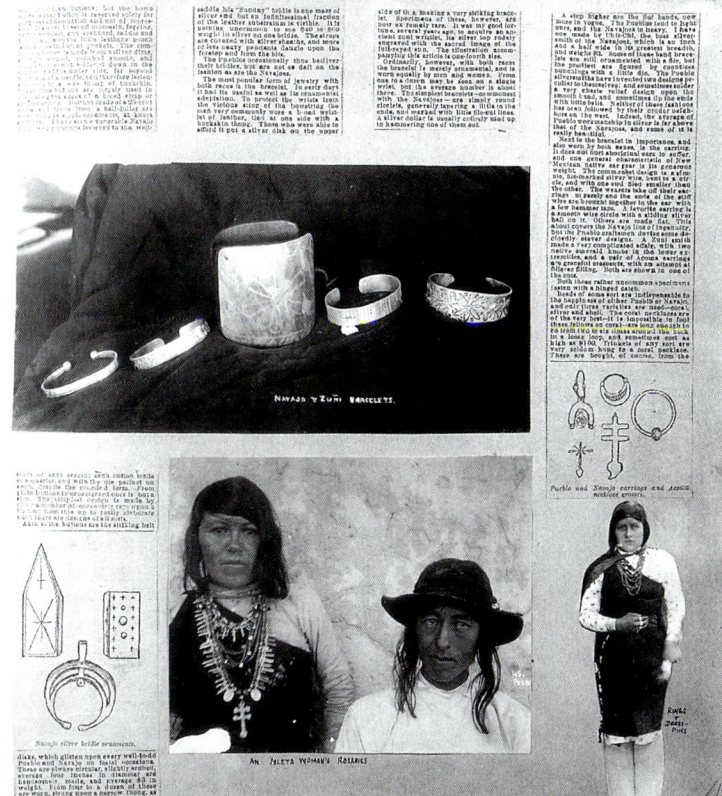

Lummis's scrapbooks overflow with his articles, haphazardly cut photos (many trimmed to fit between other items pasted on the page), and handwritten notes. Next to this article, dateline Acoma, New Mexico, July 6, 1888, there's a notation that the article actually ran in the *San Francisco Chronicle* on August 5. Courtesy the Southwest Museum, Los Angeles, Photo # 43016

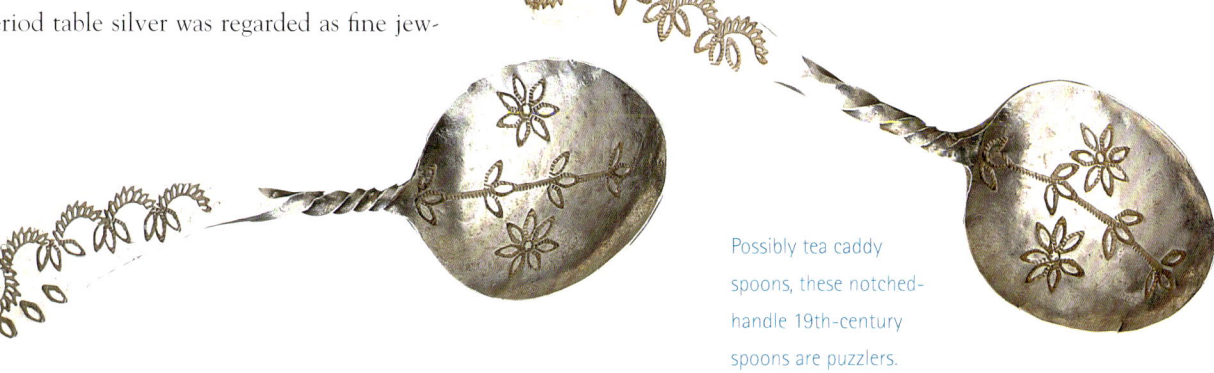

Possibly tea caddy spoons, these notched-handle 19th-century spoons are puzzlers.

Stirring up Tourism 33

elry. Today, the name "Tiffany & Co." conjures up jewelry, not forks, knives and spoons, but for decades silverware was purchased not at department stores but through respected jewelers. A 1920s ad placed by the International Silver Company for "1847 Rogers Bros. Silverplate" even touts the beauty of its mirrored silverware chest, suggesting that with the pad removed, it would serve as a "lovely vanity case for your dressing table." Jewelry and table silver were

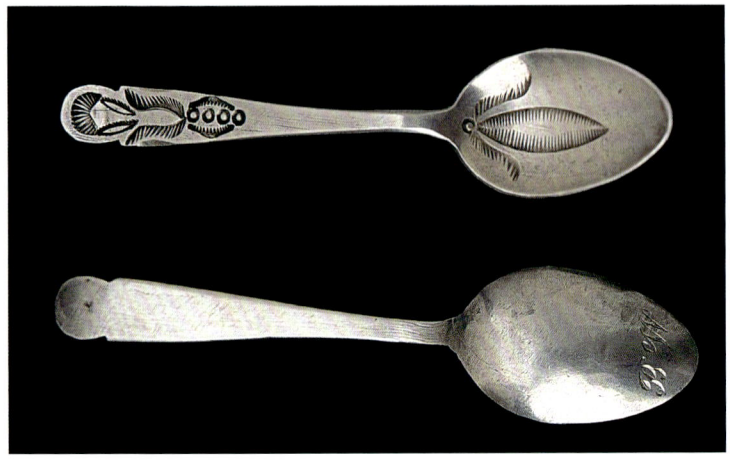

The Victorian love of engraving frequently led to Anglo jewelers' addition of initials to Navajo spoons, as shown on this bowl tip.

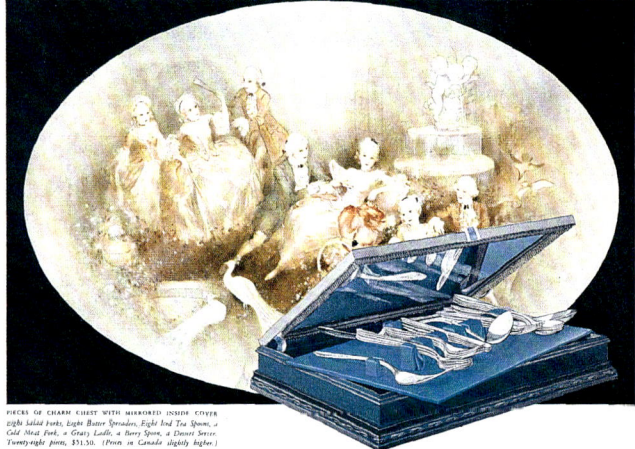

This 1920s advertisement reveals the intimate relationship between table silver and fine jewelry.

inextricably intertwined. This jeweler-silverware connection also explains why many Navajo souvenir spoons, purchased during travels and brought home as treasured remembrances, were later engraved by Anglo jewelers.

Late Victorians were enthralled with engraving. Between 1880 and 1901, it was fashionable to wear "message brooches" or "love brooches" engraved with names or other endearing thoughts, a proclivity that lent itself easily to the souvenir spoon movement. Between 1890 and 1915, when

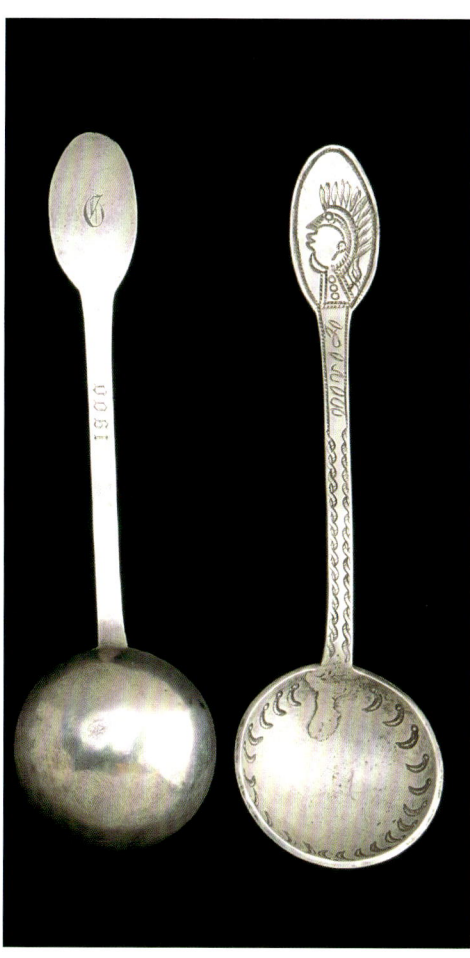

Shown front and back, the Native smith wrote "Navajo" on the front of the handle and an Anglo jeweler later added the year "1900" and the initial "C."

which referred to the small box in which tea was packed. Short-handled spoons were created to fit inside tea caddies, and the records of Paul Revere, the American patriot and silversmith, from the year 1792 make mention of a spoon sized to fit within a tea caddy (Bridwell 1965, 531). Often misidentified as "baby spoons," the size of the bowl is the tip-off: they're for scooping up tea and are much too large for even the hungriest infant's tiny mouth.

In the era of train travel, Navajo spoons reigned as the convenient, consummate way to preserve a Southwest memory. Native American pottery, baskets, and textiles demand visual attention. They dominate rooms and make important "design statements." Navajo spoons rest quietly on tabletops, content to whisper simply, "I am a souvenir."

spoon collecting was at its zenith, Navajo spoons were often Anglo-engraved with dates, names, and details of purchase.

Another unusual spoon type, predating Victorian tables, was the tea caddy spoon. As the drinking of tea became fashionable, so did small chests of wood or silver in which to keep tea under lock and key. The name "tea caddy" now applies to these chests, a derivation of the Malayan word *kati* and/or the equivalent Chinese word *catti*

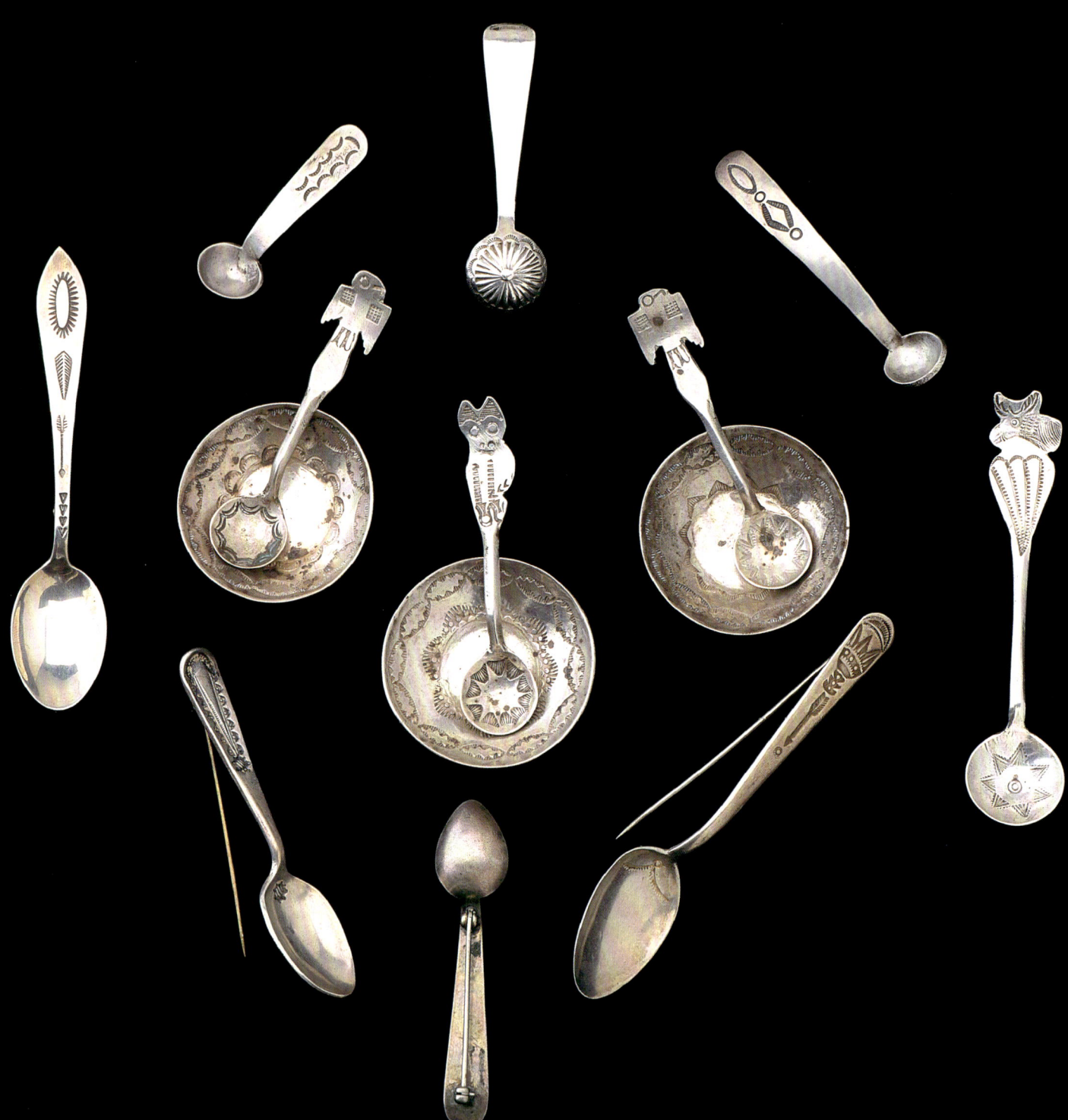

2
Navajo Silver Comes of Age

WHILE SPOONS MADE OF METAL are not traditional Native American items, they are objects for which Navajo silversmiths had an apparent affinity. Along the Pacific Northwest, coastal tribes such as the Haida, Tlingit, and Kwakwala began crafting silver bracelets and rings from American silver dollars and half-dollars in the middle 1800s, and souvenir spoons with Northwest Coast motifs (their bowls often engraved with the Alaskan city name of "Sitka") also turn up occasionally. But such spoons are few and far between when compared with the range, quantity, and diversity of Navajo spoons. Once visitors in the 1880s began requesting spoons of Navajo silversmiths, it seems their shape and form were a delight to maker and purchaser alike. Unlike rings and bracelets, which curve beneath the wrist and finger and leave the totality of the design unseen, spoons lie flat and offer two separate elements—handle and bowl—to work with. There is no evidence that Navajo smiths ever made spoons for their own use, but the word for "Spoon, silver" did make its way into the Navajo language: *be slagai be si te*.

Navajos were introduced to Spanish metal goods in a variety of forms from early in their contact. Buckles, buttons, objects of adornment, and gear for horses became sources for Indian creativity, and by the 1850s, Navajos were fashioning jewelry for the trade. European- and American-made trade items flooded into the Southwest after Mexican independence was won in 1821, and the opening of the Santa Fe Trail that year provided cultural exchange in both directions, some via the

Many salt spoons were paired with round, stamped silver dishes, the Navajo equivalent to "saltcellars." The two Fred Harvey Co. Thunderbird salt spoons are ca. 1910. *Top center,* the salt spoon bowl's tiny underside was finished like a button. Ordinary small spoons, such as the example *far left,* and salt spoons separated from their original cellars, were sometimes converted to pins.

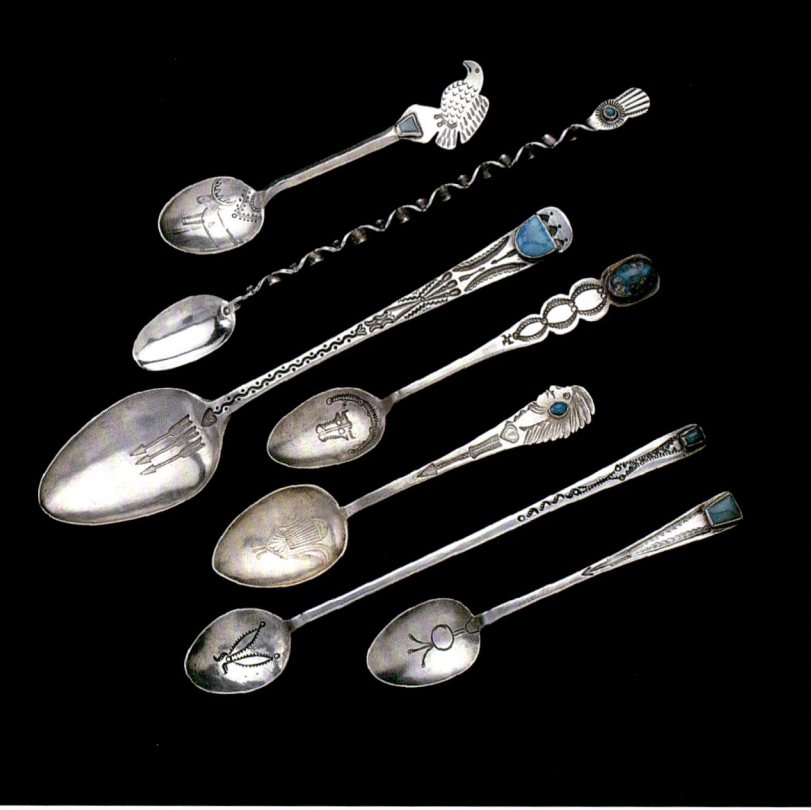

Turquoise was not a common feature on spoons until it became readily accessible to silversmiths after 1915. Beginning in the 1920s, iced tea spoons and salad sets sometimes featured turquoise.

Plains tribes. By 1846, traders were supplying the reservations with manufactured items and metals to work.

We know that at least by the 1860s, Navajo smiths were working silver.

In fact, the Navajo smith Atsidi Sani, who worked primarily in iron, is credited with being the first to work silver as early as 1853 (Laboratory of Anthropology 1989, 77). U.S. Army campaigns against the tribe culminated in the internment of some seven thousand at Bosque Redondo, a military reservation in eastern New Mexico, in 1864. By the time the Navajos were released and allowed to return to their lands in 1868, they were becoming accomplished silversmiths.

By 1880, silver making entered its classic period, exemplified by refinements in materials, tools, and techniques. Navajo smiths begin to exhibit mastery in the new techniques of soldering and appliqué decoration, as well as in the fabrication of stamps, repoussé, and other techniques. Utilitarian items began to appear along with a proliferation of curio items of nontraditional designs fabricated to meet the burgeoning tourist trade.

The first setting of turquoise into silver appeared between 1880 and 1890, but turquoise was scarce at that time and would not become prevalent until the next century. The only turquoise mine in the Southwest during the 1800s was approximately twenty miles south of Santa Fe, and most of the turquoise it yielded was green, not blue. Lack of turquoise, along with rocker-engraved designs and crude solder work, is characteristic of First Phase silverwork.[3] Turquoise didn't become easily obtained in the Southwest until about 1915, after the opening of several mines in Nevada in 1912 and just as souvenir spoon collecting began its decline. Even if made, it's possible that spoons set with turquoise didn't sell well unless a spoon's sole purpose was that of a souvenir for display. Buyers may have been wary of the impracticality of turquoise attached to an item likely to be

immersed in soapy dishwater or on spoons intended for use in a drink, as in the case of coffee spoons or teaspoons.

Navajo silverwork took a great leap forward with the introduction of solder and the use of dies. The term "die" refers to anything used to stamp a design onto silver, and, in fact, the terms "stamp" and "die" are interchangeable. Stamps could be created from most any bit of scrap iron, including leftover bolts and railroad nails and worn-out chisels, so long as there was a flat surface upon which a design could be carved into the tip. Designs were simple at first, being no more than lines made with the ends of files or diminutive circles impressed into silver with a punch, the same tool used for making the border holes on conchas (oval silver discs strung on leather to make belts).

Another decorative technique, borrowed from Plains tribes, was rocker-engraving. Rocker-engraving is just that—the engraving of a design via the rocking back and forth of a very small tool. Rocker-engraved designs appear, when finished, as a line drawing comprised of lightly etched, continuous zigzags.

While silver jewelry decorated with rocker-engraving did not hold up well because the shallowness of the engraving readily rubbed off, spoons retain rocker-engraved designs because, aside from occasional washing or polishing, they're not subjected to daily wear or harsh conditions. If a spoon bowl is rocker-engraved, it's actually well protected. Similarly, early spoons show a roughness in their surface consistent with the beginning methods of silver finishing, when sand and files were used to smooth silver prior to the introduction of commercial sandpaper. Unlike jewelry, which wears smooth from constant contact with skin, souvenir spoons often were purchased only for display purposes. Even if actually used, say to sprinkle sugar or stir a

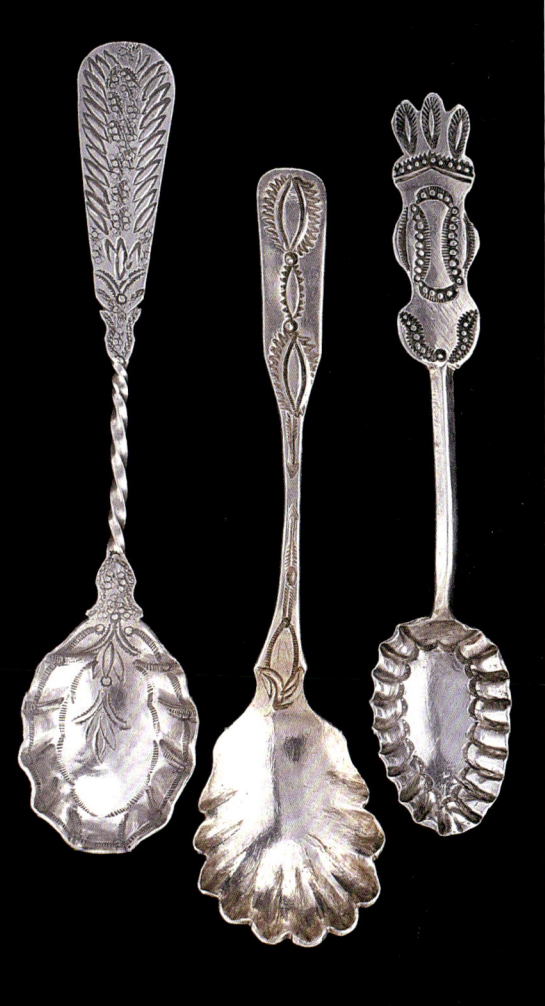

This turtle's shell has stampwork reminiscent of the earliest silver decoration, when the ends of files were impressed into silver to create simple lines.

The deep ridges of the center sugar shell retain the roughness of early, pre-1900 finishing methods.

Navajo Silver Comes of Age 39

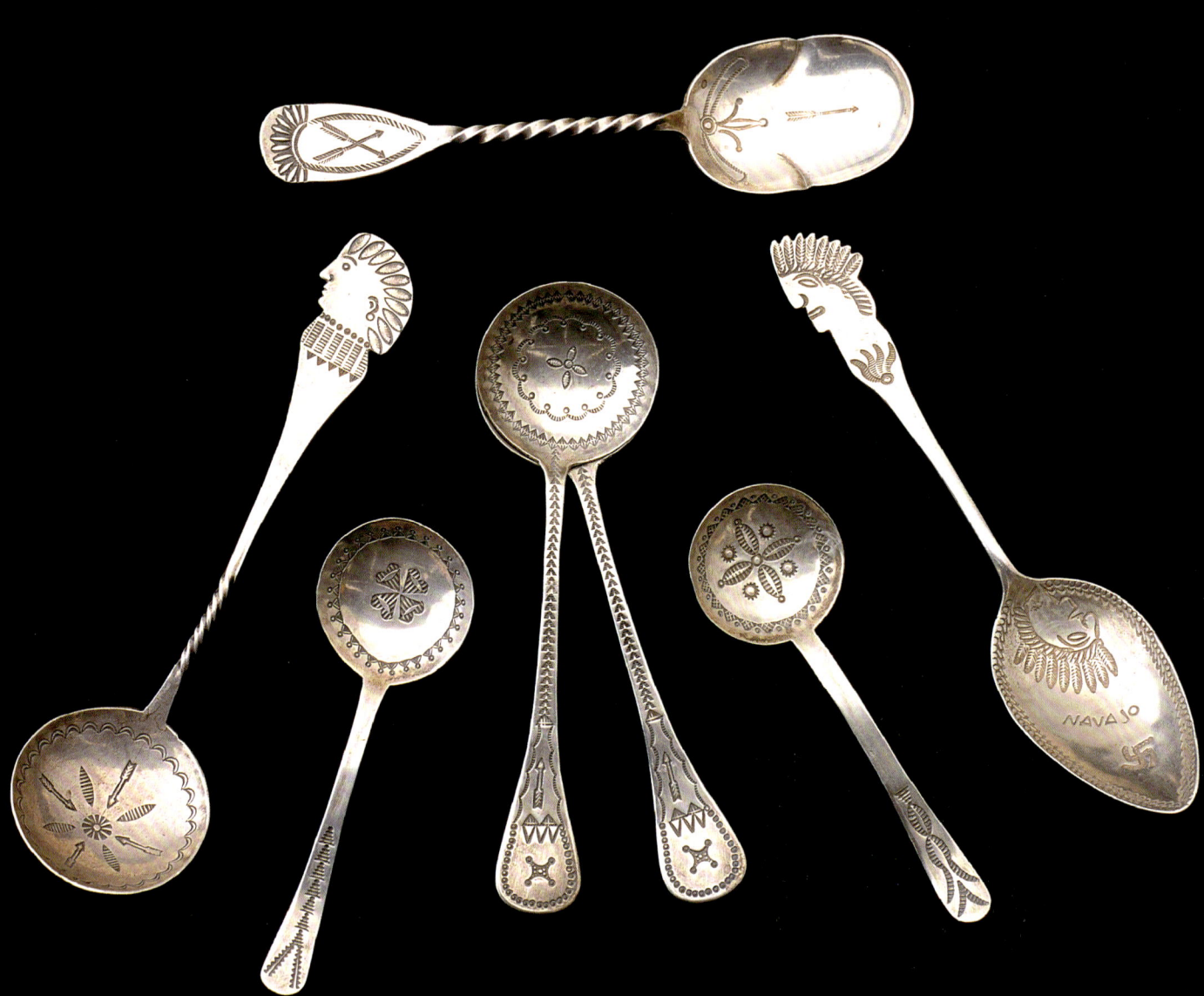

Thomas Pattison, a prominent resident of Gallup, New Mexico, collected this assortment of spoons in the early 1900s.

drink, the wear a spoon received was so slight that original details remain intact.

While rocker-engraving fell out of favor in the mid-1870s, Navajo spoons sometimes contain a combination of rocker-engraved and stamped motifs since smiths relied upon the older method to render more intricate or curvilinear drawings than what they could easily accomplish with their then still-limited range of stamps. As smiths gained access to scissors, pliers, tongs, awls, chisels, emery paper, fine files for carving stamps, and commercially produced stamps, they could create an expanded range of designs and spoon types.

Techniques and tools did not disperse equally, however. Silversmiths living a distance from the railroad produced spoons with an earlier appearance but during a later date than the spoon's characteristics might indicate. Whether a spoon is "early" or "remote" is often a judgment call.

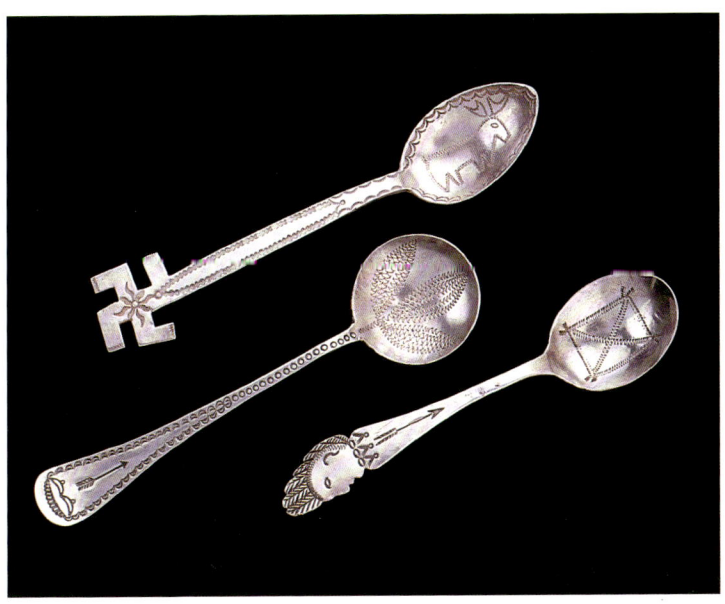

Rocker-engraved designs are often remarkably well preserved due to the protection offered by the depth of spoon bowls.

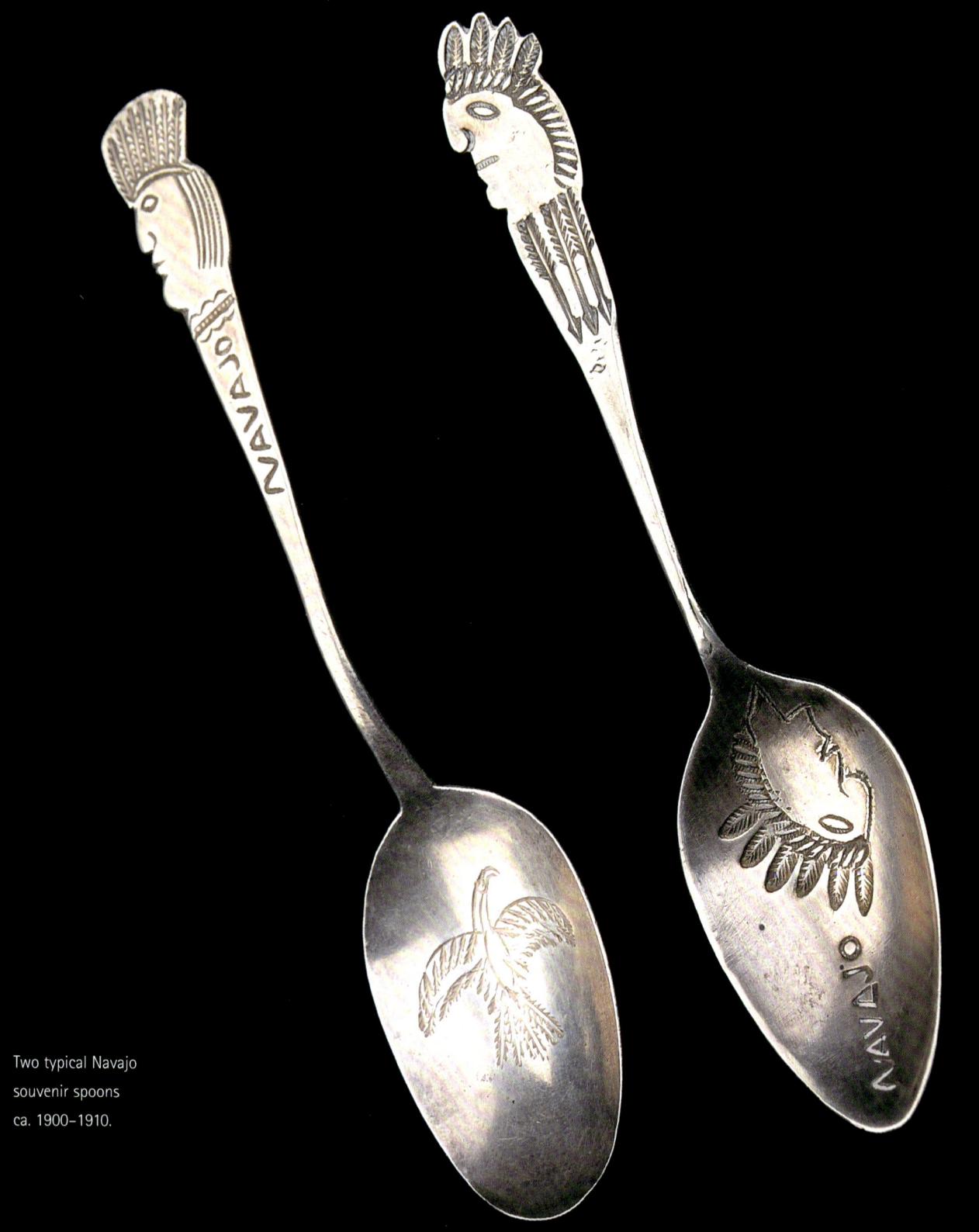

Two typical Navajo souvenir spoons ca. 1900–1910.

3
Traders, Trains, and Teaspoons

Traders preceded tourists. Trading posts began to dot the Southwest following the release of the Navajos from Bosque Redondo and after Fort Defiance was converted to Navajo Agency Headquarters and became the location of the new Indian Office. A few traders set up shop at Fort Defiance, but most sought their fortunes in the barren desert.

Trading required finding an area with enough Navajo families to sustain a business. Once the nearest Navajo headman granted approval to stay, a hopeful trader unloaded his wagon and staked his tent. If things worked out, he built a permanent structure. By the time that happened, a trader was part of daily Navajo life and could greatly influence items being made for trade by encouraging the making of what he could, in turn, sell.

Navajo spoons appeared in trading post catalogs beginning in 1902, as far as we know. This is because the survival of paper materials is extremely rare—no one thought to save such items. When an old catalog does turn up, it generates great excitement. The inevitable first question is, "Is there a date?" More often than not, the answer is "no." Clues are sought as to its age, and a "circa" date is assigned until additional information surfaces.

J. L. (Juan Lorenzo) Hubbell began his trading days with a brief stint at Fort Defiance in 1871, but by 1879 he was well established in Ganado, Arizona. He would eventually become the largest old-time trading presence in the Southwest. To his friends—President Theodore Roosevelt among them—he was "Lorenzo" while the Navajos he traded with affectionately called

him "Eyeglasses." Hubbell managed many posts during his lifetime but always maintained Ganado as the hub.

Hubbell's life took a detour from trading in 1882 when he was elected sheriff of Apache County, a time commitment that required some hired help. He selected Clinton N. Cotton, a well-liked Atlantic and Pacific Railroad employee. Despite Cotton's lack of experience, he proved a natural-born trader, and it was he who convinced Hubbell to hire a Mexican *platero* (silversmith) to teach the craft to the local Navajo men.

Although their friendship spanned a lifetime, Hubbell and Cotton's partnership spanned just ten years. Once on his own, Cotton is credited with being the first trader (circa 1897) to circulate a national pamphlet selling Navajo textiles. Hubbell followed his friend's lead a handful of years later, producing a pamphlet that, when first discovered, was dated "circa 1905." Personal correspondence later surfaced between Hubbell and the photographer pinpointing the publication date to 1902 (Author's papers, JBW, 1999).

In his pamphlet, three Navajo spoons are pictured: a profile spoon, an arrow spoon, and a nondescript spoon with turquoise. Hubbell assured his customers that all were the work of Navajo silversmiths and that all were made from coin silver.

The year 1902 falls at the outset of the "commercialization" of Indian jewelry. In 1899, the Fred Harvey Company began supplying Native silversmiths with precut turquoise and preweighed silver for the manufacture of lightweight jewelry along its train routes. Fortunately, Navajo spoons held their own against this influx of thin jewelry because the time and effort they required virtually guaranteed a spoon would be well finished. Although the stamped designs equated with jewelry commercialization—swastikas, arrows, and the like—are prevalent on spoons, the spoons themselves remain impressive.

Navajo spoons were included in Hubbell's pamphlet but the term "souvenir spoon" was not. That came the following year, when Indian trader J. B. (John) Moore put them in his 1903 catalog (Moore 1987, 27). Moore purchased the trading post at Crystal, New Mexico, in the summer of 1897. A lovely but ill-placed spit of real estate, it already had beaten previous proprietors due to the impracticality of the location. It was eight miles west of Washington Pass, and at an elevation of eight thousand feet, snow often rendered the area inaccessible. Moore, an optimistic Irishman from Wyoming, renamed the post "Crystal" because he was so taken with the beauty of the place. He built a new log structure, hauled in ample provisions for winter storms, and began a successful trading enterprise. Moore's true love and focus was

It was customary in the late 1800s and early 1900s to price spoons by their weight in silver, as this original label indicates.

Navajo textiles; his own group of expert weavers created distinctive patterns now referred to as "Crystal rugs." For a period of about seven years, he included silverwork in his merchandise, but orders were so abysmal that he dropped jewelry and Navajo spoons entirely when printing his 1911 catalog.

In Moore's 1903 catalog, with no photograph, Navajo spoons received only a brief description: "Souvenir Spoons. Many sizes, per oz., $1.50." By 1906, though, with mail-order business and the souvenir spoon movement thriving nationwide, Moore devoted several pages exclusively to spoons and offered varying patterns of Navajo souvenir spoons, teaspoons, coffee spoons, and two types of sugar spoons. He specified "Indian-head Handle" spoons, stamped with the word "Navajo," as his "souvenir spoons" (Moore 1987, 106–108).

His spoons were priced by weight, not valued according to their aesthetics, still the prevailing custom. Both the souvenir and teaspoons were offered in three weights—half-ounce, three-quarter ounce, and one ounce. One-ounce spoons sold for $2. "Navajo Coffee-spoons" were described as "strong and serviceable" and were offered in only two weights. On a separate page, Moore ran a photograph of two spoon designs with the caption: "SPOONS—Showing the Twist-Handle Patterns." These he called "Navajo Sugar-spoons" and described them as follows: "Round bowl, twist handle (which gives greater strength) terminating in Indian head" (Moore 1987, 108). The second sugar spoon features what Moore referred to as a "regular" bowl: oval instead of round, its oval bowl also stamped with the word "Navajo."

Moore invited custom orders ". . . upon reasonable notice, if a clear sketch is supplied and specifications as to weight, etc., plainly stated." Traders' willingness to provide items from customers' sketches may account for some of the odder, seemingly one-of-a-kind Navajo spoons.

As with Hubbell, no records were kept (or, if records were kept, no one kept the records that were kept) as to the identity of

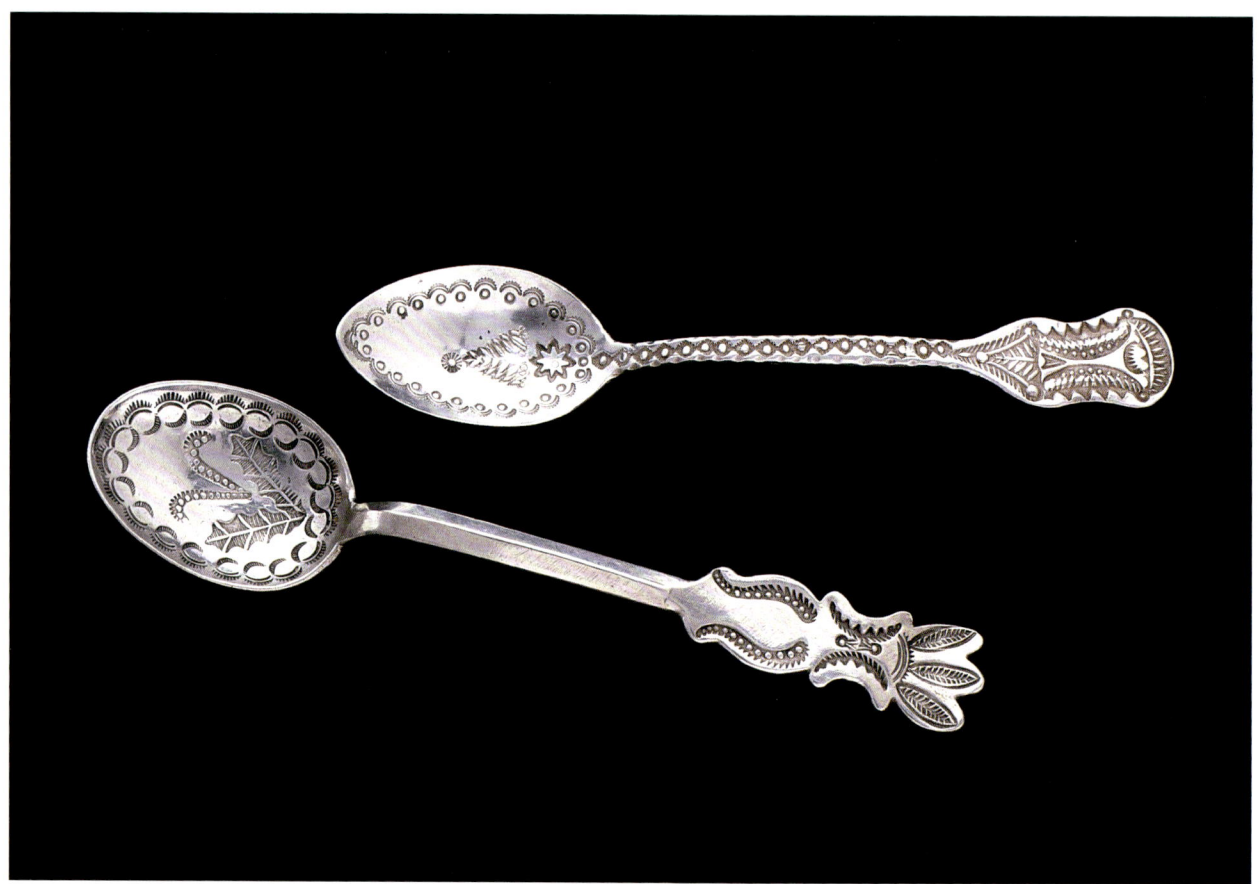

Candy canes and Christmas trees—likely the holiday request of an Anglo tourist.

Moore's silversmiths other than his statement that they were "the most expert known to me" (Moore 1987, 105). Although a photograph of a silversmith is included in Moore's catalog, no name accompanies the image, and within his text Moore only goes so far as to say that his silversmiths are "the most expert known to me."

The Francis E. Lester Company of Mesilla Park, New Mexico, offered Navajo spoons in its 1906 "Annual Holiday Offering" catalogue, which included a greeting to "our 100,000 customers the world over" and the signature "Yours for the beautifying of homes everywhere, Francis E. Lester, president" (Author's papers, FL, 1906). One page contains a photograph of five Navajo spoons, and Lester included a "SPECIAL OFFER: One each of the five spoons illustrated, for $5.70." Of note is the fact that Lester's catalog sells spoons by design, not by weight.

Only one of the five spoons was larger than a teaspoon. Catalog copy called it "full size, about 5 1/4 inches long" and described it

Francis L. Lester Company 1906 holiday catalog featured a snake design, *second from left*, considered rare by the trader due to the Navajos' reverence for the symbol. Three spoons at right are from J. B. Moore's 1906 catalog.

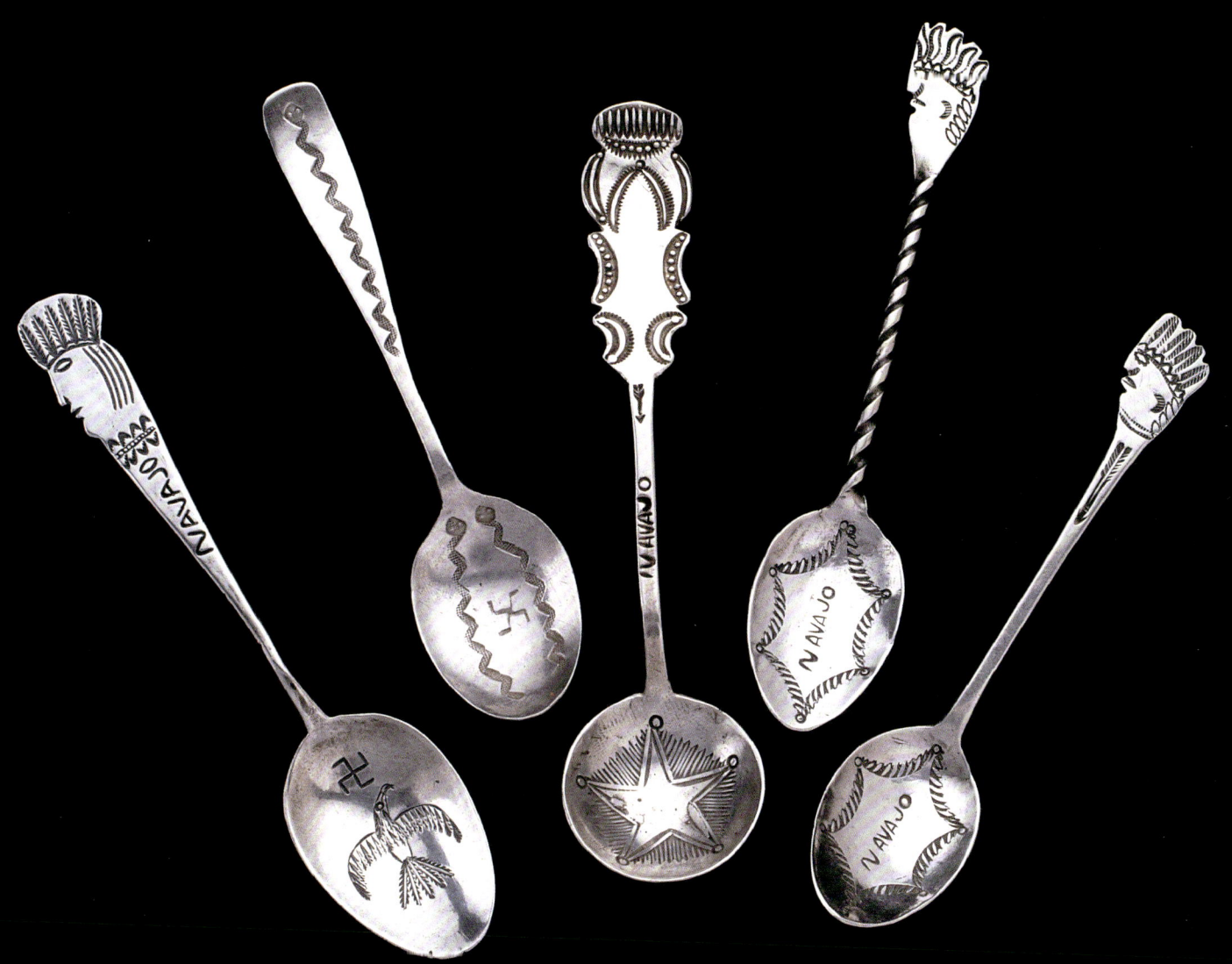

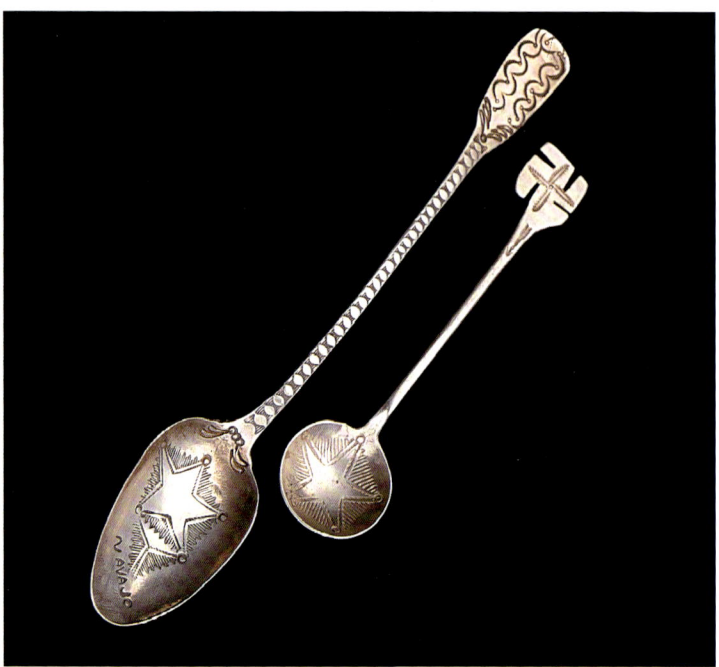

as: "Round Bowl Spoon. An extra heavy spoon, with bowl hammered in the basket-star design: twisted stem and handle in Navajo head design" (Author's papers, FL, 1906). Such "basket-star" design spoons, an unusual and short-lived type also offered by J. B. Moore, must have been suggested to silversmiths by traders in response to the popularity of that design on Pueblo baskets: two souvenirs for the price of one. (These basket-star designs therefore date only to the first decade of the twentieth century, and Moore's brief and rather unsuccessful venture into silver sales make it a rare design.)

Lester's remaining spoons, called "teaspoon size," were just under five inches long and sold for $1.10 each or in sets of six for $6, with the exception of his most popular design, a "swastika cross"–handled spoon with arrows in the bowl. Popularity upped the price—these were $1.25 each or a set of six for $7.

Swastikas were extremely popular during these years. Sixty thousand swastikas in various forms were sold to tourists in New Mexico between the summers of 1905 and 1906. On page 12 of Lester's 1906 catalog, nineteen of twenty-six jewelry items (from rings to spoons to watch fobs) include the swastika in some form, and such intense popularity likely wearied the public of the design long before the German Nazi party's use of it. In a letter writ-

"Basket-star" design spoons, suggestive of popular Pueblo baskets, were featured in catalogs in 1906. This short-lived design works best on round spoon bowl, but smiths adapted it for oval bowls as well.

Standing beside an horno (bread oven), this San Juan Pueblo woman holds a star-design basket similar to those stamped into Navajo spoon bowls. Museum of New Mexico 4488

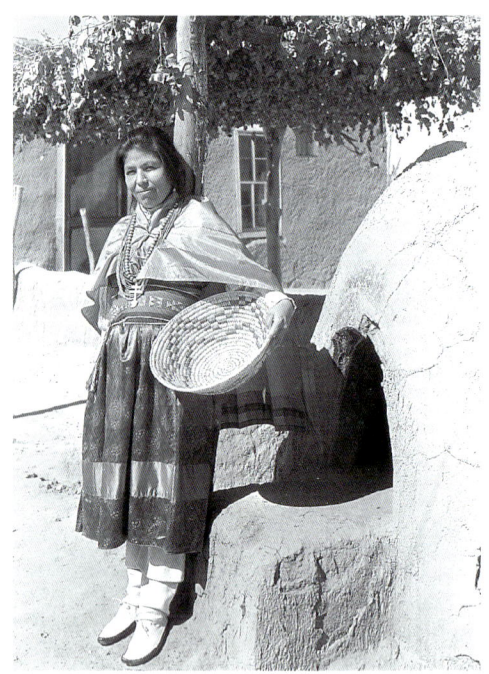

ten to Hubbell by the Fred Harvey Company in 1908, it was requested that Navajo weavers cease use of the swastika because such rugs were no longer selling well (Howard and Pardue 1996, 45).

One of Lester's motifs, exclusive to his catalog, is nothing short of bewildering. He offers a "Thunder Bird Design" in a Navajo spoon bowl, but to find a thunderbird in New Mexico in 1906 was unheard of. Not until the Fred Harvey Company introduced and copyrighted its "Thunderbird" motif three years later would the image have any presence in the Southwest.

Printed in enormous letters upon the lengthy storefront awning of Candelario's Original Old Curio Store, occupying 301-03 San Francisco Street in Santa Fe, was the claim: "The Largest Curio in the U.S., The Only Native Born Curio Dealer in the

Side-by-side examples of Lester's "Thunder Bird" of 1906, *far left* and *far right*, and the Fred Harvey Company's "Thunderbird," three shown *center*, copyrighted in 1909.

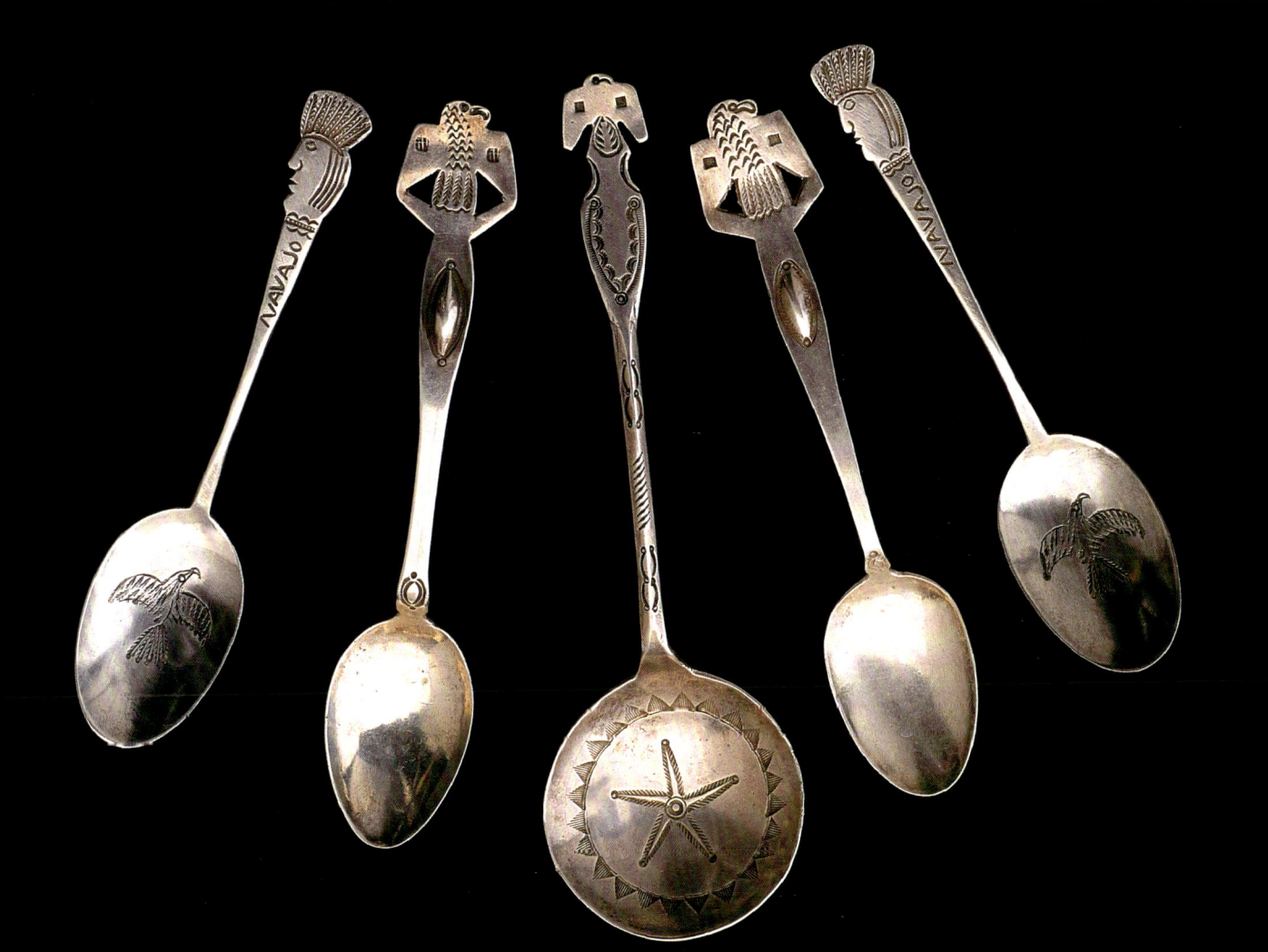

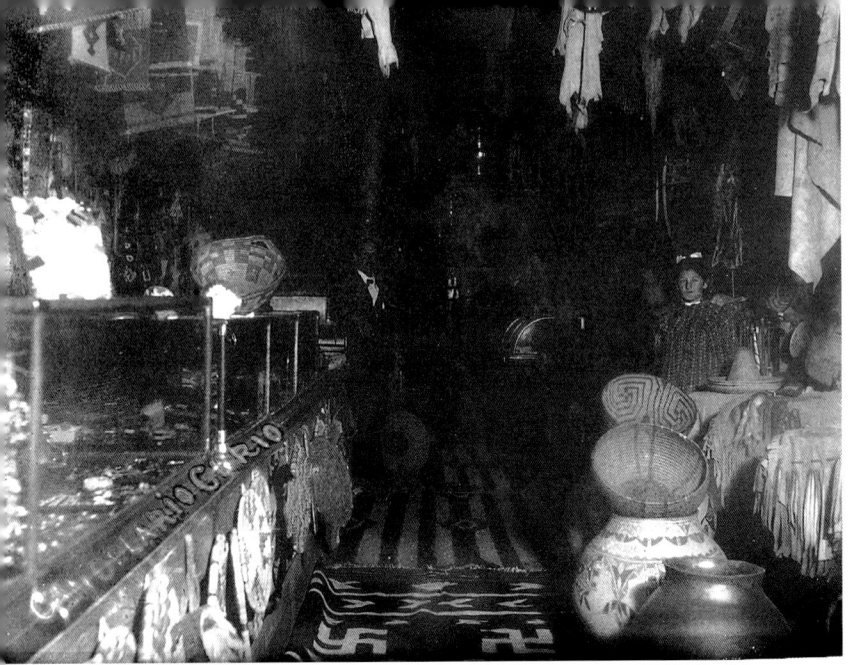

The interior of Candelario's Original Old Curio Store, on San Francisco Street in Santa Fe, ca. 1900. Museum of New Mexico—93713

Territory." Operated by Jesus Sito Candelario, it was a must-stop for turn-of-the-twentieth-century tourists. It was also a major supplier of Indian material to trading posts and shops around the country, including the Fred Harvey Company. In 1908, a lengthy Candelario inventory list included the following diverse items: armadilla baskets, buckskin suits, elk teeth, jumping beans, Moqui Gods, Navajo blankets, and silver ware; papoose cradles, souvenir goods, spoons, scalps, tiger skins, and war-bonnets (Author's papers, CR, 1908). A pamphlet produced by Candelario, also in 1908, refers to himself as "Candelario, the Curio Man, Santa Fe, N.M." and includes the sentence: "Navajo Silver Ware, Bracelets, Spoons, etc. Send 2 cents for Price list and Free Souvenir to Ladies" (Author's papers, CR, 1908).

Compared to Candelario's enormous enterprise, John Lee Clarke's The Little Indian Shop in Albuquerque was aptly named. Clarke produced a catalog, circa 1910, that included only one Navajo spoon shaped like an arrow. His description read: "Navaho Hand-hammered Silver Spoon. Souvenir spoons are still as popular as ever, and the one we offer is exceptionally interesting because it not only comes from the Southwest, the only real Indian country left, but is actually made by an Indian out of a silver dollar. The design speaks for itself" (Author's papers, TLIS, n.d.).

Clarke's reference to souvenir spoons being "still as popular as ever" confirms that souvenir spoons remained sought-after nationwide. Back on the East Coast, even the Witch spoon was enjoying continued popularity. A regional article written in 1909 observed, "The only witchcraft exercised by Salem now is upon the pocketbook of the summer person who has a fad for souvenir spoons" (Stutzenberger 1953, 35).

H. H. Tammen, a Denver-based company established in 1881, had been hot on the trail of Moore and Hubbell back in 1903 and 1904, when their catalogs offered a single "Indian head design on handle" spoon (no photo and one flat price). Tammen even unabashedly swiped the description of "Navajo Silverware" from J. L. Hubbell's 1902 pamphlet:

HUBBELL: "All these productions of the Navajo silversmith are from coin silver,

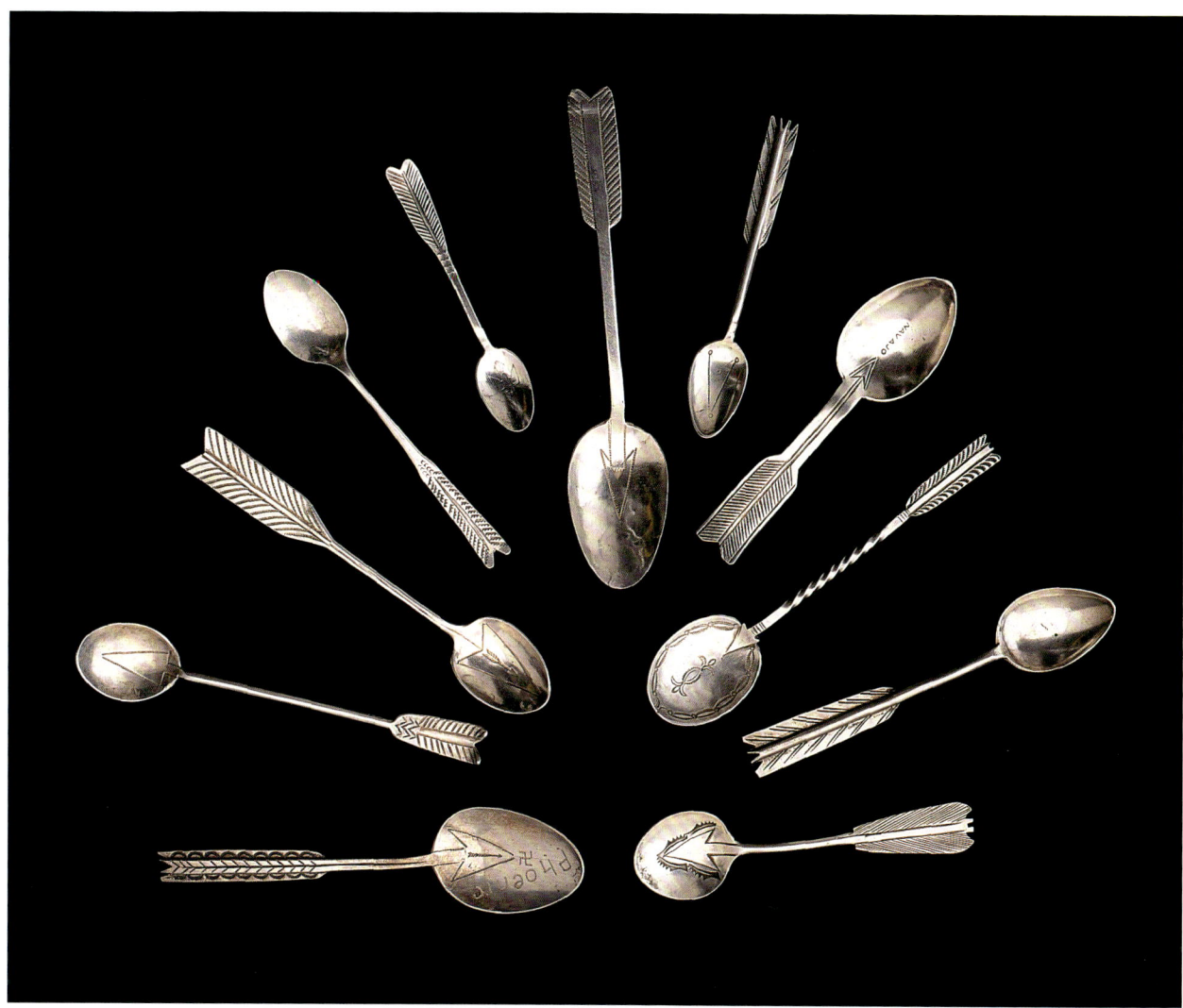

melted, hammered or molded with their own primitive appliances."

TAMMEN: "The productions of the Navajo Silversmith are made from silver coins hammered or moulded with their own primitive appliances."

Shortly before 1910, however, Tammen's operations took a dramatic turn. While its

Arrow spoons were not as prevalent as one might expect. Tourists seemed to prefer life-forms, such as animals and profile spoons. The large spoon, *top center*, is an exact match to the spoon photo in John Lee Clarke's catalog from ca. 1910. An arrow spoon was included in J. L. Hubbell's 1902 pamphlet.

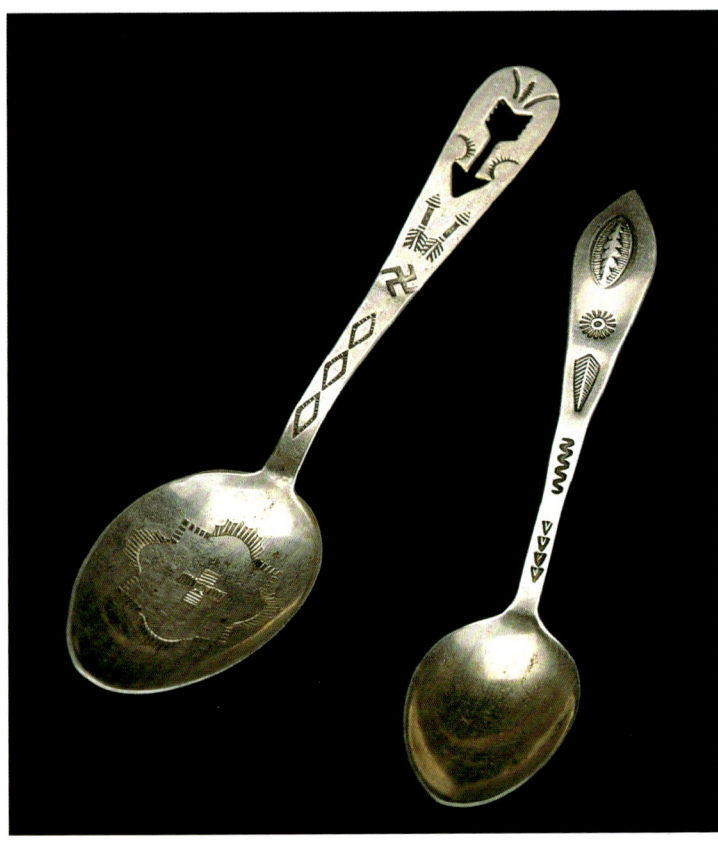

Not to be confused with wrought Navajo spoons, imitation "Indian Design" spoons such as these were sold by companies such as Arrow Novelty and H. H. Tammen.

1903 and 1904 catalogs spoke proudly of being "in easy reach of the principal Indian reservations in the West" and featured ingot bracelets "guaranteed to be the productions of Navajo Silversmiths," little but the cover of its 1908 catalog remains recognizable. John Adair's book states: "In 1910 a firm in Denver began to manufacture this imitation jewelry, using white labor. By mass production techniques the manufacturer was able to undersell the traders" (Adair 1944, 27). It's an obvious reference to Tammen, but no proof has yet surfaced that such jewelry was actually produced in Denver. Adair knew something was up, but he didn't have the details. Those details are just beginning to surface, but it is now known that Tammen's departure from its previous publications, very similar to an undated catalog produced by the Arrow Novelty Company, is due to a familial link between the two enterprises.

Arrow Novelty Company, incorporated in 1917[4] and located on West 14th Street in New York City, sold, among other things, "Indian Design Coin Silver Jewelry." Many products were identical to Tammen's, right down to the oddly large identification numbers in the 17000s and 18000s. Tammen's 1903 and 1904 catalogs had no such system of identification numbers (handmade items of a general design nature don't lend themselves to assigned numbers). The name listed on the Certificate of Incorporation as Arrow Novelty's president, Rudolf Litzenberger, holds the key to the companies' connection: Carl Litzenberger, Rudolf's brother, worked for Tammen's Denver operations.

Arrow Novelty's mission statement read as follows: "The purposes for which this corporation is formed are to buy, sell, manufacture, import, export, trade and deal in jewelry, precious and imitation stones, gold and silverware, china and glassware, musical instruments, toys, ornaments, leather, felt and metal goods, all kinds of novelties, curios, souvenirs, post cards, books, folders, bric-a-brac, fancy articles, furniture, pictures, bronzes, rugs, carpets and merchan-

dise of all kinds" (Author's papers, ANC, 1917).

The era of "Indian jewelry" regarded as nothing more than bric-a-brac had begun in earnest.

Arrow Novelty skirted the issue of authenticity: "We present this catalog to our customers in the hope that it will help stimulate the sale of this popular line of Indian design Silver jewelry, which is strictly American in idea, design and manufacture. It is made of 900 fine silver—the same composition of metal as used in coining American Silver Dollars" (Author's papers, ANC, n.d.). Vaughn's Indian and Curio Store, located in Phoenix, Arizona, padded its inventory with such items, as did many others throughout the Southwest, but much remains a mystery as to the interrelationships of novelty companies and curio traders. After all, vagueness about "Indian design jewelry" was an integral part of their success.

Among the vagueness is great cleverness. An undated brochure for Vaughn's states on the cover: "When we tell you it is GENUINE you can rest assured it is." We can rest assured that their "Indian Spoons" are not, then. Vaughn's catalog, so deliberate in many of its other headings—Genuine Apache, Pima, Papago and Hopi Indian Baskets; Genuine Navajo Indian Rugs—avoids use of the word "genuine" in the description of its stamped silver spoons (Author's papers, VIACS, n.d.)

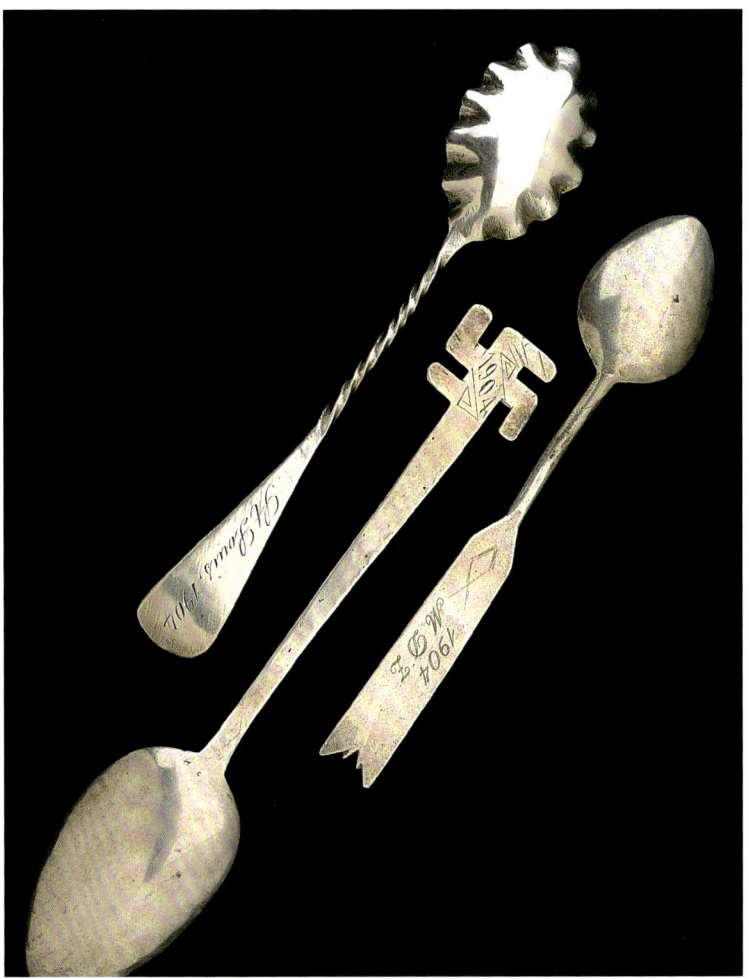

Likely souvenirs of the St. Louis Exposition in 1904, a Christian fish symbol was later scratched onto the top spoon—perhaps an attempt to offset the spoon's "pagan" origins.

Genuine Navajo spoons, however, still were being produced by Native smiths and were making their way about the country as souvenirs of the world's fairs and expositions, such as the Louisiana Purchase Exposition held in St. Louis in 1904. Ideal opportunities to promote and sell enormous quantities of Southwest goods, Native arts exhibits were among the most popular features of these events.

In 1909, Navajo spoons even found their way to Seattle, Washington. From June 1 to October 16, a $20 million party was held in Seattle called the Alaska Yukon Pacific Exposition. Its purpose was twofold: to celebrate the conquering of the Alaskan frontier (Seattle being the new "Gateway to Alaska") and to showcase the cultures of what were then considered the United States' "possessions," Hawaii and the Philippine Islands.

Souvenir items produced for this event contain the initials "A.Y. P." or "A.Y.P.E."

That Navajo spoons would be considered souvenirs of the Pacific Northwest seems to defy logic until one realizes that the celebration of a "conquered frontier" would have conjured up images of Indians; for the sensibilities of the time, that meant a feathered headdress.

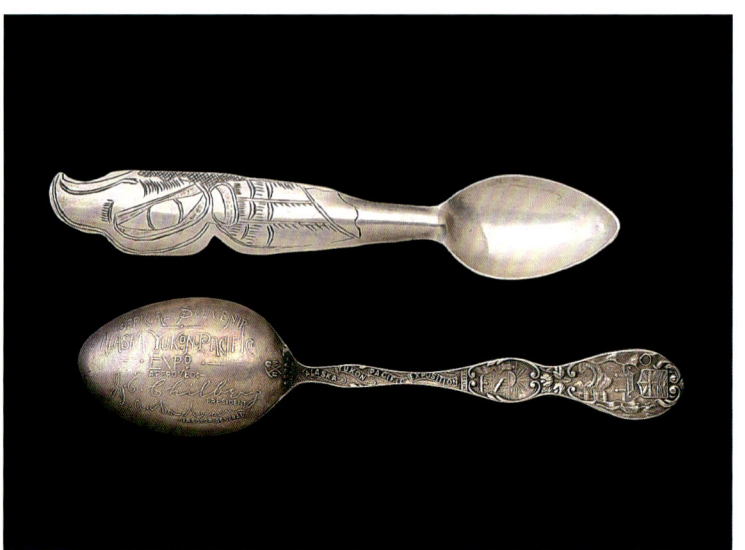

ABOVE
Paired with a typical Northwest Coast souvenir spoon, the "official" souvenir spoon designed for the Alaska Yukon Pacific Exposition of 1909 is shown backside. The front includes depictions of Chief Seattle; the federal eagle with liberty shield; a portrait of William H. Seward, the "Father of Alaska"; pine trees, mountains, and a totem pole; an explorer with a walking stick; and a gold pan with three nuggets and a pick and shovel. Commercial souvenir spoons were often remarkably detailed.

RIGHT
The bowl of this Navajo profile spoon, shown with a commercially produced souvenir shaving mug, was engraved as a memento of the Alaska Yukon Pacific Exposition.

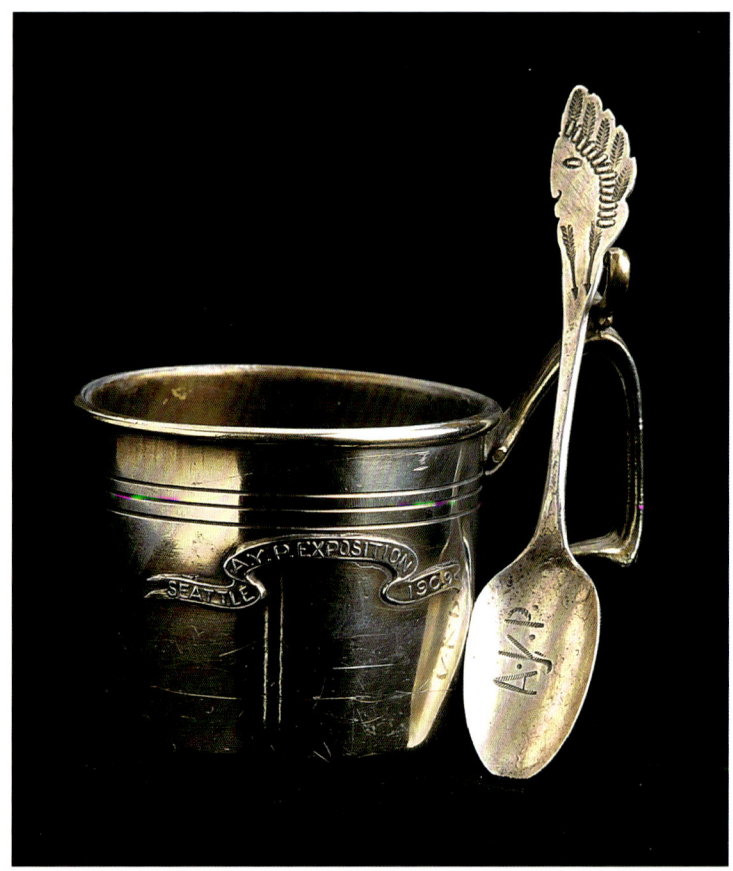

In addition to traders and expositions, Indian schools were a source of and influence upon Native arts, including Navajo spoons. At the Carlisle Indian School in Carlisle, Pennsylvania, where the student population was comprised of children from seventy-seven tribes from the far corners of the country, students received instruction in the art of making "Navajo" spoons by William ("Lone Star") Dietz—the son of a German civil engineer and an Oglala Sioux mother.

Carlisle, formed in 1879, was the nation's first federally run Indian boarding school. A brochure, circa 1910, promotes Dietz and silver items produced at the school: "Navajo Silverware. Hand-hammered out of Mexican silver dollars. The Navaho Indians

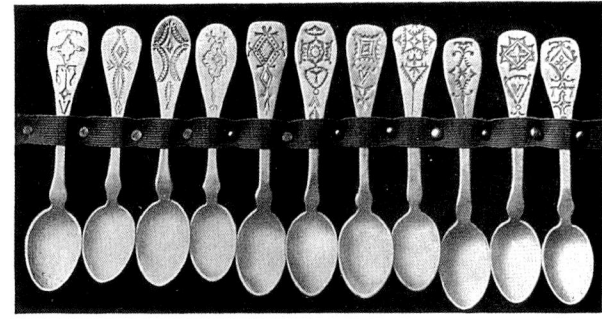

NAVAHO HAND HAMMERED SILVER SPOONS—FULL TEA-SPOON SIZE,
ELABORATELY DECORATED AS PER CUT
PRICE, POST PAID, $1.50 TO $2.50

NAVAHO BRACELETS—HAND-HAMMERED OUT OF MEXICAN SILVER DOLLARS
PRICE POST PAID, $1.50 TO $3.00

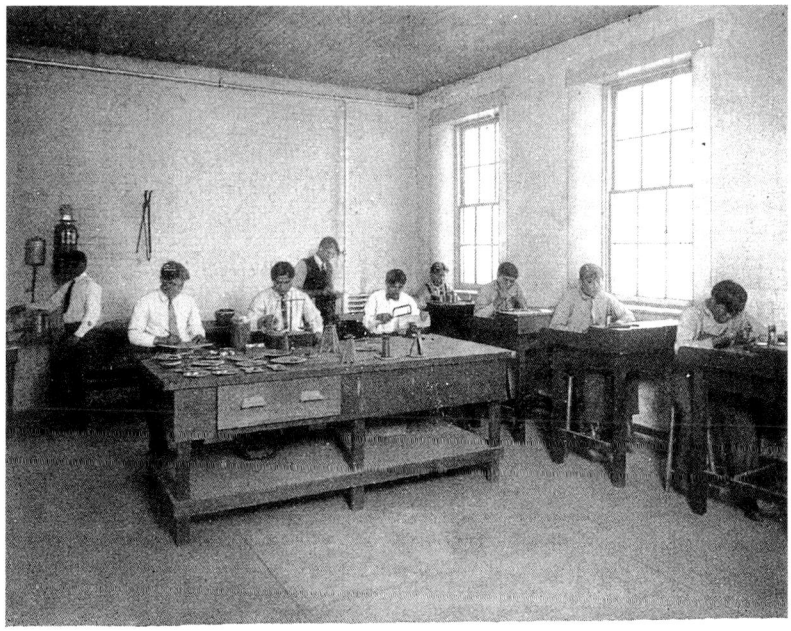

NAVAHO AND HOPI BOYS MAKING SPOONS AND BRACELETS

Navajo spoon making was part of the silversmithing curriculum at Carlisle Indian School. These pages are from a ca. 1910 promotional brochure showing students and their handiwork. Courtesy Jonathan Batkin.

excel as silversmiths, although using the crudest kind of tools, yet this work cannot be attained by modern methods.... Some of the best silversmiths from the reservations have come here to this school to study old Indian designs and silversmithing under the personal direction of Mr. William Dietz (Lone Star.) In return for their tuition, these Navahoes are doing far better work than is done on the reservation, although they make their own tools and use the same methods that are used on the reservation. Under the influence of "Lone Star" they have studied and are using the oldest designs of the tribe with most gratifying results" (Author's papers, CIS, n.d.). Not mentioned is Dietz's wife, the renowned artist Angel DeCora, although she was an integral part of the Carlisle Indian School. By ancestry part Winnebago (Ho-Chunk) and part French, DeCora held numerous college degrees. She accepted her teaching position at Carlisle only after the administration agreed she "shall not be expected to teach in the white man's way, but shall be given complete liberty to develop the art of my own race and apply this, as far as possible, to various forms of art, industries and crafts" (Witmer 2000, 78). DeCora's culture-based approach was the first of its kind, and it was

Leupp Art Studio at Carlisle Indian School, ca. 1910. Navajo spoons can be seen in the glass case, far left, along with a diverse collection of Indian arts brought in from reservations for students to study and the visiting public to purchase. Courtesy Cumberland County Historical Society.

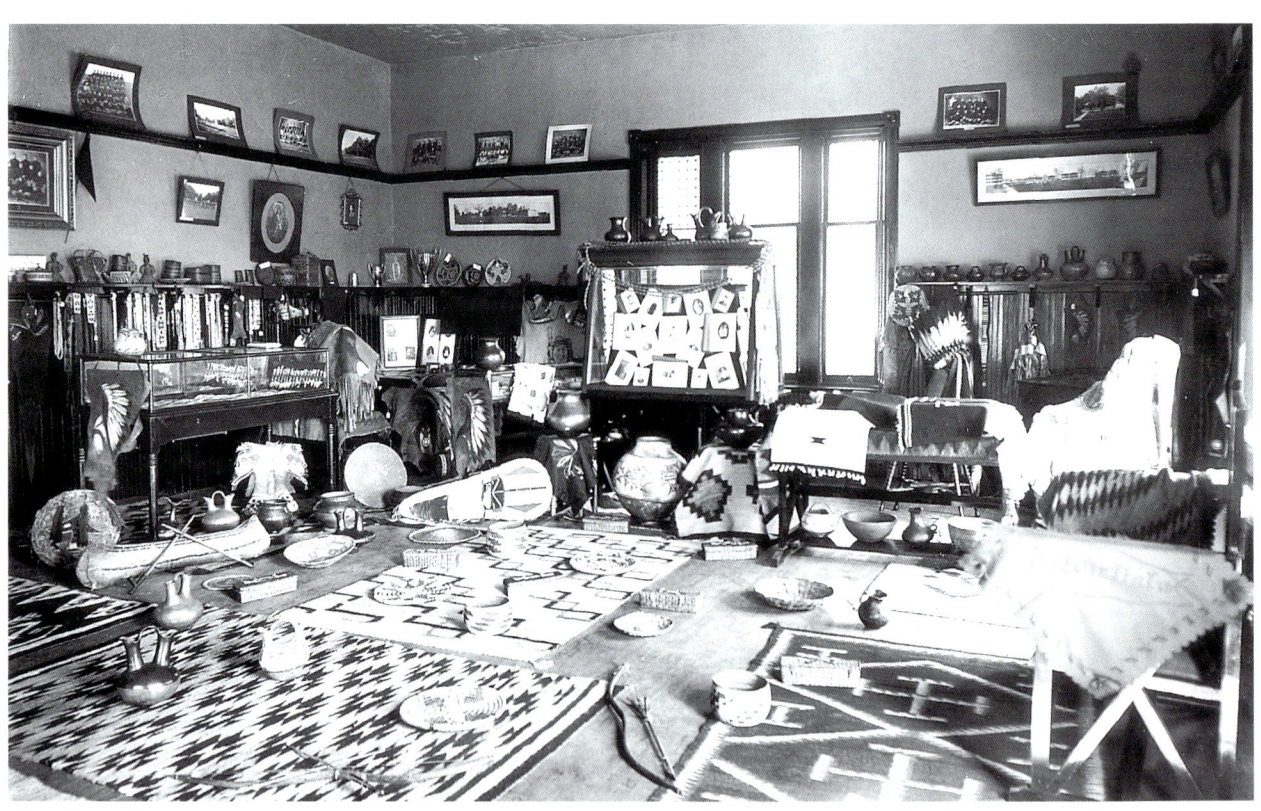

"Lone Star" Dietz, ca. 1911: silversmithing instructor at the Carlisle. Courtesy Cumberland County Historical Society.

her life's goal to reawaken Native American art in students who had lost touch with their heritage.

Dietz and DeCora met in 1904 at the St. Louis Exposition, and Dietz enrolled at Carlisle in 1907. Despite the fact that he was a student and some fifteen years her junior, they married shortly thereafter. Dietz then became both assistant art teacher at the school and a celebrated hero for the school's football team.

Silversmithing was introduced to the Carlisle curriculum in 1908, when eight Navajo silversmiths from the Southwest were brought to the school to get the program started. Examples of the students' silver work were exhibited in 1910 at the Industrial Exposition held in Turin, Italy, but despite the global attention, Carlisle reverted to nonculture-based curricula and put an end to DeCora's ambitious programs. World War I eventually closed the school completely. It was converted to an army medical center, and Dietz found employment on the opposite coast as a football coach at Washington State University at Pullman. Dietz and DeCora divorced, and she died just three months later in Massachusetts, a victim of the 1919 influenza epidemic.

As Carlisle was closing its doors, the Arrow Novelty Company was filing its Certificate of Incorporation with the state of New York, and, back in the Southwest, Navajo silversmith Grey Moustache recalls it was around 1918 that ". . . money was falling down just like rain, and everyone went crazy" (Adair 1944, 9). If "money was falling down just like rain" in New Mexico, you can bet it beckoned to Manhattan businessmen.

From fringed chaps to pinstriped suits, from horses to trains to automobiles—life

was changing, and changing rapidly. J. L. Hubbell was already losing out to the proliferation of large trading firms and wholesalers, a situation only exacerbated by America's fresh fascination with automobiles. Louisa Wade Wetherill, herself a trading post operator along with her husband John, remembers cars first arriving in the Southwest in 1914: "In the automobiles began to come a different type of moving people, impatient of delay, frightened of hardship, desiring the comfort of settled places" (Gillmore and Wetherill 1953, 218).

These "moving people" began to return to the comfort of their homes with items other than souvenir spoons. Cars provided room for weighty and breakable items whereas bags packed for train travel had demanded economy of space. If you had an automobile, you weren't limited to purchasing only what was offered for sale at train stops. Navajo spoons would continue to charm and entice buyers, but car travel was eroding their essential appeal as convenient, portable souvenirs.

4
Silver Words and Thunderbirds

Spoons could be elevated from mere souvenirs into cherished, personalized gifts through artful engraving. The Anglo engraving on the back side of some Navajo spoons rivals the beauty of the stampwork on the front, in large part because of a change in the way books were printed.

Books need pictures, and book publishers needed engravers to carve picture plates. Engraving was a well-paid and respected profession, passed along with pride from father to son. It required ten years of training to be considered of "master status." Unfortunately, engraving was rendered obsolete by the invention of lithography. Master engravers, whose skills had been vital to the publishing industry for hundreds of years, found themselves out of work in the 1880s.

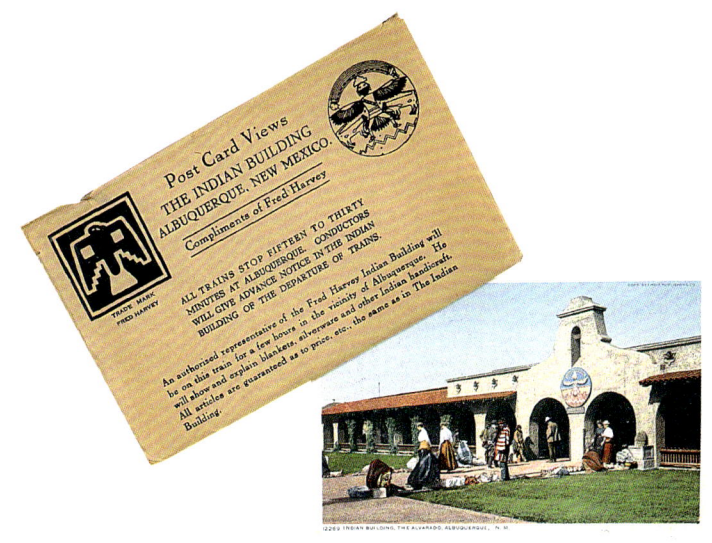

The exterior of the Alvarado Hotel, alongside an envelope that held assortments of Fred Harvey Company postcards.

Souvenir spoons saved engravers' careers, at least for a few decades. The souvenir spoon movement was a perfectly timed blessing for these artists; they shifted from engraving pictures for books to engraving pictures for souvenir spoon companies. Many designs on bowls and handles were as intricate and detailed as any found in books and at times even more so. Commercially

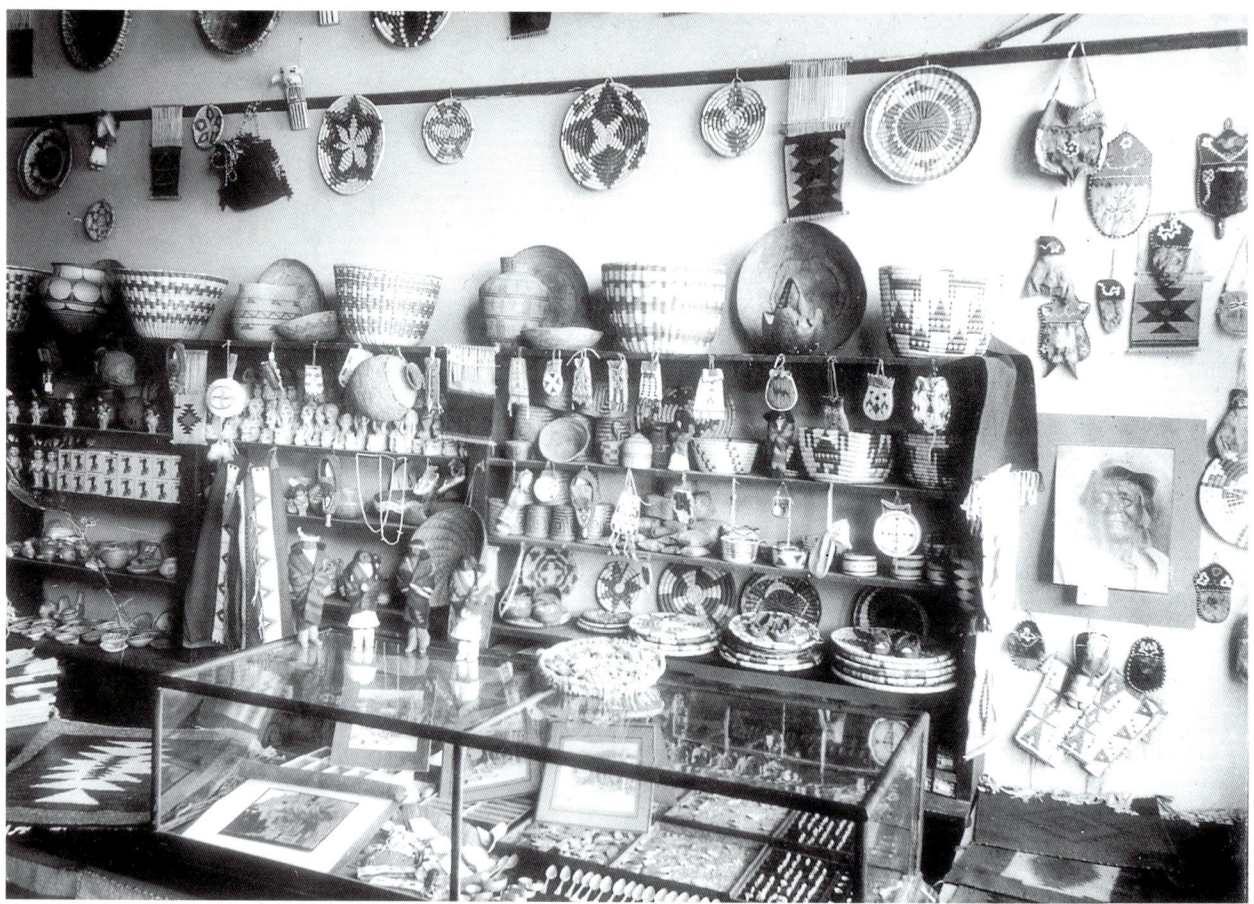

An undated shot of the interior of the Fred Harvey Company store in the Alvarado Hotel, Albuquerque, one of famed Harvey Company designer Mary Colter's buildings. Spoons are just visible in the bottom of the glass case. Colter's work survives today in the La Fonda Hotel, just off the plaza in Santa Fe, and in the Grand Canyon's Hopi House. Photo by Dorothy Stewart,. Museum of New Mexico 4573

produced souvenir spoons could contain astonishing amounts of realistic detail. An article in the May 1907 issue of *Great West* magazine describes a commercial souvenir spoon for sale in Albuquerque: "A spoon having engraved on it a train such as the visitor arrived on, a swastika, the coat of arms of Hernando Alvarado, the Santa Fe Hotel of Albuquerque, a typical Indian woman, a modern train, and on the back the residence of General Phillip Sheridan in Old Albuquerque, an Indian house, and a bridge over the Rio Grande" (Bennett 1970, 70).

If an independent jeweler needed a small quantity of souvenir spoons for some local event, such as a building dedication, he'd hire an engraver to carve the same intricate design of the building over and over again into as many spoon bowls as the jeweler anticipated he might need. This was extraordinarily fussy, time-consuming labor. Even a simple picture could take four to six hours to carve into a concave spoon bowl, with the engraver continually sharpening his tools to ensure crisp lines and taking care to apply just the right amount of pressure. One slip could scratch the silver surface and ruin an afternoon's work.

In addition to engraving complicated souvenir spoon pictures, jewelers hired these artists for simple lettering, although lettering at the turn of the twentieth century was anything but simple. There were innumerable styles that could be requested by customers, from script to block to Gothic (much like today's computer fonts), and engravers had to be skilled at all of them. Jewelers gladly subcontracted this lesser work of engraving silver lockets, love brooches, and odd Navajo spoons so that they could get back to their gold and gemstones.

It worked out nicely then, and it works out particularly nicely for us today. "How old is it?" is the most often asked question concerning a Navajo jewelry item, and even the most knowledgeable scholar often can do no more than examine the stampwork and stones, determine if it is ingot or sheet metal, and make a best guess.

With a Navajo spoon, oftentimes, all you have to do is flip it over.

Souvenir spoons encouraged the engraving of names, dates, and details, and this provides a huge advantage in discerning the age of *other* Navajo silver. Dated spoons can be used for comparison purposes against jewelry items with the same characteristics, helping to date the nonspoon. Find a Navajo bracelet with unique stampwork, compare it to an engraved-date Navajo spoon with a similar stampwork, and you've honed in on the time period of the bracelet.

Engraved dates are not a foolproof method of dating a piece, of course. Any date can be engraved at any time. However, the ornate engraving found on so many Navajo spoons bodes well for their authenticity because the quality of such engraving is impossible to reproduce today. Take a silver spoon to your local jewelry shop and ask if they can hand scribe, in cursive, an infant's first and last name, time of birth, day of the week, calendar date, birth weight, hometown, and state on the back of the handle. See what they say.

Engraved dates on spoons also pique curiosity. Finding many spoons engraved with the same year or date sparks investigation into significant events taking place at that time because souvenir spoons were cre-

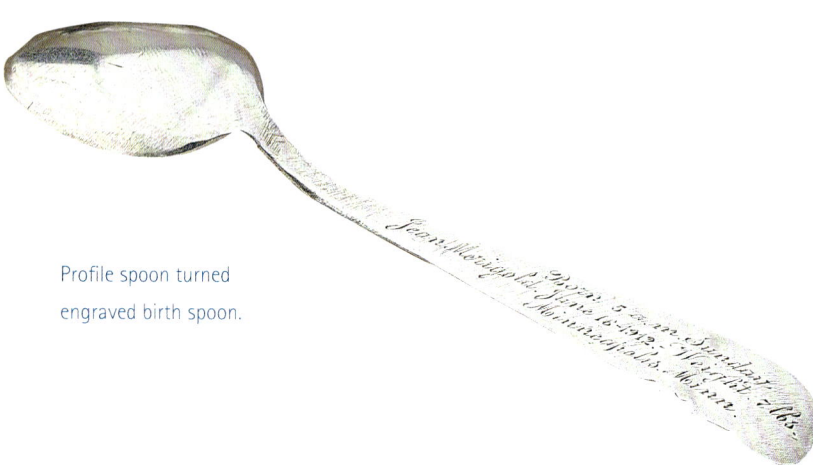

Profile spoon turned engraved birth spoon.

ated and engraved to commemorate most any event of importance.

In the first years of the twentieth century, increased public concern about vandalism and recognition of the historical importance of unique and fragile spaces in the Southwest generated the preservation of many sites. In 1906, the cliff dwellings at Mesa Verde, the Petrified Forest, and Montezuma's Castle were designated as national parks and monuments. In 1907, Chaco Canyon became a national park and Oklahoma[5] became a state. With so many significant "Indian-themed" events within two years, souvenir spoons proliferated: 1906 and 1907 are the most commonly found engraved dates on Navajo spoons. Other events and dates frequently linked to engraved dates include:

Chicago World's Columbian Exposition (Chicago 1893)

Pan-American Exposition (Buffalo, New York, 1901)

St. Louis Louisiana Purchase Exposition (1904)

Portland, Oregon's, Louis and Clark Exposition (1905)

Mesa Verde National Park (declared 1906)

Montezuma's Castle and Petrified Forest National Monument (declared December 8, 1906)

Chaco Canyon National Monument (declared March 11, 1907)

Navajo National Monument, Betatakin and Tsegi (declared March 20, 1909)

Panama-Pacific International Exposition (San Francisco 1915)

Grand Canyon National Park (declared April 1, 1931).

No dated Navajo spoons have yet been found from the 1893 Chicago World's Columbian Exposition, but it's known that Navajo silversmiths and a re-creation of an "Indian School" were included among the exhibits (Author's papers, KH, 2001).

The engraving of Navajo spoons to commemorate such events, as well as the public's fondness for Navajo spoons at that time, inspired a respectable attempt at a Navajo-style profile spoon in 1911. Intended to

commemorate both Arizona's statehood day and a birthday, the spoon's unusual history is revealed by two tattered notes that accompanied its purchase. The handwriting explains that the spoon was made by a convict at a prison ". . . after the designs of Peshlakai Utkitly, chief silversmith of the Navajos. It is solid silver, handmade and the last that will be made there so it may be a curiosity sometime. It was made by a Jew, a man who is in there for life; a bright fellow who helps Frank in the office. . . . I wanted it marked Florence, Arizona August 21, 1911 for that was statehood day and your birthday; but I could . . . " (end of legibility of note; author unknown) (pers. corresp., Joe Breidel, 2001). The second note, in different handwriting and dated 1911, reiterates the first note's faded information but has a variation in the spelling of the Navajo name: "Made after the designs of Pesh-lee-ki Ut-kit-ty" (pers. corresp., Joe Breidel, 2001).[6]

Navajo spoon popularity inspired the Warren Mansfield Company of Portland, Maine, a prominent turn-of-the-twentieth-century flatware company, to create an impressive imitation of a wrought Navajo spoon: Design #22629, unique to its line. The spoon, found frequently with 1906 or 1907 engraved onto the back of the handle, features a full-figure profile of a Plains Indian holding a spear, faux stampwork down the handle and around the bowl rim, and a bow with two crossed arrows and a

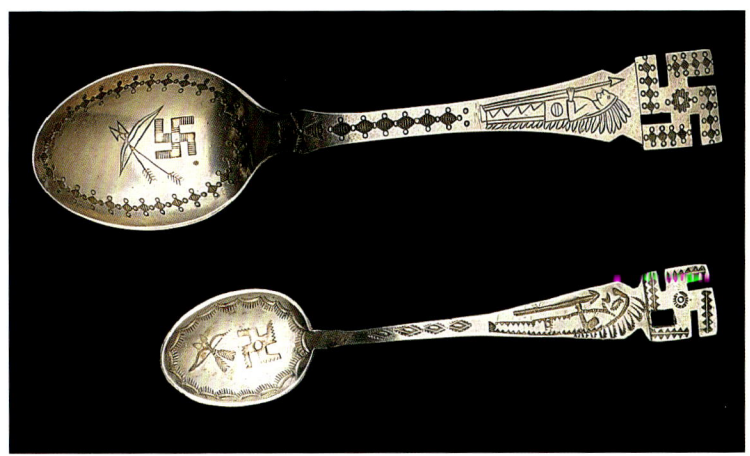

The Warren Mansfield Company of Portland, Maine, created this interpretation of a Navajo souvenir spoon, ca. 1905. *At bottom*, a Navajo smith's interpretation of the Mansfield spoon.

whirling log in the center of the bowl. Like the Charles A. Robbins design that received "top honors" at the St. Louis Exposition in 1904, Mansfield's spoon also features a swastika atop the handle.

Because commercial makers often sold their plates and because many commercial makers had access to the same plates, the manufacture of this spoon exclusively by the Warren Mansfield Company is unlikely. It's too common and appears in too many variations, appearing on other (unidentified) catalog pages with different design numbers. This sneaky spoon has turned up in museums, where it has been mislabeled as a genuine Navajo spoon, and in jewelry cases at reputable Indian art shows in both coffee spoon and teaspoon sizes. Some examples have engraved pictures or place names in the bowl (including Dubuque, Iowa) instead of the bow and two crossed arrows shown in the Mansfield Company's catalog.

Silver Words and Thunderbirds 63

When encountering one of these clever imposters, examine the realistic hand-hammered appearance and the underside of the bowl: It bears imperfections imitating those formed when ingot silver is beaten out flat. However, side-by-side comparison of several of these spoons reveals identical markings, right down to the finest lines on the bowls—indisputable evidence of mechanical production.

Navajo spoons depicting thunderbirds appear no earlier than 1909, the year the thunderbird became the logo for the Fred Harvey Company after employee Herman Schweizer sketched the figure from a rare pictograph at Abó, a prehistoric pueblo in southeastern New Mexico (Howard and Pardue 1996, 97). Thunderbirds were common in the stormy Great Plains and the moss-laden forests of the Pacific Northwest, not so in the arid Southwest, but Abó sat at the center of trade lines between the Plains and the Rio Grande to the west, and evidently the thunderbird migrated along these paths of exchange (Logsdon 1993, 122). The Fred Harvey Company's appropriation of the image allowed it to spread its wings wide across New Mexico and Arizona and was embraced as an authentic Southwest "Indian symbol."

In keeping with the copyrighted version of their logo, Harvey Thunderbirds have two squares to the right and left of the bird's chest. The earliest Harvey Thunderbirds stamped onto spoons and jewelry keep true to the copyrighted version, with many featuring unusual, crosshatched, square stamps. Variations include turquoise sets, plain squares, cutout squares, squares made from a series of small dots, circle stamps, and even swastikas, but some type of design is consistently placed to the right and left of the center of the chest in early Harvey Thunderbirds.

Other characteristics of Harvey Thunderbirds include broad, squared-off shoulders and stair-stepped wings. On Navajo spoon bowls, stampwork surrounding Harvey Thunderbirds often incorporates a similar stepped motif, as if to further allude

This Fred Harvey Company postcard shows the company's thunderbird motif decorating Bright Angel Lodge, a welcome stop for travelers to the Grand Canyon.

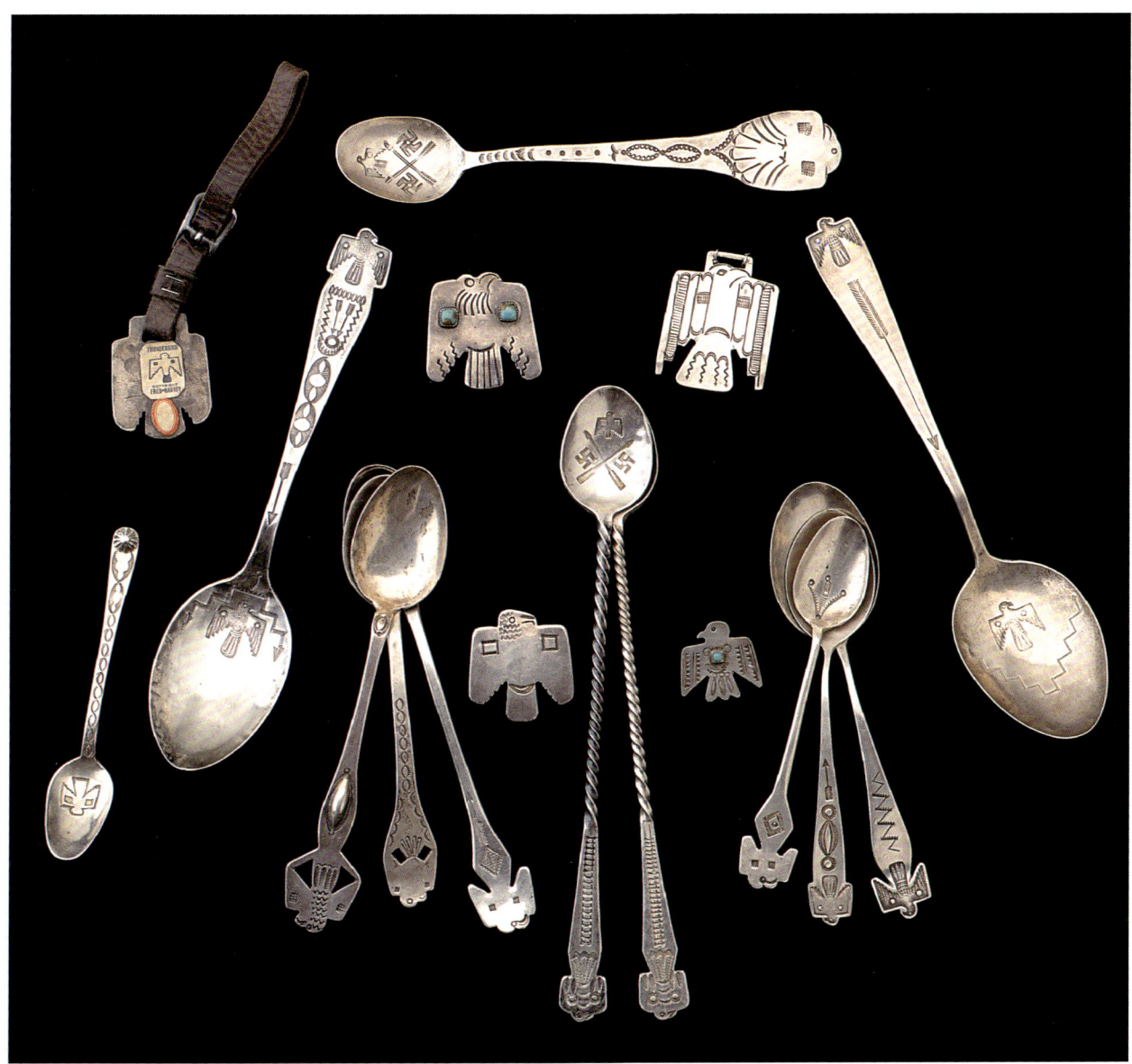

"Harvey Thunderbirds" adorn an assortment of hammered silver items, including a watch fob on its original leather strap.

Silver Words and Thunderbirds

This original artwork displays the logos for both the Fred Harvey Company Thunderbird and the Santa Fe Railroad. Courtesy Skip Gentry.

to the copyrighted design. Heads typically face to the right, in keeping with the logo, and many renderings are Art Deco in appearance.

These distinctions for Harvey Thunderbirds fade throughout the decades. Originally, Harvey Thunderbirds were quite stylized, with clean lines and few or no feather stamps, but thunderbirds of all shapes and sizes began to appear as the design took on a life of its own.

Tourists' enthusiasm for the thunderbird gained it a new and perplexing meaning as "Sacred bearer of Happiness unlimited" (Author's papers, ANC, n.d.). Postcards and curio catalogs, Arrow Novelty Company among them, assigned the thunderbird similar definitions, all some version of "Bearer of Happiness." This would dumbfound Plains tribes and Indians of the Pacific Northwest—their thunderbird origins are anything but happy. They believed the thunderbird to be an enormous, supernatural creature that produced thunder by beating its wings and lightning by blinking its glowing red eyes. The Quillayute, a Chimakoan tribe located on the Northwest Coast's Olympic Peninsula, believed their thunderbird lived in a cave high in the mountains and subsisted on a diet of whales, scooped up from the ocean in its great claws. Southwest tourists of the 1920s and 1930s, however, returned home with silver stamped with what they believed to be little images of the "Bearer of Happiness."

This ca. 1915–1925 salad set contains thunderbirds with left-facing heads contrary to the trademark Harvey design.

The only thunderbird to make a Navajo spoon appearance prior to the Harvey Company's introduction of it is the anomaly found in Francis E. Lester's catalog of 1906. Lester's Navajo spoon description broke it

into two words— "Thunder Bird Design"— and he called it "A rare figure, used in many of the Navajo ceremonials." Perhaps Lester was familiar with the thunderbird's use by tribes elsewhere in the United States, and perhaps he took it upon himself to "borrow" it for the purpose of adding a little cachet to his "Navajo Indian Spoons," but there is no evidence that thunderbirds were ever used in Navajo ceremonials. Lester might actually have been aware of this, covering himself on that count by asserting in his sales copy that the bird was a rare ceremonial (hence, secretive) figure (Author's papers, FL, 1906).

A reference to an image similar to the thunderbird, and indirectly confirming that the motif was not yet found in the Southwest in the latter decades of the nineteenth century, comes from the writings of John G. Bourke. Describing decorations found in a Moqui family's living quarters, 1881, he wrote of wooden tablets ornamented with various Moqui gods and the rain prayer and stated: "The little bird in the clouds suggests the Thunder Bird of the Plains Indians" (Bourke 1884, 135).

The "Thunder Bird" stamped into Lester's spoon bowl has textured feathers (in contrast to the Harvey Thunderbird's graphic outline) and an elongated, oval body. Were it not called a Thunder Bird, it's more visually suggestive of an underfed eagle. Navajo spoons with thunderbirds therefore can be categorized into three distinct species: "Harvey Thunderbirds," "Lester Thunder Birds," and "tourist" ("bearer of happiness") thunderbirds.

Birds of all types alight upon spoons. Feather images and birds are incorporated into countless aspects of daily Native life and religious rituals because birds are admired and respected among Navajo and Pueblo peoples. Only owls are regarded with caution. Creatures of the night, owls are prominent in Navajo mythology. Beliefs include that humans can transform themselves into owls and spy on their enemies; when an owl hovers near it means death is near; and that owls are messengers of evil spirits. If an owl is hanging about as a Navajo family prepares for a trip, the family will delay its departure. Should an owl take a liking to a spot near its hogan, a Navajo family will actually move.

"When Navajos are walking or riding in the moonlight, it is bad luck to have an owl pass over them or to see the yellow glare of an owl's eye.... When this happens a night ceremony must be held to dispel the evil portent" (Newcomb 1940, 55-56). This makes the preponderance of owls on Navajo spoons a bit quizzical, though it may be as simple as Anglo adoration of the design— "oh honey, look at that cute little owl"—or that the rendering of an owl was less of a concern than a living, hooting owl.

The rendering of snakes, however, is quite another matter.

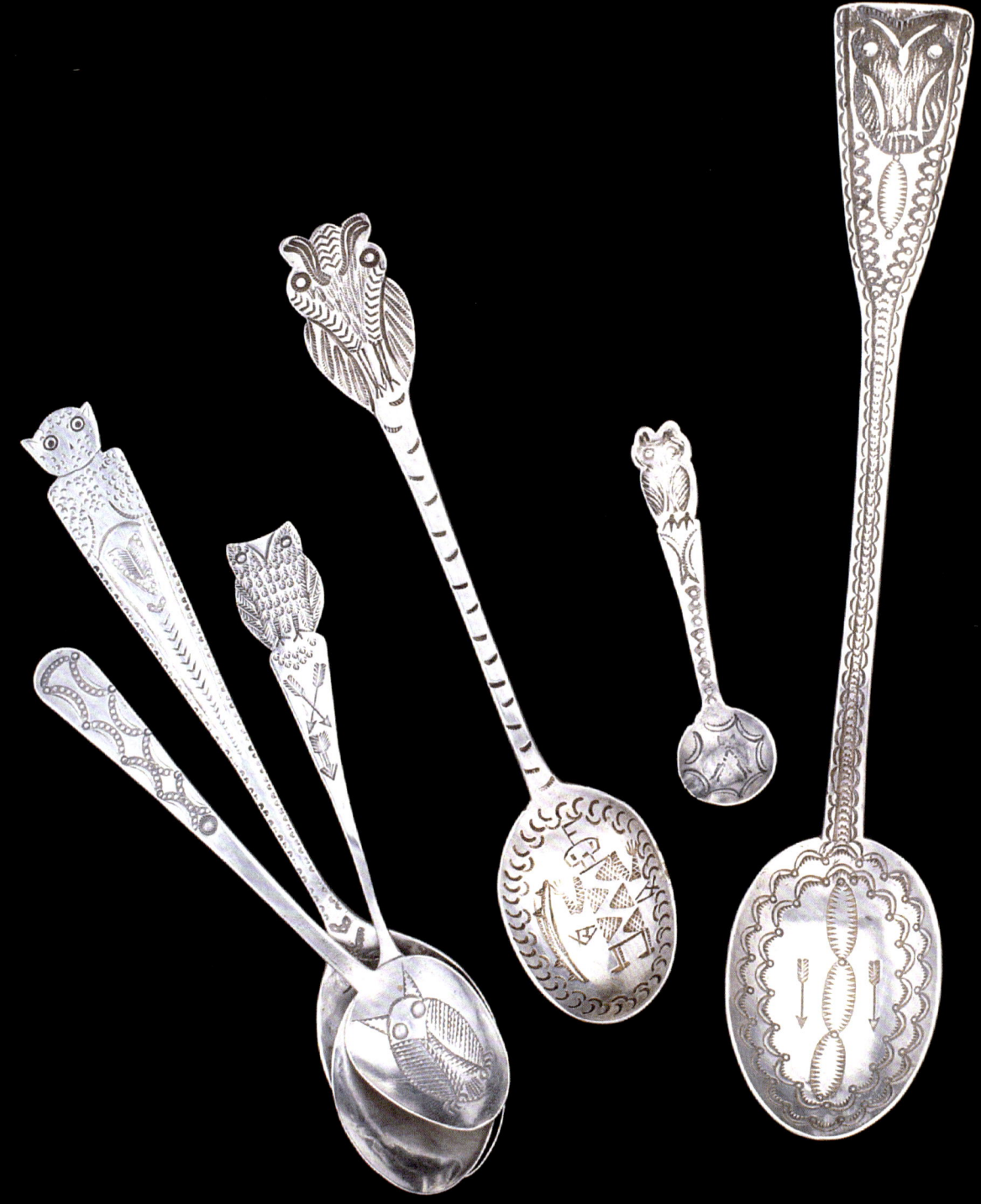

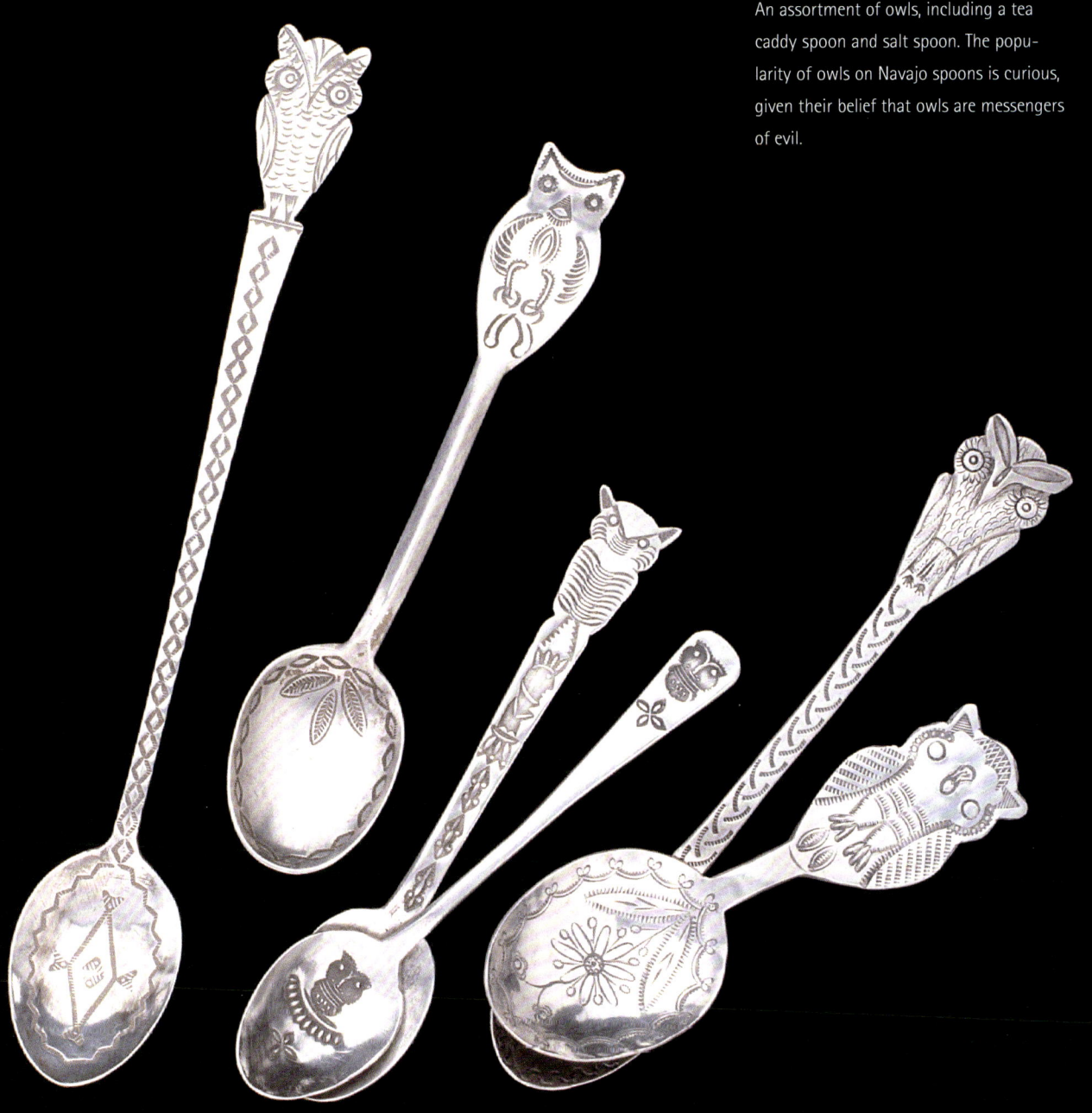

An assortment of owls, including a tea caddy spoon and salt spoon. The popularity of owls on Navajo spoons is curious, given their belief that owls are messengers of evil.

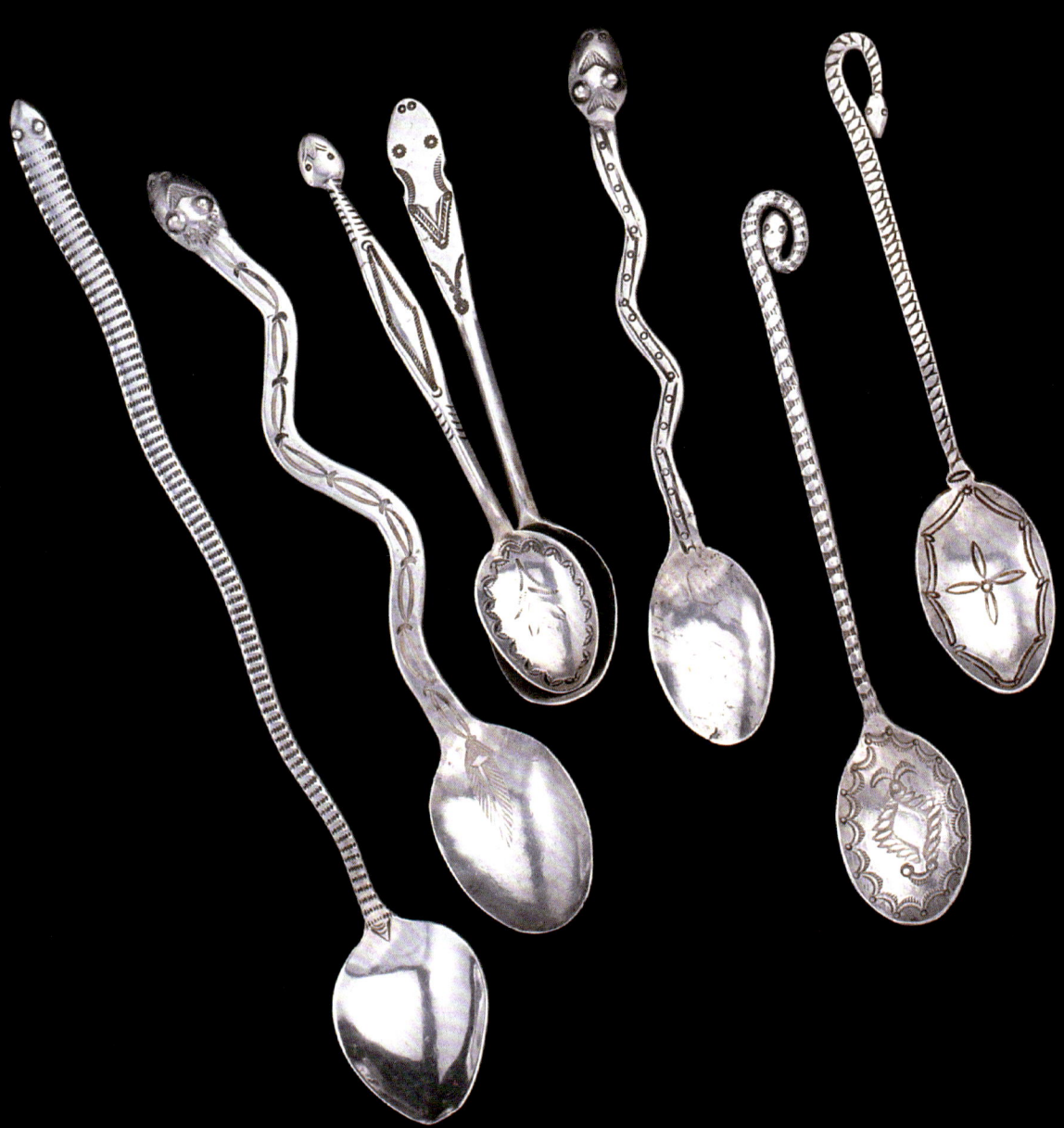

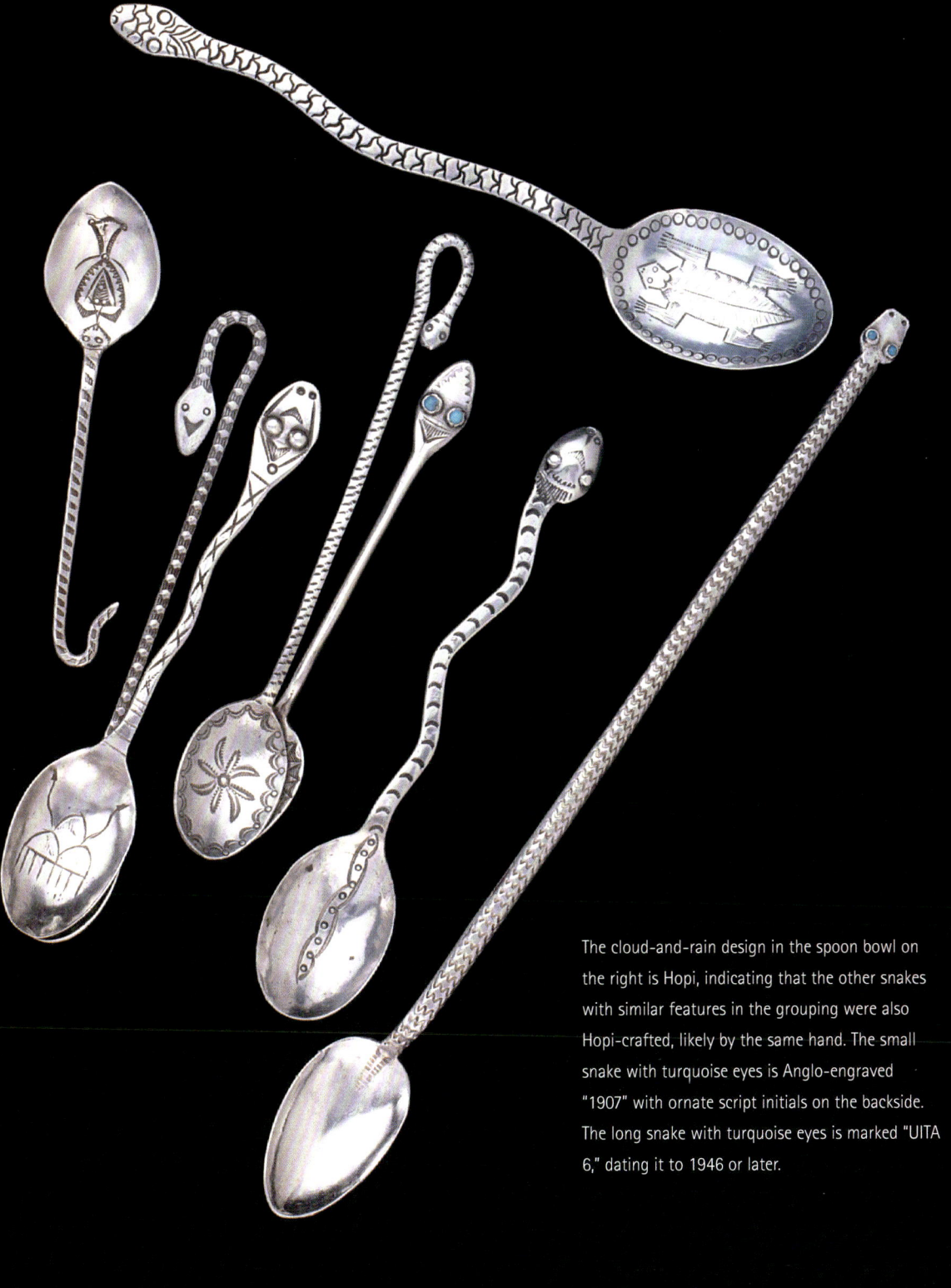

The cloud-and-rain design in the spoon bowl on the right is Hopi, indicating that the other snakes with similar features in the grouping were also Hopi-crafted, likely by the same hand. The small snake with turquoise eyes is Anglo-engraved "1907" with ornate script initials on the backside. The long snake with turquoise eyes is marked "UITA 6," dating it to 1946 or later.

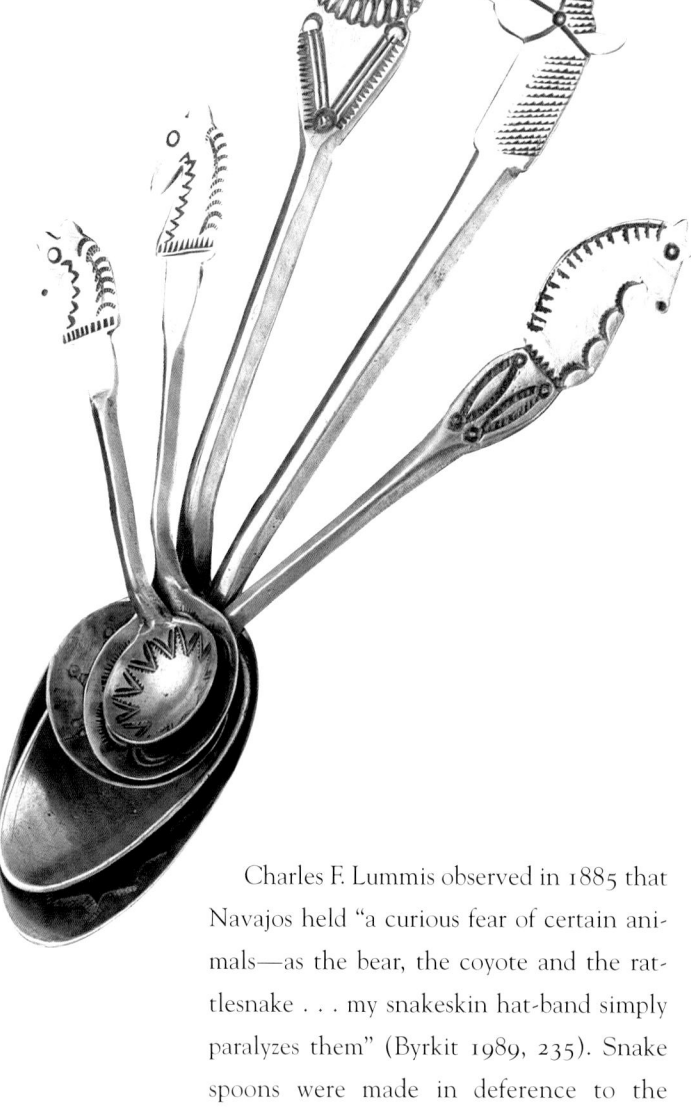

Charles F. Lummis observed in 1885 that Navajos held "a curious fear of certain animals—as the bear, the coyote and the rattlesnake . . . my snakeskin hat-band simply paralyzes them" (Byrkit 1989, 235). Snake spoons were made in deference to the extraordinary popularity of snake designs with Anglos, but the historical Navajo aversion to depicting snakes continues even to this day. Many contemporary Navajo silversmiths still refuse to render a snake, saying, with a shudder, "We leave them alone."

Lummis tells a story about a "skilled silversmith beaten nearly to death by his fellows for making to my order a silver bracelet which resembled a rattlesnake; and the obnoxious emblem was promptly destroyed by the raiders—along with the offender's hut" (Bedinger 1973, 98). In another telling of the same tale, Lummis identified the ostracized smith as Chit-Chi (Lummis 1896, 57).

Initial aversion may have dissipated somewhat over time. Snakes were produced as an iced tea spoon motif in the 1920s and again after World War II. When made, the length and form of a spoon handle transfers perfectly to the rendering of a snake, and the respect for snakes was transferred to well-crafted spoons—spoons in the form of snakes are beautifully wrought. Snakes may also be one of the more common spoon types made by Zuni and Pueblo smiths since their beliefs about snakes vary from those of the Navajo.

Profiles, swastikas, and, after 1909, Fred Harvey-inspired thunderbirds—these are the most prevalent figurative Navajo spoon forms. Beyond those three, there's almost an "anything goes" approach. Creatures of all types, from frogs to horses to bugs, wander onto spoons. Given that the circus passed regularly through Albuquerque, even unexpected animal images, such as elephants, appear on Navajo spoons.

Rare spoon motifs, bugs and a butterfly landed upon these whimsical spoon bowls.

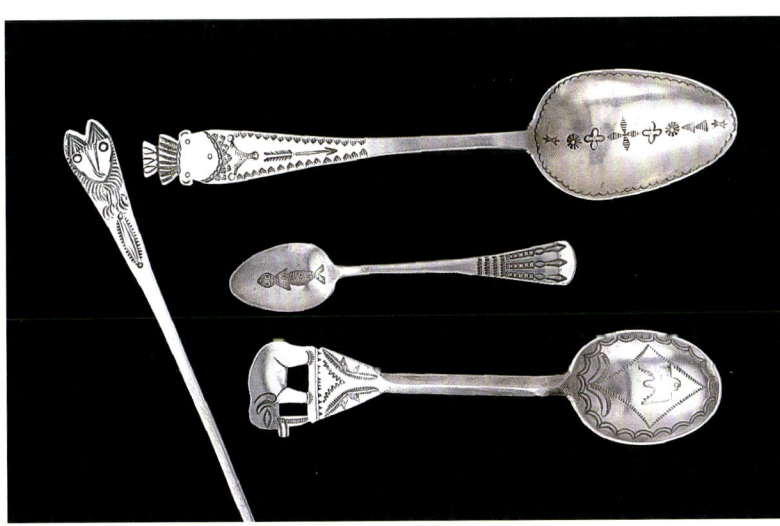

Perhaps the circus coming to town inspired these renditions of a lion, elephant, otter (stamped deep into the bowl), and a bear adorned with a performance hat. Whimsy overtook spoons around 1920.

Silver Words and Thunderbirds

As the 1920s approached, souvenir spoons declined in popularity. Navajo souvenir spoon making would segue into spoons intended for actual use, such as salad sets, sets of beverage spoons, and even butter knives, as the legendary social events of the Roaring Twenties led to a renewed interest in impressing guests. Such spoons didn't invite engraving. That special skill died as the souvenir spoon movement died and the master engravers themselves died. The beautiful silver words sliced deep into Navajo spoons—"Mother to Echo, 1915" reads the back side of a small Navajo teaspoon—would soon be but an echo of a time and art long past.

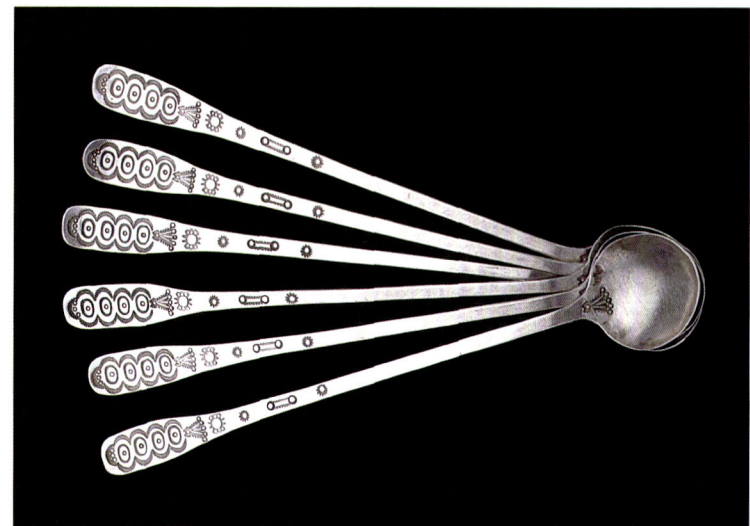

Sets of spoons, like this iced tea set, became popular for entertaining in the 1920s.

This Anglo-engraved spoon features a full-profile Indian stamp on the front of the handle.

5
The Making of a Navajo Spoon

Navajo spoons were made one of two ways: wrought (hand-forged and hammered) from Mexican pesos and/or American coins melted into ingots, which were then pounded into the spoon shape, or from a single coin hammered out directly.

After the spoon was formed, stampwork was applied. Stamping had to be done prior

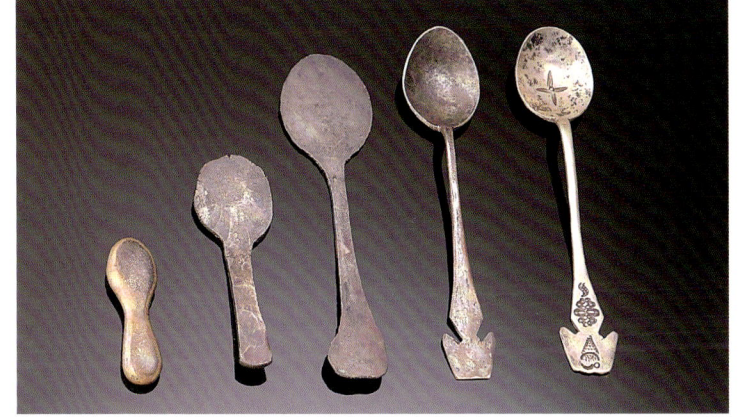

TOP
The progression of a Harvey Thunderbird spoon, ca. 1915–1920, hammered out from an ingot made from melted coinage. Photo courtesy the Fred Harvey Company, Heard Museum, Phoenix.

BOTTOM
Taken in 1938 by John Adair, this photo reveals how a Navajo spoon can be beaten directly out of a single coin. Courtesy the Wheelwright Museum of the American Indian, Santa Fe, New Mexico.

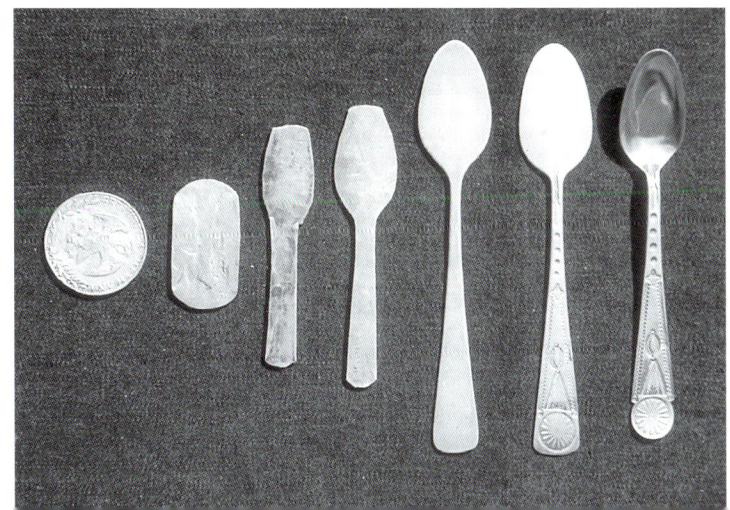

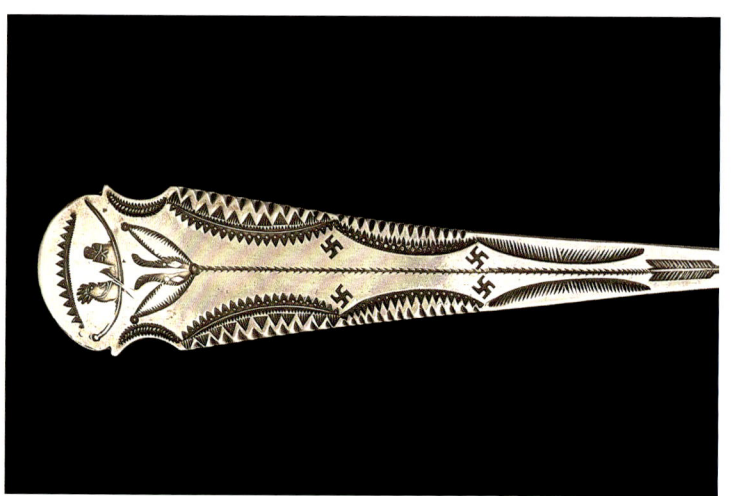

to any final shaping of the bowl or handle (tips of handles were often slightly upturned, a popular finishing touch found on commercially produced flatware) while the spoon was still flat. Although Anglo "master engravers" carved designs into the curved surfaces of finished spoon bowls, Native stampwork required a flat surface because it is impossible to stamp a curved spoon bowl with a flat tool. Stamping is precarious work because it can't be corrected — if a stamp is misplaced, it stays misplaced short of melting it down and starting over. Bowls were shaped by pounding the end of the stamped spoon over carriage bolts (in the early years) or wooden forms, with care taken to protect the already stamped surface.

Stampwork falls into two categories: individual stamps and compilation stampwork. Individual stamps create the same design over and over, and most are simple shapes, such as crescents, that can be combined into a myriad of complex designs. Far less common are figurative individual stamps—a goat, for instance—and, if original to the smith, they can be used to identify his work. Silversmiths shared stamps and purchased stamps from others, including commercial sources, so it is not the most reliable method of identification, however. Few smiths made their own stamps. It takes painstakingly fine work to perfect a detailed design on the end of a small piece of scrap iron, and additional eyestrain was the last thing a smith wanted or needed. Many smiths, from years of working by the light of kerosene lanterns, eventually went blind.

This detailed single stamp of a couple seated in a canoe fits so perfectly into the tip of the handle that it might well have been crafted just for that purpose.

Given the otherwise precise stampwork on this spoon, the Navajo silversmith must have cringed when accidentally hitting the handle emboss just off-center.

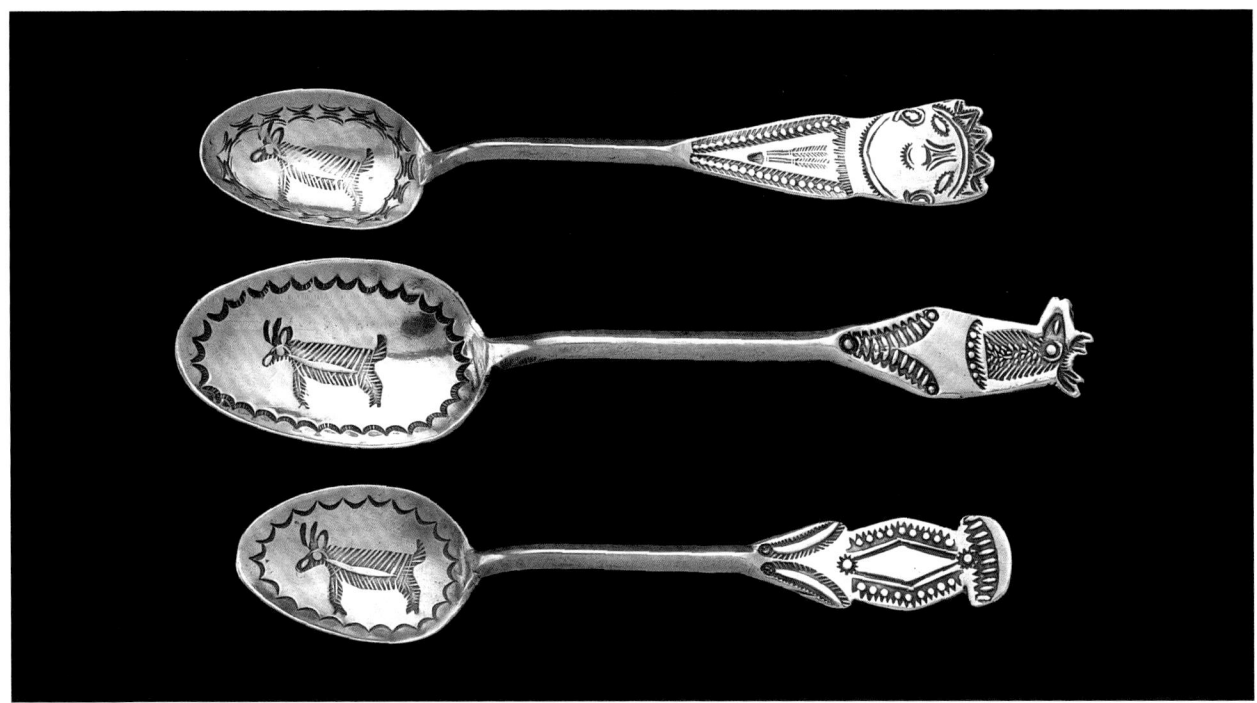

Compilation stampwork is the use of small stamps to create a larger, more elaborate design. Profile spoons are a good example of compilation stampwork, with many different types of stamps used to create feathers, facial features, and details such as earrings or necklaces. Profiles, one of the most prevalent early Navajo spoon motifs, are not found on other types of Navajo silverwork and appear only rarely on the terminals of ingot bracelets.

Why were profiles so common on Navajo spoons? Probably because they were so common on commercial spoons of the late nineteenth century. Indians and profiles of Indians were extremely popular on manufactured souvenir spoons. In 1891, for example, two patents were issued for a nearly identical spoon design, both named "All American Indian" and manufactured by several different companies. The "All American Indian" spoons featured a stoic Indian profile in full headdress atop the handle, and the bowls of these spoons were engraved with names of places all over the United States and Canada. ("All Purpose Indian" would have been a more accurate name for the design.) Such spoons served to further perpetuate the perception of the Plains Indians, with their picturesque tepees and dramatic style of dress, as the "superculture" against which all other Native Americans were compared. Even J. B. Moore chose to designate "Indian head

An individual stamp in the bowl renders the complete goat. All spoons are by the same hand, the goat stamp probably unique to the smith using it, yet the three have very different handle treatments. The goat at the top is lightest because the smith did not stamp the image as deeply as he did on the other bowls.

The Making of a Spoon 77

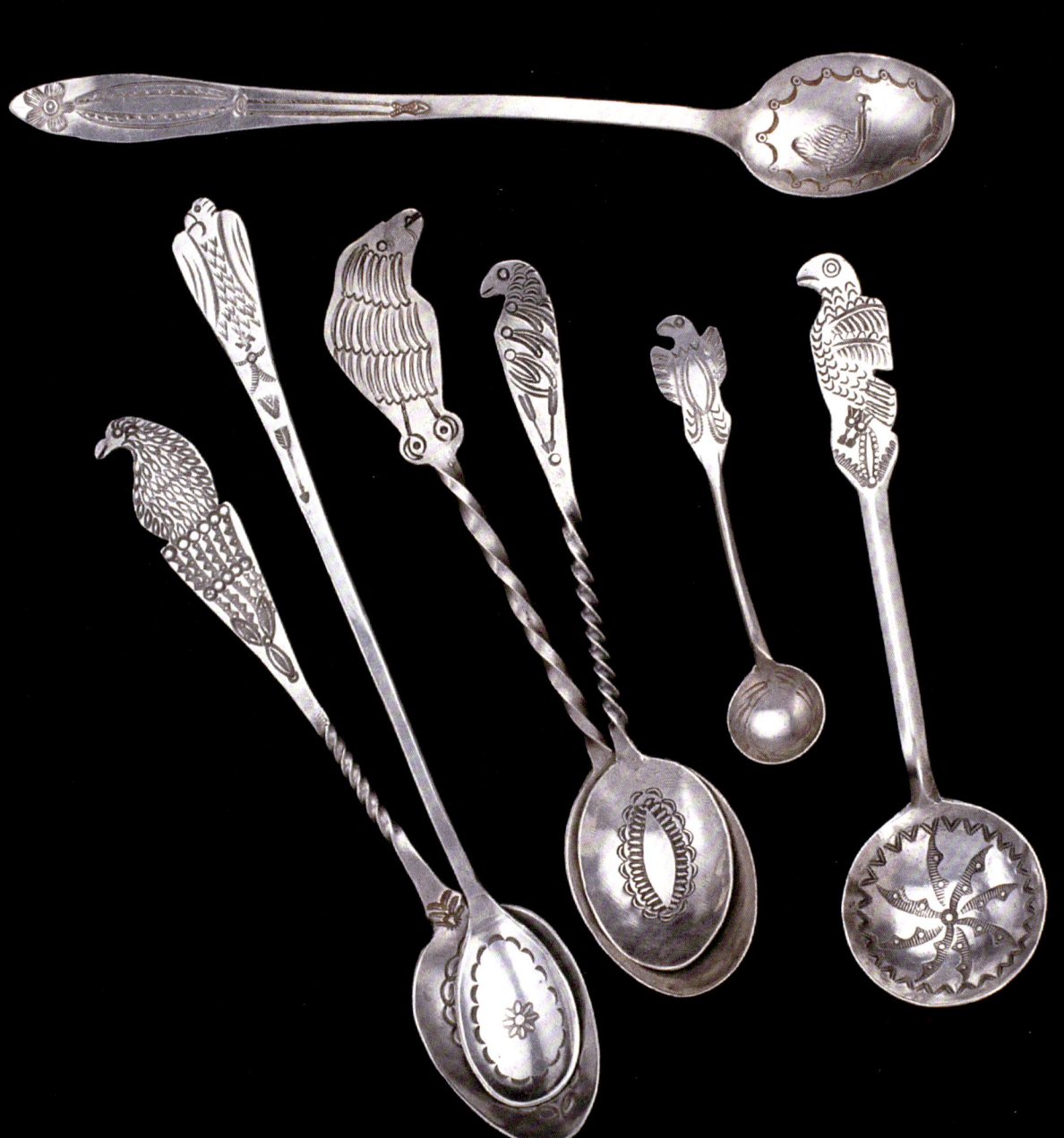

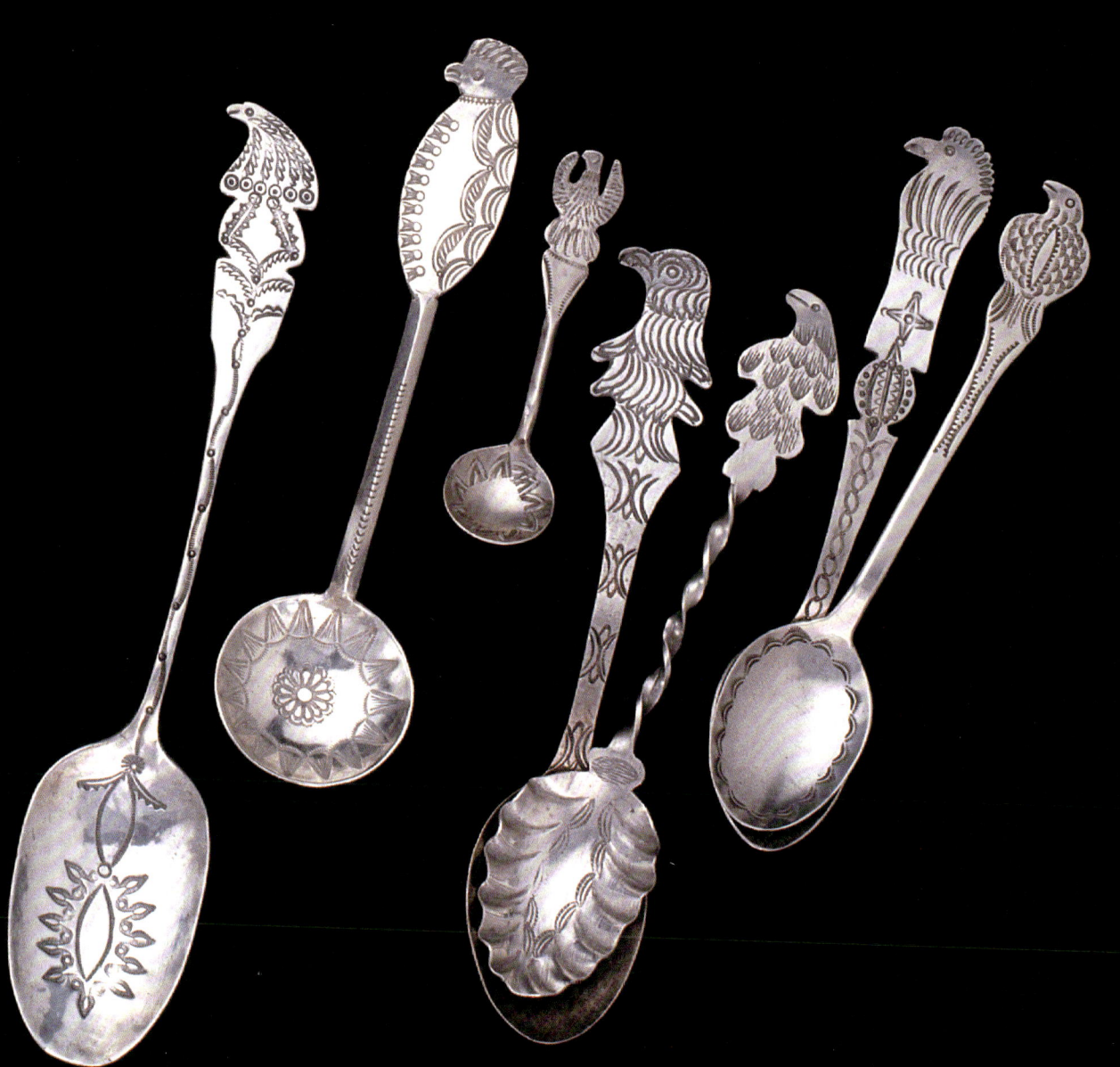

These turn-of-the-century birds were created by compilation stampwork whereby smaller stamps are combined to create a more complex final design.

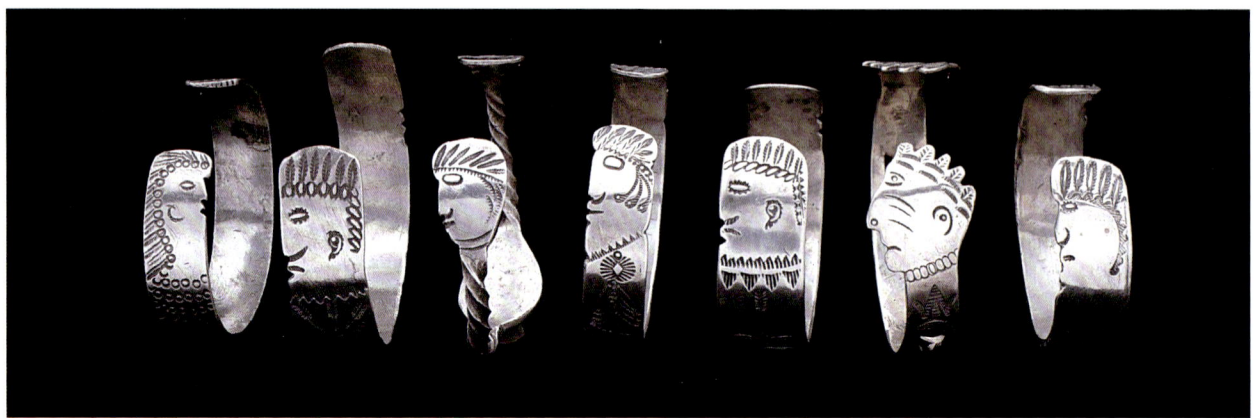

spoons" as his "souvenir spoons" in his 1906 catalog whereas his other spoons were described as coffee, tea, and sugar spoons.

It was also an image known by everyone with a penny in his pocket—"Indian head pennies" were not pulled from circulation until 1909. It's a simple premise, but as likely as any other, in finding an explanation for the popularity of profile spoons around the turn of the twentieth century.

Profile spoons stamped with the word "Navajo" take on a deeper psychological dimension. These are more representative of the cunning used by traders and even the Navajo themselves to acquiesce to Anglicized preconceptions and misconceptions. Navajo men traditionally wore bands of cloth tied around their foreheads. What became recognized as "Indian feathers" is actually the traditional "Sioux bonnet" worn by chiefs of Plains Indian tribes. Lummis wrote in 1885 that on "festal occasions" the Navajos wore plumed headdresses, but it was by no means regular attire (Byrkit 1989, 234).

Rare ingot profile bracelets patterned after turn-of-the-century spoons.

This postcard shows a Navajo silversmith wearing the traditional band of red cloth around his forehead.

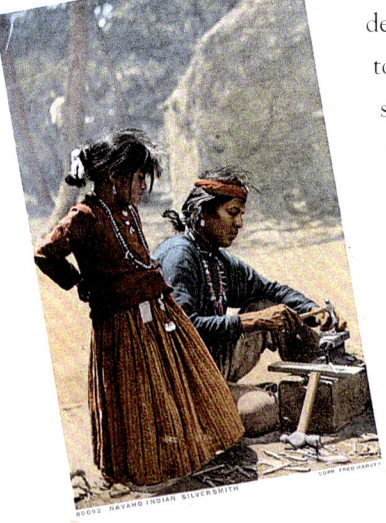

You'd be hard-pressed to know that judging by turn-of-the-twentieth-century postcards, however, or by the photos of Southwest Indians in headdresses poised at train platforms. Buffalo Bill Cody was, by 1883, showcasing Plains-style Indians in full war paint and feathered headdresses in his Wild West shows, and this led to a widespread belief that Native Americans looked a certain way. When Navajo silversmiths began depicting "Indians" on spoons for tourists, even if the spoons were stamped "Navajo," they created profiles of what they thought tourists thought Indians should look like.

Similar blurring of cultural lines continues today, with powwows' varied dance competitions and blending of

tribal styles, but there are practical, contemporary reasons behind it. As languages and traditions are diluted or lost forever through the death of elders, for many it has become less important to observe strict adherence to one's own heritage than to preserve any and all Native American practices, lore, and culture. Debra ("Ruling Hissun") Eaves, a Mississippi Choctaw woman married to a full-blood Pawnee husband, explains that her children perform Tlingit dances and her husband belongs to a Lakota Sioux sweat lodge (the Pawnee's historical enemy); their family belief is that it's most important to honor what still remains of Native culture. In an interview in *Rocky Mountain Spirit* magazine, Eaves stated: "To me, it doesn't matter how much blood you are or even what blood you are, it's how you live and what you believe and how you respect the [Native] culture" (Kline 2000, 13). Anything to keep old ways alive.

The majority of spoons stamped "Navajo," falling within the years of the souvenir spoon movement, predate 1920, and the alphabet letter stamps used to imprint "Navajo" upon souvenir spoons did not often find their way to other silver items. Unlike the unique writing of the word "Navajo" in script on the early set featured in chapter 1, spoons with "Navajo" stamped on them used block letters. The stamping of the word is often quirky and erratic. Letters don't line up well, especially in spoon bowls, and at times the "J" or "N" is inverted if the smith accidentally held a stamp backward.

The letters "A" and "V" often were created with the same stamp—silversmiths

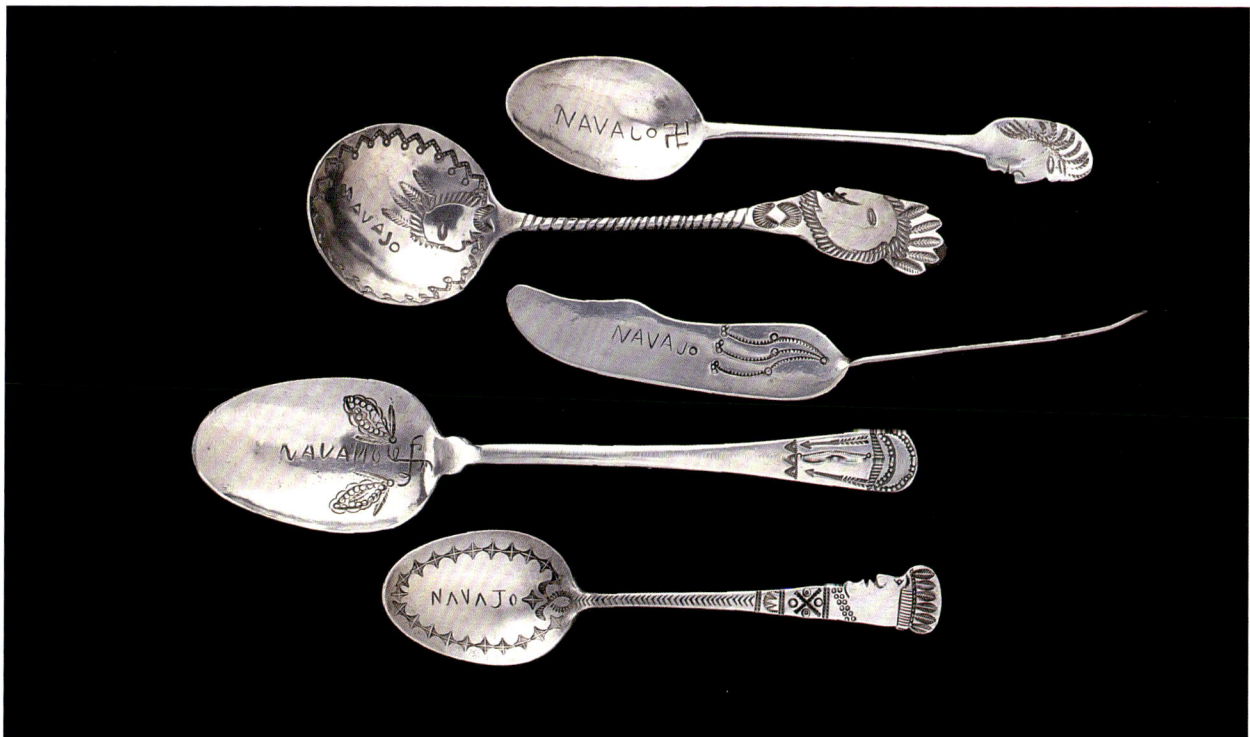

Silversmiths took liberties with the English alphabet. Note the older spelling of "Navaho."

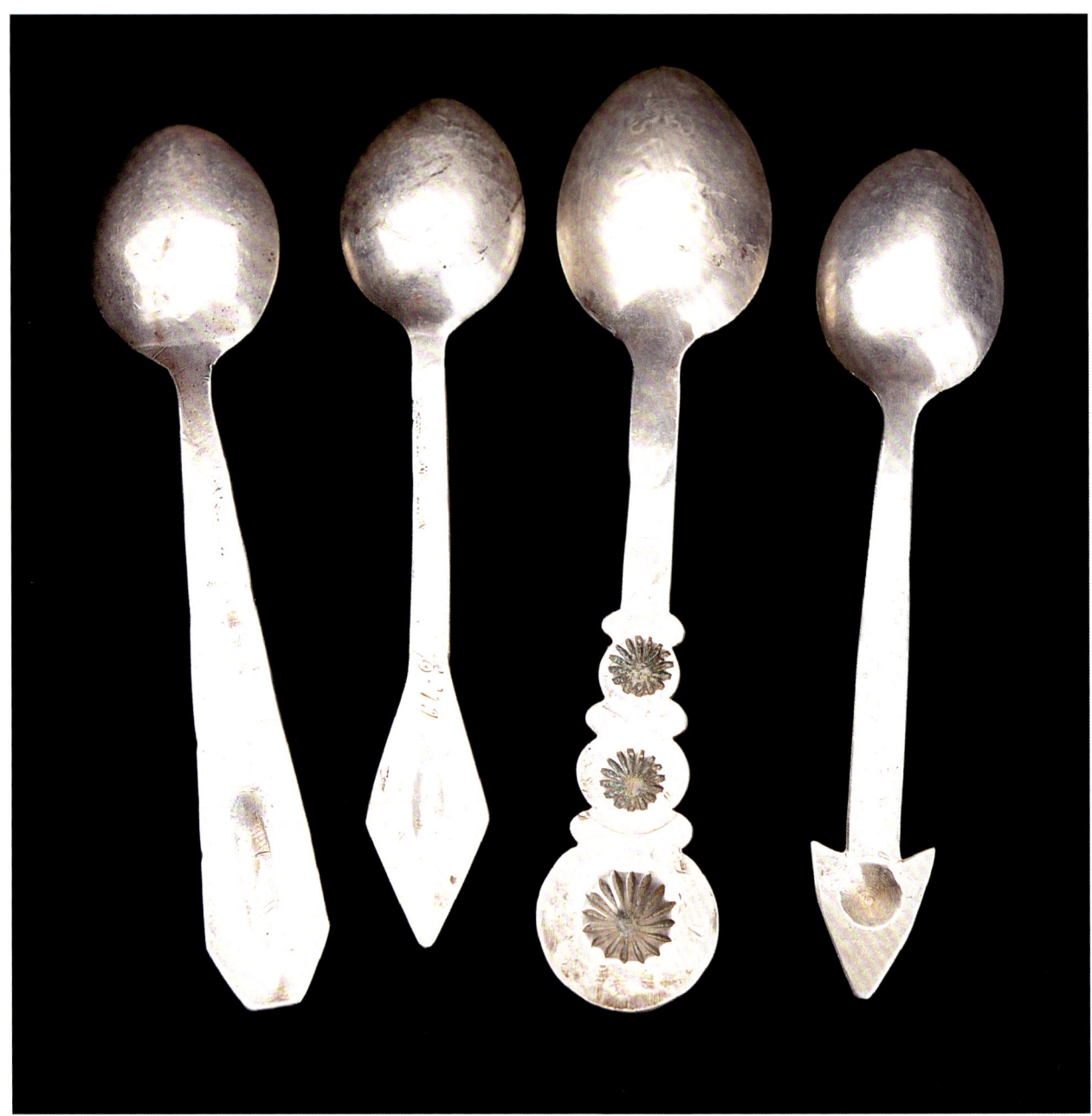

Back sides showing repoussé and embossing techniques. The spoon *second from right* is Anglo-engraved with the initial "E" and the abbreviated date of 1919.

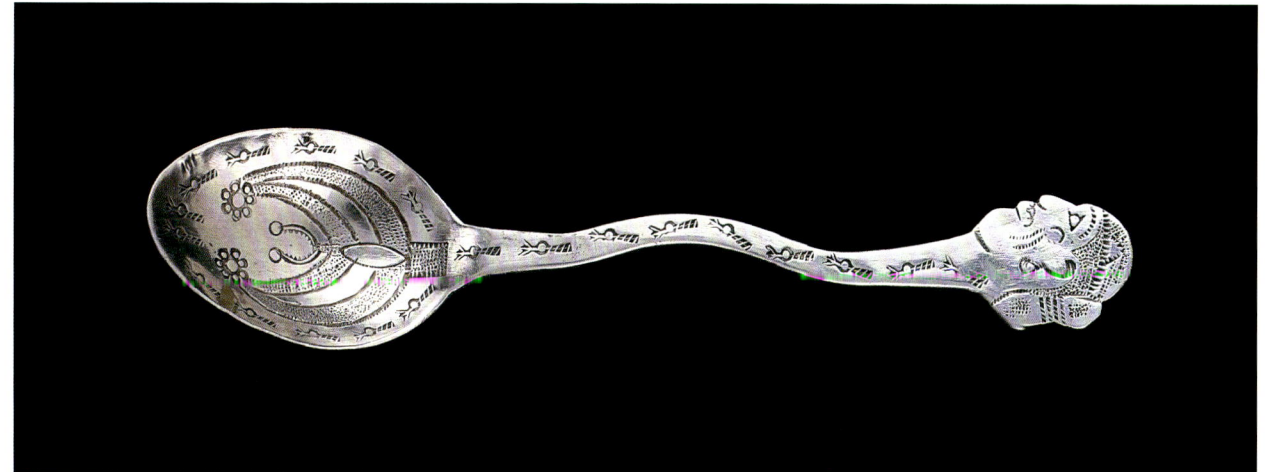

This atypical profile spoon has a unique squash blossom stamp along the handle, representing a necklace, with the pendant (*naja*) terminating in the bowl. This spoon exemplifies the form's more sculptural aspects.

simply flipped the "V" over and added a line across the center to turn it into an "A"; this accounts for some very odd-looking "A"s. Even the "N" was sometimes made using an upside-down "V" stamp, with the smith just adding a little line at the front. "N" could be made with three lines like those used to cross the "A"s. The letter "O" could be formed by impressing the punch used to make concha belt holes (yielding a tiny "O," much smaller than the other letters) or from two curved lines forming an oval "O" (on a profile spoon, this type of "O" sometimes matches the oval eye rendered in the face on the handle). In short, the entire word "Navajo" could be made using just two letter stamps—a "V" and a "J"— with other lines added as needed. Fortunate was the silversmith who had actual letter stamps for the letters "N" and "O." The use of the older spelling of Navajo (as Navaho, with an "h" instead of a "j") is rare: By the time souvenir spoons were popular, the "h" spelling had fallen out of popular use.

Occasionally, the distinction can be made that a grouping of Navajo spoons is the work of one smith. Unless a distinctive stamp is used that can be traced to a particular smith, however, the best that can often be done is to call a grouping the work of the "same hand" and hope later research will reveal whose hand. Sometimes it is repeated use of a method, not stamps, that links spoons to the same maker; repoussé and embossing, techniques that involve the "bumping out" of a design from the back side, are common on buckles and bracelets but are uncommon on Navajo spoons, given the limited space on spoon handles.

Despite their occasional crafting by Pueblo smiths, spoons made before World War II may be generalized as "Navajo spoons." The great majority of them were made by Navajo silversmiths, but even

when Pueblo smiths crafted spoons they tended to be rendered in the Navajo style. Also, some seemingly Navajo-made spoons incorporate Pueblo motifs, making definitive determination of origin difficult. Native smiths learned from each other and borrowed ideas from each other all the time. Plains Indians frequently traded with the Southwest tribes between 1870 and 1900; hence, their work influenced early Navajo fabrication. Navajos copied some of their most distinctive designs from Plains ornaments, including the *naja* (the Navajo word for the horseshoe-shaped pendant found on squash blossom necklaces). The Naja turns up occasionally on Navajo spoons, stamped into the bowls, or in cutouts atop handles.

As much as Anglos like to attach significance to Native American designs, there's usually no "deeper meaning" to spoon decoration than that of making a sale to a tourist. John Adair's surveys in the winter of 1940 found "more than forty Navajo craftsmen living at Zuni and working for the trading posts" and that the smiths who were actually Zuni made Navajo-style jewelry if asked to by traders. At Cochiti Pueblo, Adair found the silver "made in this pueblo is Navajo in type" and also that "Santo Domingo silver is an imitation of the Navajo" (Adair 1944, 204–28).

Prior to 1905, Mexican pesos had a silver content of .903, close to sterling's .925, which made them soft to work with and which resulted in a finished piece with a finer luster than items made with American coins. Pesos were the silver source of choice for Navajo smiths, but both American and Mexican coinage was widely used until the U.S. government outlawed the melting of currency in 1890. In actuality, the new law did not present much of a hurdle. Indian traders simply kept smiths well supplied with their preferred pesos, and many smiths just continued using American coins they already had or coins they acquired through barter.

Lummis wrote of seeing large quantities of silver coins stockpiled by Navajo smiths, saying, ". . . it is astonishing what store they have of it. Their supply is now drawn almost exclusively from the cartwheel dollars of the Yankee and Mexican daddies" (Lummis 1888, 41). Coins provided an excellent source of silver because of their significant precious metal content, unlike the currency in circulation today. Morgan silver dollars, for example, contained 412.5 grains of pure .900 fine silver and were first issued in 1878 using silver mined from Nevada's legendary Comstock Lode, the discovery of which made silver affordable and readily available throughout the United States and abroad.

Shield nickels, on the opposite end of the spectrum from Morgan silver dollars, are of interest because they originated during the Civil War when desperate Americans stock-

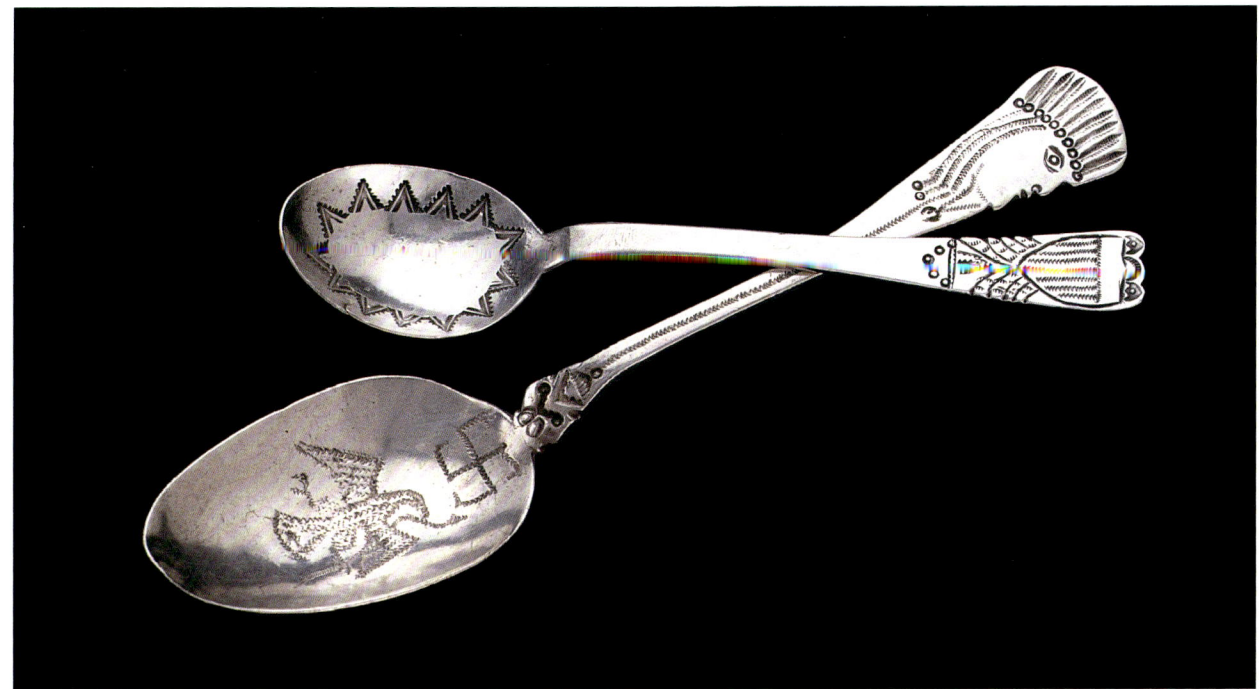

piled their silver currency; the shield nickel was first minted in 1866 to discourage this practice. Shield Nickels contained .75 copper and .25 nickel—no silver—to ensure they'd remain in circulation, and this may be the reason behind an early 1880s observation that Native Americans regarded nickels with "ill-concealed distrust" (Bourke 1884, 254).

Very rarely, Navajo spoons were cast from molds, which could be shaped into precise designs. Ketohs (bow guards traditionally worn to protect the wrist from the snap of the bowstring when hunting) and bracelets were created in such molds, and the method first came into use by Navajo silversmiths in the mid-1870s. Lightweight volcanic stone resembling pumice (called tufa, or tuff) was carved into the shape of the desired item, and the stone was then blackened with smoke to prevent the hot, liquid silver from sticking to the mold. Items made in this method are often called "sandcast" in reference to similar, earlier techniques where harder sandstone was used, or fine sand was packed into a frame and either a design carved or a model pressed into the sand to receive molten metal. Tufa was easier to work with, but what smiths gained in convenience they lost in durability: the molds broke easily and did not hold up well to repeated use. Sandcast pieces have rough and pitted back sides from the release of oxygen as the silver hardens in the mold,

The snake with an eagle is an image found on Mexican coins. The shield design appeared on numerous American coins. Both of these motifs are rocker-engraved. The profile spoon has an Anglo-engraved date of 1906 on the back side.

The Making of a Spoon 85

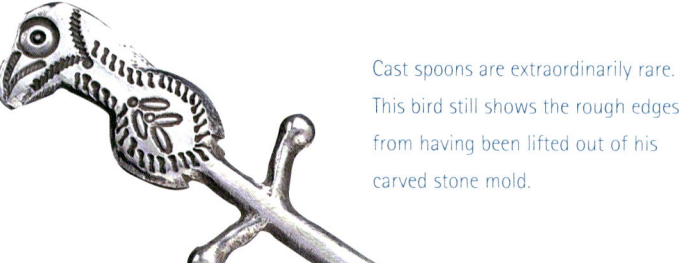

Cast spoons are extraordinarily rare. This bird still shows the rough edges from having been lifted out of his carved stone mold.

although meticulous smiths would file it smooth in the finishing process. Triangular (carinated) handles on Navajo spoons, similar in appearance to sandcast bracelets and ketohs, are actually a result of hammering wrought silver into a grooved form, just as spoon bowls were shaped over a curved form.

Also rare are cutout handle designs. With all the work it took to make a spoon, few smiths sliced out their designs from handles, preferring instead to render designs with stampwork.

Once sheet silver became available in the 1920s and 1930s, it became popular almost immediately because it saved silversmiths a lot of pounding. Ideal for the simple manufacture of items such as bracelets and pins, sheet silver caused the practice of working from ingots of melted coins to diminish significantly. The preference for sheet silver indirectly contributed to the decline of the making of wrought spoons because Navajo smiths could create so many other items so readily and easily.

Wrought silver was dealt another blow when the Mexican government outlawed exportation of their currency around 1930. Traders, understanding that Native smiths were accustomed to working with the size and weight of Mexican pesos, made arrangements with refineries to manufacture one-ounce slugs of coin silver, comparable to the size of coins. By 1932, such slugs were in widespread use, although the practice of working with sheet silver increased yearly, and even if slugs were used, it was common to use a silver roller to reduce a slug to a sheet of the required

Because smiths were accustomed to working with the size and weight of coins, Indian traders supplied them with silver slugs of similar size and weight.

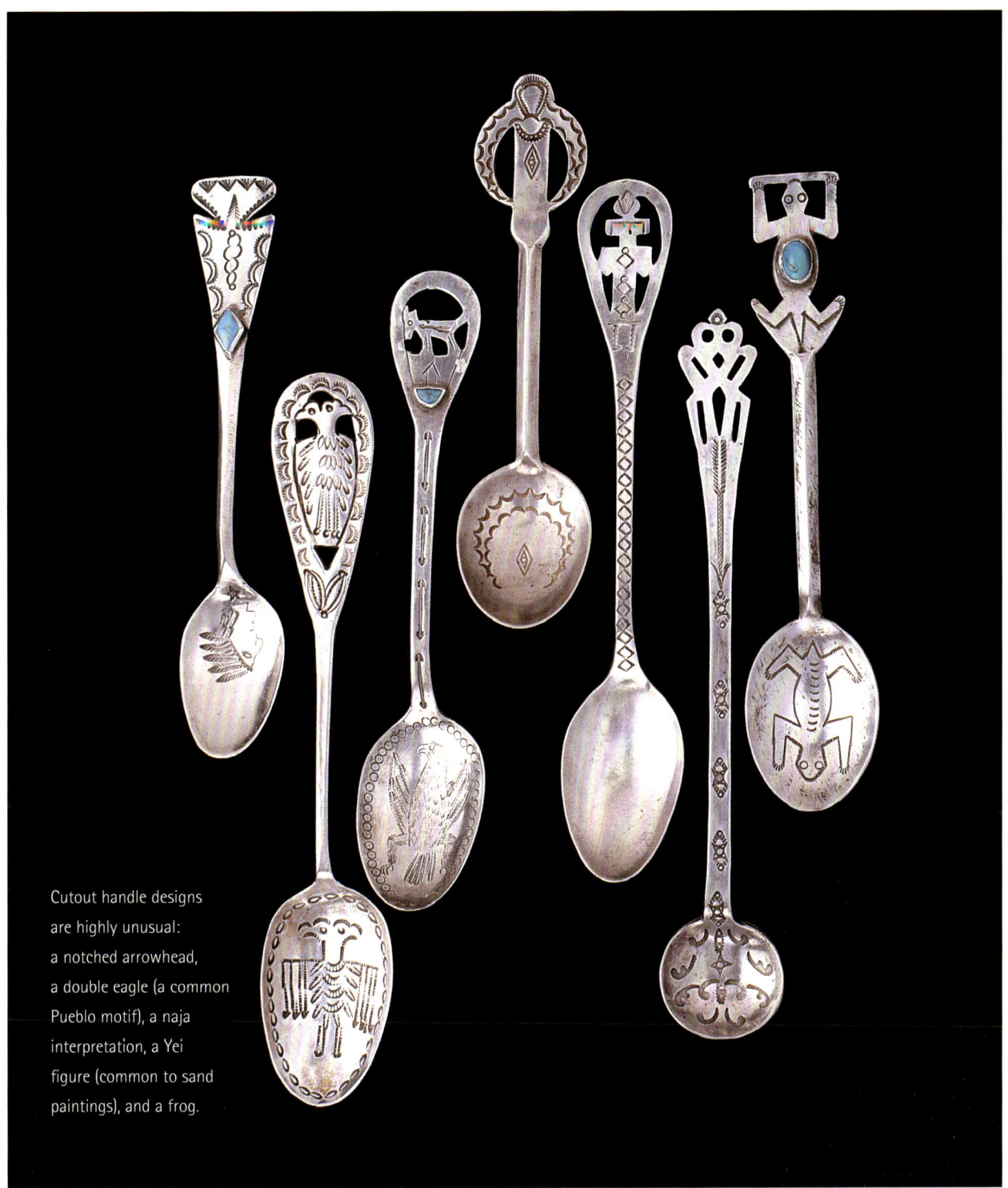

Cutout handle designs are highly unusual: a notched arrowhead, a double eagle (a common Pueblo motif), a naja interpretation, a Yei figure (common to sand paintings), and a frog.

The Making of a Spoon 87

thickness. Silver rollers pressed slugs thin enough for a bezel "in . . . seven to twelve minutes, an operation which would take at least forty five minutes to perform in hammering by hand" (Adair 1944, 205).

The majority of Navajo spoons have identifiable forms, and this is, in and of itself, remarkable. Except for floral or leaf patterns, "life-forms" upon Navajo silverwork, such as animals and profiles, are the exception, not the rule. With Navajo spoons it's the rule, not the exception. Nonrepresentational spoons are the exception, and when they were made, it was most often because they were utilitarian spoons—sugar shells or bonbon spoons, for example—inherently decorative by the spoon's intended function. It is often these spoons that best reflect the Navajo concept of *hozho*.

Classic Navajo design, renowned for its simple beauty and focus on the center, is evident in many elegant serving pieces. Hozho, which is complex and has no precise English definition, loosely translates to mean "beauty." Hozho is inherent in, and gives focus to, all aspects of Navajo life. No matter the pursuit, whether weaving a rug or stamping a spoon or baking a loaf of bread, the Navajo believe that in order to fulfill the task properly, a person must be in a state of *hozho* and that the task should encompass the aesthetic considerations of harmony and balance. It is often nonrepresentational spoons that best reflect Navajo aesthetics and may be considered the most "Navajo" of all Navajo spoons.

Twisted handles, very common on early Navajo spoons, sometimes have an interesting twist: They're not twisted at all but instead just a series of surface slash marks to

Middle Phase spoons, made between 1900 and 1930, show increased perfection and experimentation.

Skillfully executed with an emphasis on the center, this shallow, flat-bottomed Victorian sliced cucumber or tomato server (similar in appearance to a bonbon spoon) exemplifies the concept of *hozho*.

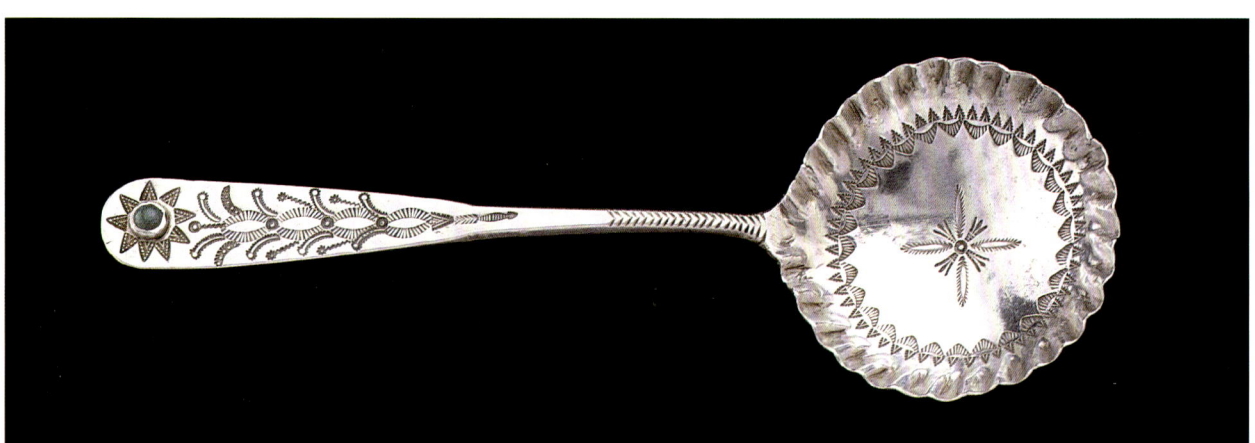

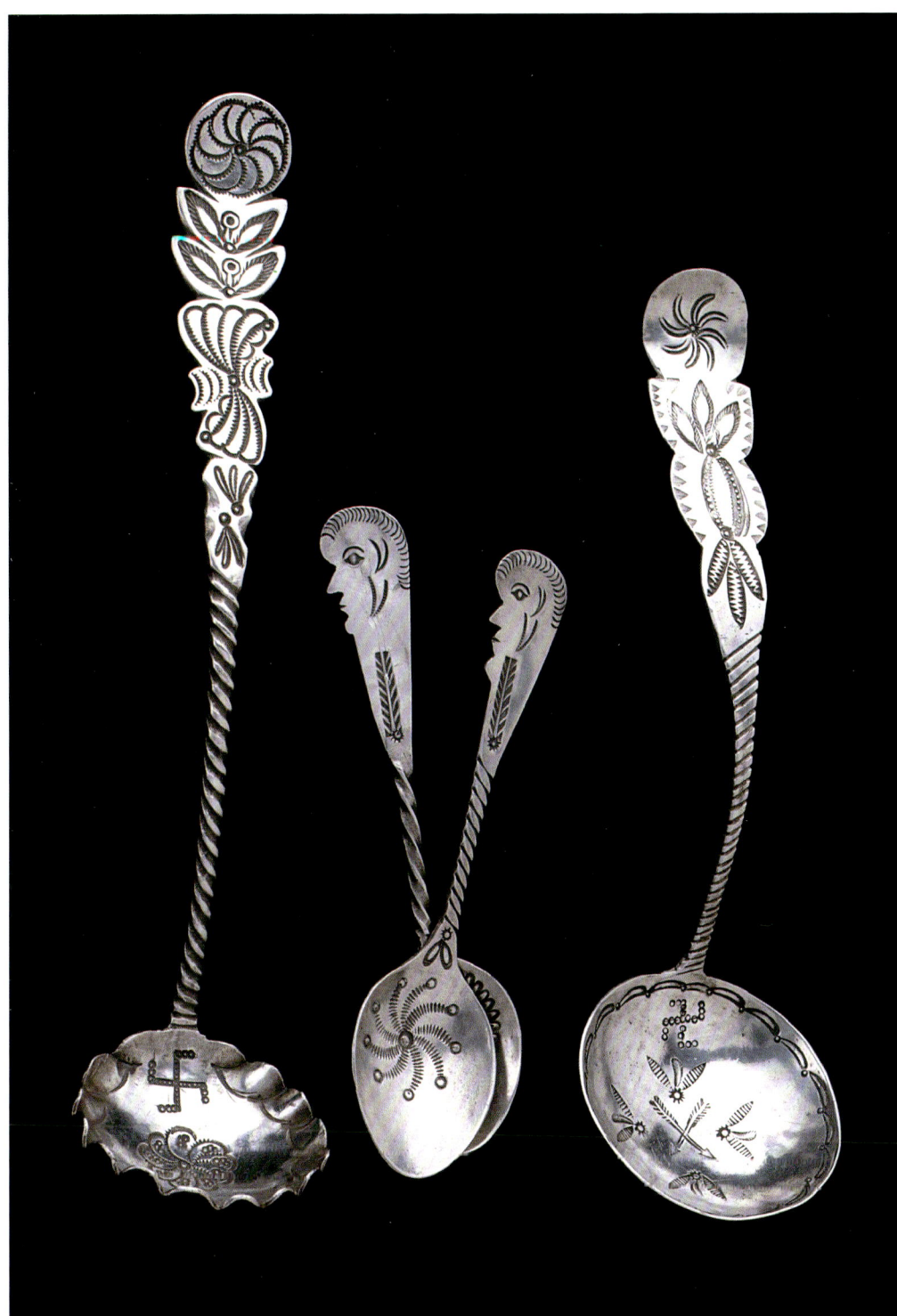

Twists with a twist: On the pair, *center*, crafted by the same smith, one handle is twisted and the other is only made to look that way, as are the handles of the larger spoons. The backsides are smooth.

The Making of a Spoon 89

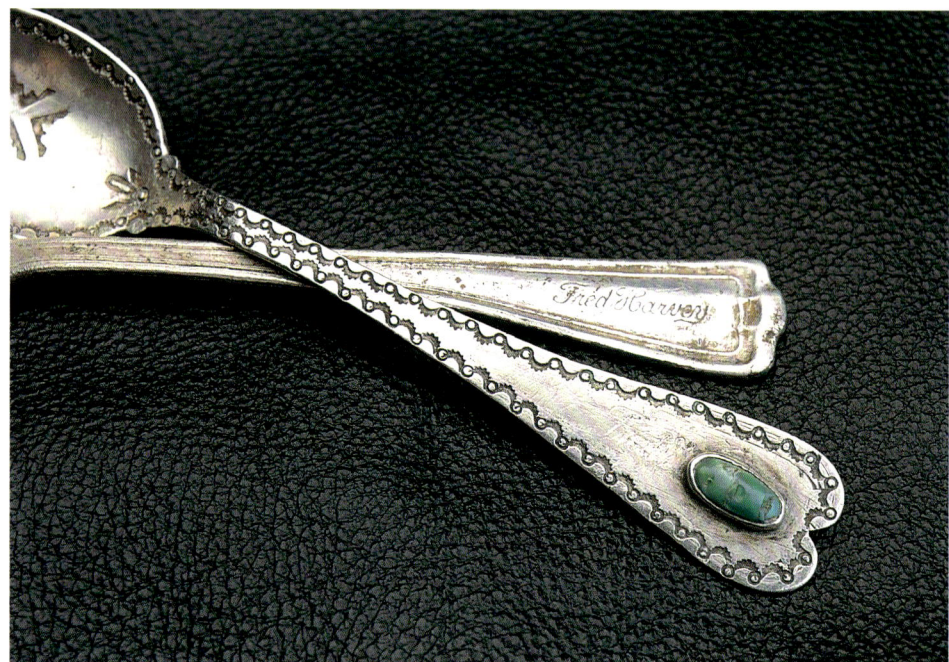

Altered commercial flatware is rare because it was often silver-plated nickel, a notoriously difficult alloy to work, and the effort required did not make it an appealing option. Hammering proved so difficult for the smith that he left faint traces of the Fred Harvey Company signature still visible, just left of the stone.

make the handles appear, from the front, as if they *were* twisted . . . a simpler method that achieved the same visual effect.

Turquoise does not find its way to spoon handles as often as it does to other Navajo and Pueblo silver items. The only Navajo spoons upon which the setting of turquoise could be called common are iced teaspoons. (Prior to the popularity of iced tea in the 1920s, these same spoons were called iced beverage spoons, cocktail spoons, or lemonade spoons.) There are several possible reasons for this: the lengthy handles safely distanced the stone from contact with the beverage; too narrow to allow much stampwork, the thin handles invited the use of a "finishing touch" such as a stone; or because iced teaspoons were most often used for guests, a bit of blue turquoise dancing above the tops of tall glasses was festive and invited comment and conversation.

Salad sets are visually exciting for the stampwork variations on the "matched" spoons and forks, and their larger size invited more elaborate embellishment although they are, technically, a "pair." True sets, such as demitasse or iced tea spoon sets, were sold in groupings of six or eight. Still, as popular as iced tea spoons and salad sets were in the Roaring Twenties, when people were entertaining frequently, they weren't wrought often in the 1930s and early 1940s, when the country was only entertaining thoughts of putting food on the table and surviving World War II.

6
End of a Phenomenon

Although America's fascination with souvenir spoons dissipated around 1915, Navajo spoons, including flatware for general use, enjoyed continued popularity. Navajo spoons from the transitional years, or Middle Phase (1900 to 1930), when techniques had been perfected, contain countless variations in the decoration of spoon and bowl handles. So while First Phase (pre-1900) spoons serve as important examples of nineteenth-century silver techniques, early-twentieth-century spoons offer unique and often whimsical explorations of form not found in other Navajo silverwork. The 1920s, a prosperous time for many Americans, renewed interest in serving pieces, such as salad sets. Setting an impressive table was many a lady's social pastime until the stock market crash of 1929.

As souvenir spoon popularity dissipated around 1915, there was renewed interest in Navajo serving pieces. Family documentation cites that this profile salad set was given as a wedding gift in 1918.

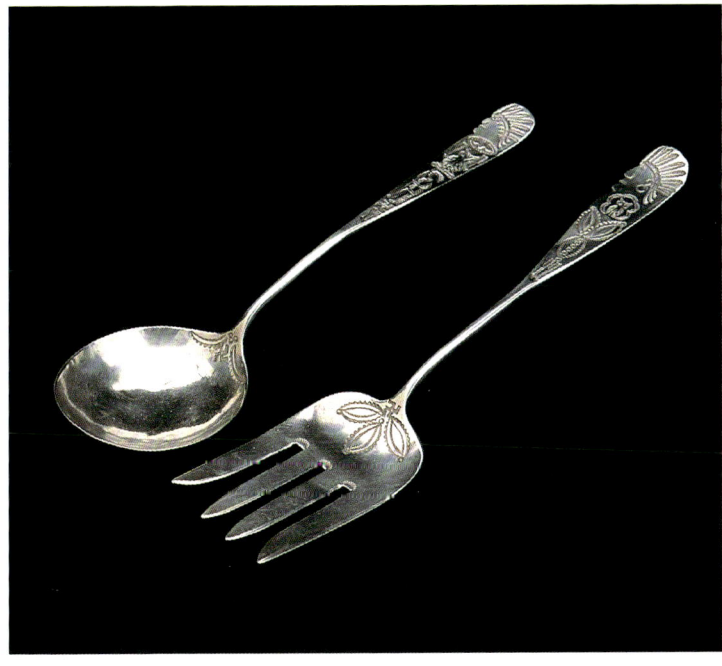

With the end of the souvenir spoon movement, beverage spoons and salad sets came into vogue. This stylish ad from 1924, selling sets of teaspoons, depicts a woman awaiting the "tea-wagon."

By 1922, all the commercial enterprises that had for decades existed for the sole purpose of making souvenir spoons and collectible spoons had gone out of business. Larger silver companies dropped their lines of such spoons and instead began promoting specialized serving pieces, reminiscent of the Victorian era, which extended their existing lines of flatware. The prosperity of the decade encouraged a handful of commercial flatware manufacturers in the late 1920s to strike a few new souvenir spoon designs, but the Great Depression squelched the attempted revival.

The old-time Indian traders who had promoted and sold Navajo spoons were struggling even before the stock market crash of October 1929. Indian trader J. L. Hubbell, weary of battling the new trading firms, wholesalers, and imitation Indian products, was, in 1925, a broken man, both emotionally and financially. Although his sons Lorenzo, Jr., and Roman would carry on the trading business and family name for a while afterward, by the time Hubbell died in November of 1930, the Great Depression held the country in a stranglehold.

The resulting economic hardships of the 1930s left most Americans unable to afford fine examples of Native American silverwork, and the machine-manufactured imitations sold in its stead diluted the buying public's expectations. "Indian Design" spoons proliferated during these years. So obviously inferior to Navajo spoons, they should only be considered relics of a time and never examples of the real thing.

In 1931, a year when one in four Americans was unemployed, the Arrow Novelty Company filed paperwork with New York State updating its list of officers, and H. H. Tammen continued to offer a full page of "Indian Design Silver Spoons" in its catalogs. One spoon, described as a "cut-out Indian head handle," is actually a full-figure

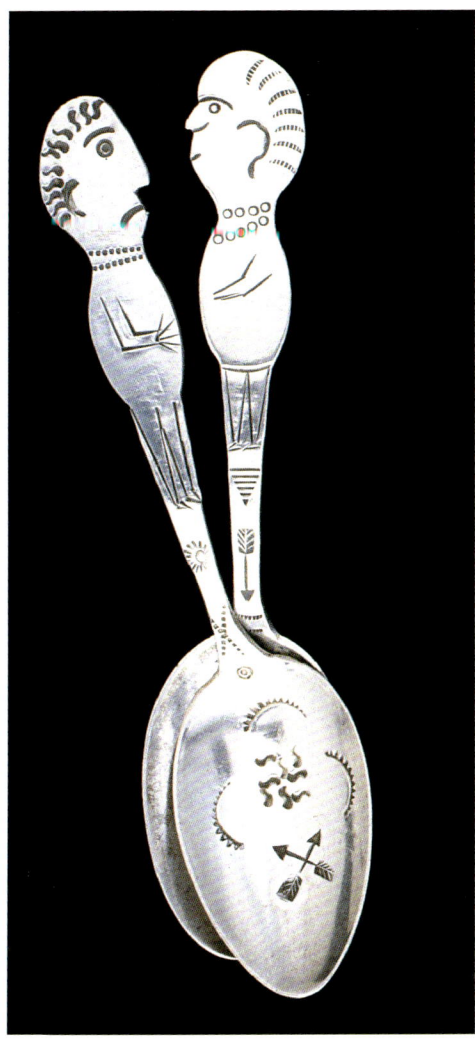

Described in H. H. Tammen catalogs as "cut-out Indian head handle spoons," these imitations are laughable when compared to actual examples.

caricature with haphazardly rendered arms and legs and stampwork about the back of the head less like a noble headdress than an unfortunate haircut. The desire for silver and turquoise had not gone away, just the ability to purchase fine examples as the public dug deep into empty pockets: "Indian jewelry" quality and the nation's economy spiraled downward together. The same designers who had once placed diamonds into gold for Tiffany and Company and Cartier began instead to set look-alike rhinestones into pot metal for costume jewelry companies such as Trifari.

Genuine Navajo spoons continued to be made, but not in great quantities and more often than not as objects to be found in "special occasion" demonstration venues, such as the Gallup Inter-Tribal Ceremonials. No longer regarded as souvenir trinkets, wrought Navajo spoons, while not "traditional"

A Navajo smith, working at an Inter-Tribal Ceremonial in Gallup, New Mexico, ca. 1930, hammers a spoon. Spoons awaiting final shaping of their bowls are scattered in the forefront. Photo by Mullarky, Museum of New Mexico 27349

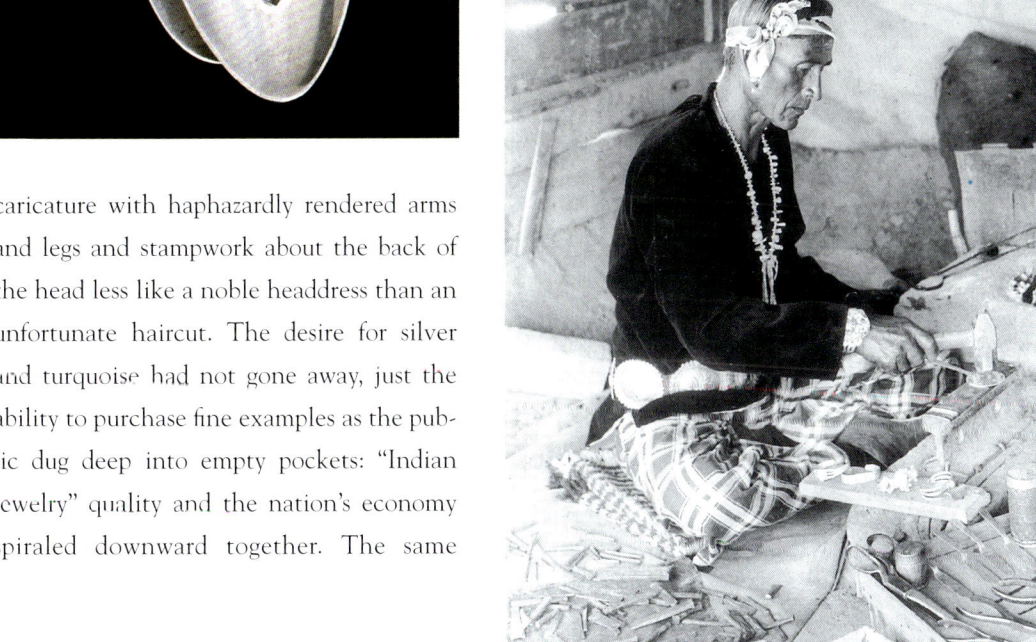

items, *were* items made in traditional methods and, as such, grew more prestigious. In 1935, two Navajo spoons were presented as a gift to the Bernisches Historical Museum in Bern, Switzerland.[7] Because the increased popularity of sheet silver in the 1930s meant less wrought silver items were being crafted, Navajo spoons gained renewed appreciation as beautiful objects unique to the American Southwest.

By the late 1930s, life in the United States was beginning to change with events leading up to World War II. The swastika, a design common to Navajo spoons and considered a goodluck symbol prior to Hitler's desecration of the motif, was eradicated from stamped Navajo and Pueblo silver beginning in 1938. Access to modern equipment also was beginning to significantly alter traditional silversmithing practices. By 1940, tools such as electrical wet-grinders, power drills, and mud saws with diamond blades for slicing through turquoise allowed for precision. Unfortunately, it was just such precision that eliminated the charm of many earlier Navajo spoons.

As train travel took a back seat to the automobile and Route 66, and as travel of any kind took a back seat to the Great Depression, the Fred Harvey Company resorted to mail order. In 1938, the year of the only catalog it ever produced, the Harvey Company positioned itself against machine producers with the statement: "No

INDIAN ARTS AND CRAFTS

This booklet, illustrating some of the most popular articles produced by the native craftsmen of the Southwest and Old Mexico, is offered in response to many requests from our patrons for something of this kind from which they could order by mail.

Until now we have hesitated to do this, chiefly because there is no standardization of style or design in genuine Indian products. No two articles of true native craftsmanship are exactly alike — a fact which we urge our patrons to bear in mind when ordering by mail.

All articles described in these pages are guaranteed to be genuine hand-made native products, excepting some novelties as specified.

We will gladly answer inquiries and furnish further information.

Fred Harvey

A loose page attributable to the 1938 Fred Harvey Company catalog. Although its trademarked Thunderbird image is featured here, thunderbird renditions within the catalog varied widely. Courtesy Skip Gentry.

two articles of true native craftsmanship are exactly alike—a fact which we urge our patrons to bear in mind when ordering by mail" (Author's papers, FHC, 1938). No souvenir spoons are offered, the souvenir spoon movement being then twenty years past, but Navajo salt spoons, baby spoons, demitasse spoons, cocktail/ice teaspoons, and coffee spoons are listed. None are figurative, however, and the spoon bowls are plain and handles are nondescriptly stamped. The only representational spoon is found in a salad set with a thunderbird motif stamped into the bowl of the spoon and integrated into the broad tines of the fork, although the thunderbirds are unlike the company's highly stylized, trademarked version of 1909. The company that brought the thunderbird to the Southwest had, thirty years later, stopped bothering to maintain the image introduced as its logo.

The imitation "Indian Design" jewelry and big-city "bench operations" (where, literally, Native employees at rows of benches stamped silver) were being met with increasing disgust. Witter Bynner, a poet and playwright active in the 1920s in Santa Fe's renowned artist colony, wrote a tirade published in *New Mexico Magazine* in 1936 titled "Designs for Beauty" (Bynner 1997, 30–33). Bynner knew whereof he spoke—his well-chosen personal jewelry collection is now owned by the Museum of New Mexico, housed at the Museum of New Mexico's Laboratory of Anthropology in Santa Fe. Bynner wrote: ". . . be cautious against factories. For factories can take art away from Indians and poetry out of people. And the fact is that many Americans, with their creative minds destroyed by the effects of factory products . . . prefer Indian jewelry made wholesale in factories set up by white traders where Indians sit in small rows and fabricate jewelry under white direction, with arrows and swastikas and thunderbirds provided in stamps by the factory keeper. An unimaginative and tinny jewelry is being imposed upon credulous and tasteless buyers in the name of Indians" (Bynner 1997, 33).

It was just such sentiment that inspired the formation of such organizations as the United Indian Trader's Association (UITA) and the U.S. Department of the Interior's Indian Arts and Crafts Board (IACB). Theirs were much-needed interventions because even in reputable stores imitation Indian jewelry was being sold side by side with genuine pieces. Maisel's Indian Trading Post, identified in UITA meeting notes as "an Albuquerque machine producer," features a handsome, handmade ingot profile salad set in its catalog number eight (circa 1930), on the same page as Arrow Novelty and H. H. Tammen-style pins. Even for well-intentioned buyers, the situation had become an indecipherable mess.

In 1938, the IACB inaugurated the stamping of "U.S. Navajo" and "U.S. Zuni"

on jewelry that was carefully inspected and deemed to be of superior craftsmanship, heavier weight, and traditional design. Numbers followed those marks, designating the trading post or Indian school where the items were crafted, but no Navajo spoons bearing those marks were found in the private collections reviewed for this book. There are two possible reasons for this. One, if spoons were not regarded as "traditional" items, they may have been rejected. The other possibility is that thin and delicate spoon handles were too fragile for the placement of a stamp, although extremely narrow row bracelets (silver bands set with a line of turquoise) have been found bearing such stamps. In a letter dated May 5, 1938, reporting on the application of the stamps to the IACB, Kenneth M. Chapman, a Museum of New Mexico anthropologist. wrote that he "found it impossible to mark certain deserving articles which present surfaces too small for the die" (Author's papers, IACB, 1938).

The letter also explains that "a total of 1500 specimens" had been rejected, with a total of 2,322 items approved for a stamp. Shops and trading posts using the stamp included the Fred Harvey Company in Albuquerque (U.S. Zuni 4 and U.S. Navajo 4: 194 items stamped), the Santa Fe Indian School (U.S. Navajo 60: 80 items stamped), and the Albuquerque Indian School (U.S. Navajo 50: 122 items stamped). In an interesting aside, Chapman wrote that "Except for C. G. Wallace [owner of the post at Zuni Pueblo, which agreed to the stamping of U.S. Navajo 2 on its items], all objected to the number 2, fearing it might be mistaken as designating second grade [second quality]" (Author's papers, IACB, 1938).

The same year that Chapman was adding stamps to jewelry, curio dealers were dropping stamps from theirs: swastika stamps. Use of the swastika by the German Nazi party brought an end to its use on Navajo spoons and other Native artworks even

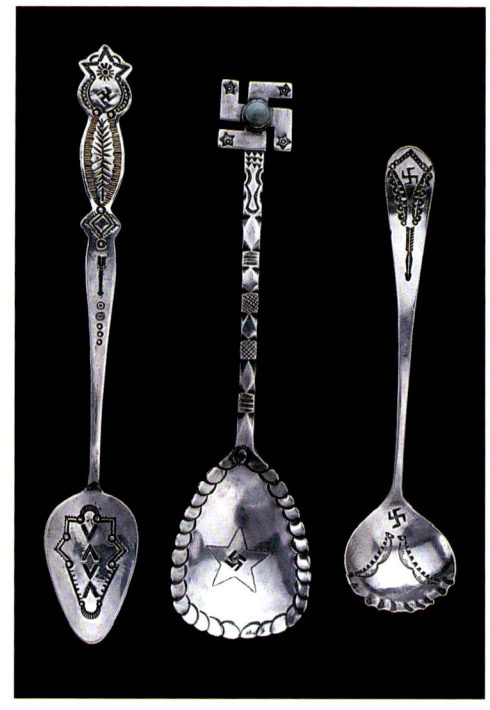

Three beautiful serving spoons featuring swastikas. Until Hitler altered the perception of the ancient whirling log symbol, it had been a popular motif on Navajo silver and textiles.

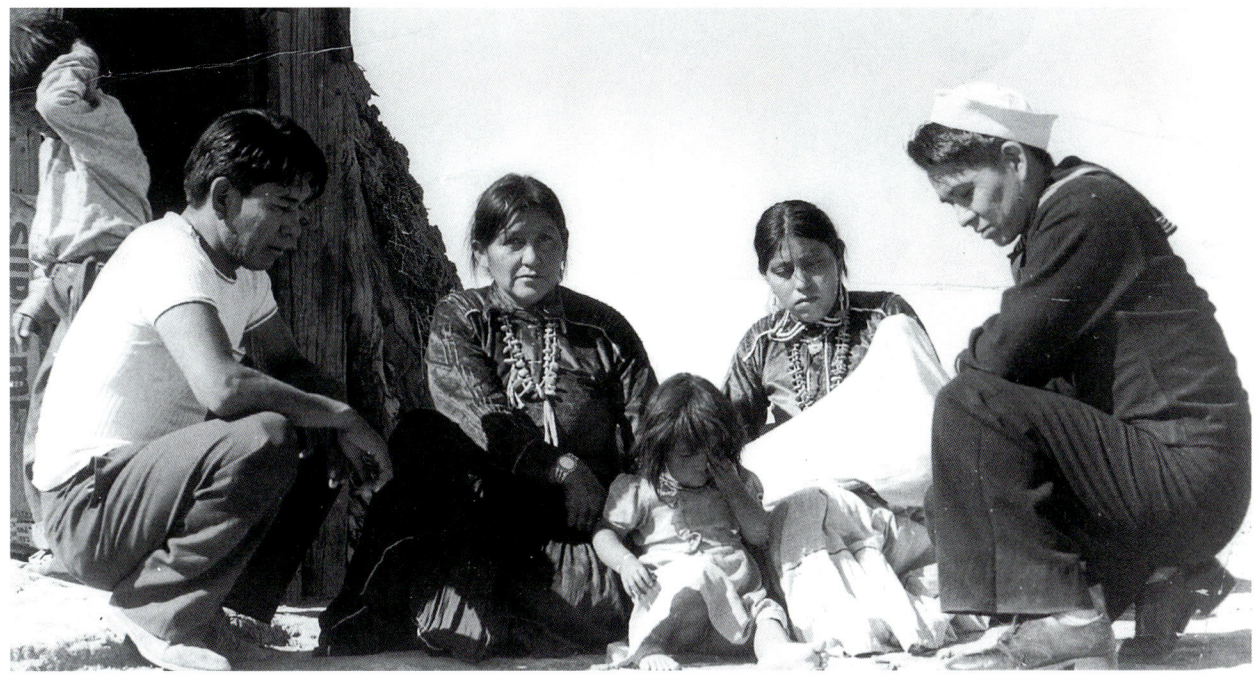

A Navajo family with their sailor son in wartime. Museum of New Mexico 30960.

before the United States' direct involvement in the war. One prominent Santa Fe dealer eliminated the swastika with such haste that, rather than redo catalog artwork, he simply blotted out one arm of the swastika from previous illustrations. The Fred Harvey Company, so encouraging of the use of the whirling log motif at the turn of the century, included no swastikas in its 1938 catalog.

Native American involvement in World War II was unprecedented. In 1940, the Navajo, the Papago, the Apache, and the Hopi drafted a document banning the use of the swastika symbol on their artworks, personal clothing, and sand paintings, and newspapers across the country ran photographs of the symbolic signing of the proclamation.

Thousands of Native Americans served in the armed forces, including the now renowned Navajo Code Talkers. Those who labored on the homefront in war-related factory jobs clustered around crackling shortwave radios with the rest of the world to hear the latest developments. The Navajo even had their own names for Adolf Hitler ("Mustache Smeller") and Benito Mussolini ("Gourd Chin").

Prior to Hitler's use of the swastika, the symbol had been a visually pleasing, ancient design representing perfection, happiness, pleasure, and good luck. Artifacts from many cultures, some dating several thousand years B.C., are decorated with swastikas in countries as diverse as the Far East and Middle East, Scandinavia, Greece, England,

and Italy. The swastika, usually called a "whirling log" in the Southwest, was connected to Native American culture because of its use in ceremonial sand paintings and the "Night Chant" or "Mountain Chant," and it was representative of the "Four Directions," a basic theme in Navajo ceremonies. Sometimes called the "swastika cross," the symbol's four arms also coincide with the revered number four, representing the four seasons, the four sacred mountains in Navajo country, and the four corners of the earth. While early Indian traders encouraged use of the swastika—particularly for Navajo textiles, it is often assumed to have been borrowed as a motif from Chinese rugs—the swastika already had its place in Native American culture.

The swastika's popularity on souvenir spoons had been primarily as a symbol of good luck. So beloved was this motif prior to World War II that inside the original nose cone of the *Spirit of St. Louis*, Charles Lindbergh's plane for his solo flight across the Atlantic in 1927, the plane's prep team had handpainted the swastika symbol as a good-luck token along with their signatures and the sentence: "We are sure with you." On exhibit at the National Air and Space Museum in Washington, D.C., the display's placard explained that "the figure in the center is a Native American good luck symbol" (Author's papers, NASM, 2000).

The Third Reich, of course, changed all that. Swastika spoons, one of the most prominent Navajo spoon motifs in the years 1900 to 1910, would no longer be produced after 1940.

It is a common misconception that the symbol has a good or bad meaning, depending on the direction of the arms. The belief that clockwise rotation of the "hooks" on the arms indicates good luck and, reversed, bad luck, is a fallacy. No matter the direction, the swastika's meaning was a traditionally positive one, and Navajo spoons used the motif in many variations. The direction of the arms was often no more than a design decision or a matter of whether a Native artisan was right- or left-handed.

"Whirling logs" whirl both ways atop Navajo spoon handles. Even the assorted commercial "Navajo Spoons" produced by the Charles M. Robbins Company for the 1904 St. Louis Exposition feature swastikas with both clockwise and counterclockwise arm direction. Whether or not such a notion may have been propelled in the postwar era because of Hitler's use of the motif, Hitler did subvert the swastika's meaning for all time.

Despite the war, the buying public continued its love affair with Indian objects or, in the case of factory-made jewelry, what they perceived to be Indian objects. Reestablishing respect and admiration for Navajo spoons and other jewelry would be an uphill battle made no easier by the end of the war. Most adult Navajos, in one way or another, were involved in World War II.

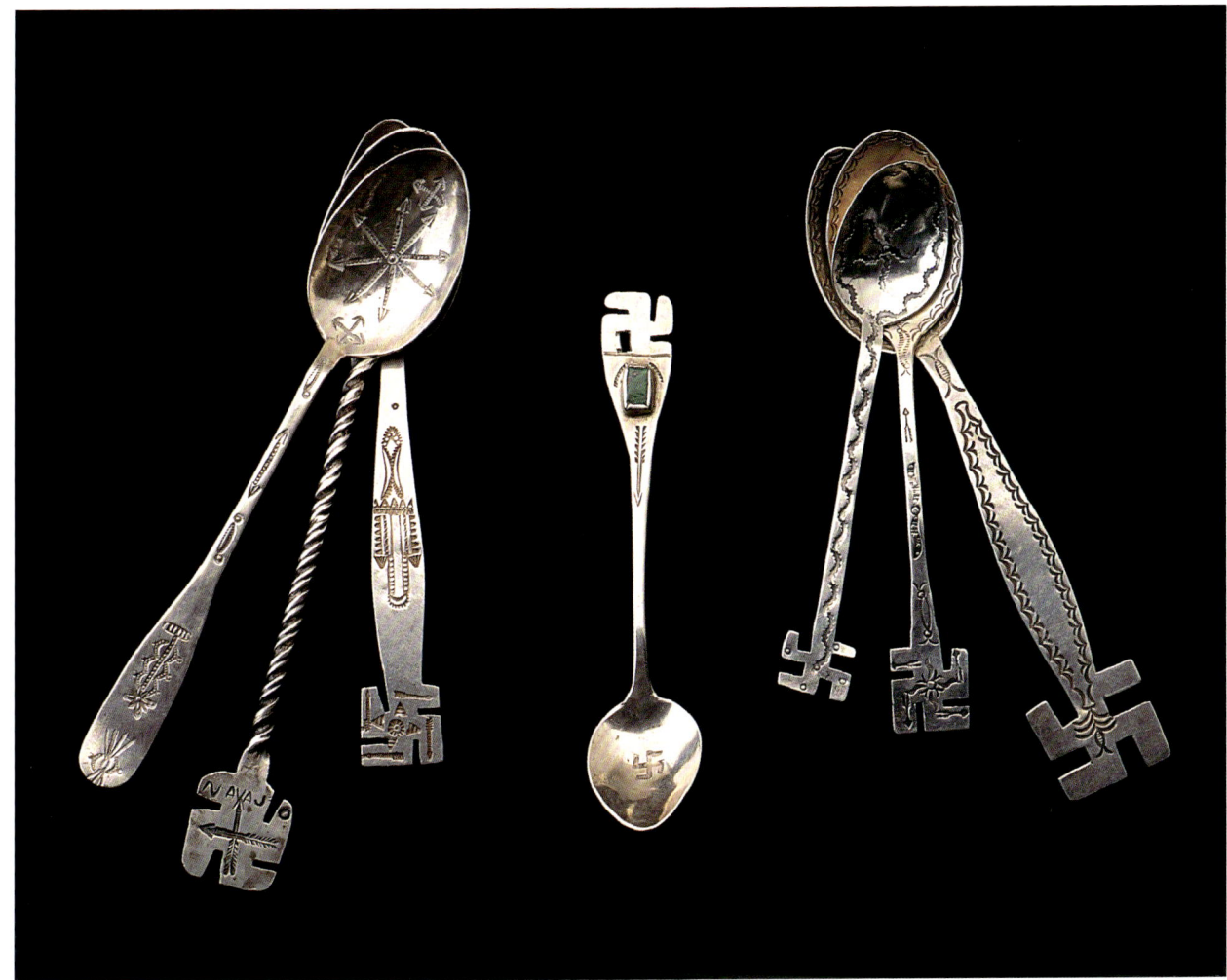

Men and women not sent to war overseas worked at home in war-related jobs, and it altered their life views. It was not such a big change, going from attaching nuts and bolts to war machines to attaching precut turquoise to prestamped silver so it could be called "Indian made." Having grown accustomed to punching a timecard and earning a paycheck, many took postwar jobs operating rollers and drop presses, stamping out

Note that the arms of the two swastikas on the 1895–1910 spoon shown at *center* whirl in opposite directions. The notion of arm direction denoting good or bad luck is erroneous.

"tourist" jewelry. Reservation homes became no more than sleeping quarters.

However, some returning veterans, having been exposed to other cultures through their war experiences, felt a renewed pride in their heritage. They sought to create Native crafts as "art"; subsequently, genuine Navajo spoons became well crafted. Matched designs in sets of six or eight spoons were a way for artist-smiths to show-

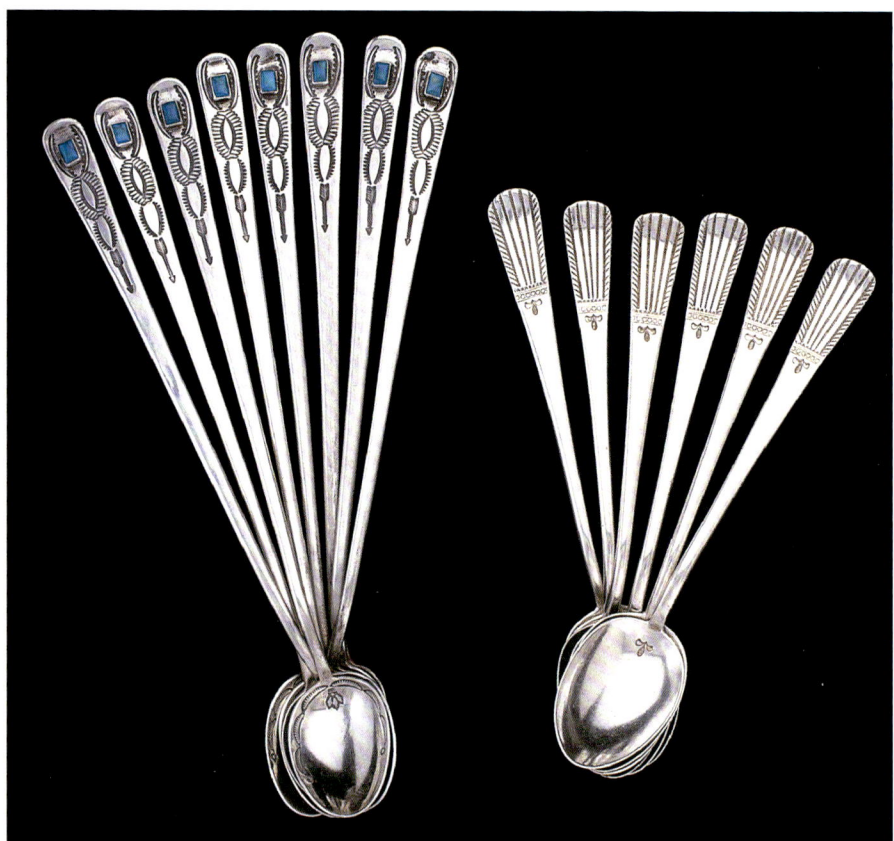

After World War II, spoons tended toward well-crafted sets. The set on the right is so pristine that it's hard to believe it's hand-stamped. Spoon bowls also became plain, making them more conducive to use and washing and replacing the stamped bowls of previous decades.

case consistency of excellence, as well as to ensure more income for time and talent: sets command much higher prices than single spoons.

The UITA, which assisted returning veterans in securing equal rights for Indians under the G.I. Bill of Rights and which even offered legal assistance if necessary, also worked hard to promote authentic Indian arts; one of its goals was that only genuine Indian handicraft be sold in national parks. A September 8, 1945, UITA "General Bulletin" included the statement: "Ever since its formation in 1931, the policy of this Association has been to encourage and perpetuate genuine Indian arts and crafts. This policy has always placed us in direct opposition to machine production. Through this organization . . . we have built an undisputed reputation of genuineness for the Indian handicrafts marketed in this area" (Author's papers, UITA, 1945).

On March 18, 1946, as the IACB had in 1938, the UITA implemented its own stamping system after seeking approval of the IACB on its proposed standards and mark. UITA was a membership organization: Posts and stores signed on, paid dues,

and agreed to certain terms and restrictions, and then each location was given a number for identification purposes. That assigned number was stamped onto jewelry and Navajo spoons after the initials UITA to identify where the item had been purchased.

UITA standards were stringent. Meeting notes tersely state that any stamps used to decorate silver were "to be entirely handmade by Navajo or Pueblo Indian craftsmen with no tool more mechanical than hand tools and vise" and were to be applied to silver "only by Navajo or Pueblo craftsmen with the aid of nothing other than hand tools" (Author's papers, UITAS, 1946). Use of "hand presses, foot presses, drill presses, power presses, drop hammers, power punches, power dies, power cutting machines, milling machines, lathes and similar equipment" was prohibited (Author's papers, UITAS, 1946). Any equipment that could be used to "shape, design, slit, stamp, blank, or cut out an object" was also prohibited (Author's papers, UITAS, 1946). Even prefabricated ring shanks, bezels (the silver edge that holds a stone in place), and twisted wire were prohibited.

Use of the stamp was met with great success. Minutes from a UITA meeting held eight months later declare: "almost forty active members are now licensed and are using the Association mark and stamp of genuineness on Navajo and Pueblo silver" (Author's papers, UITA, 1946). For collectors and dealers, although it is important to

Two spoons and a salt shovel, with a hand-twisted wire handle, bear United Indian Trader's Association (UITA) marks first used in 1946.

remember that UITA-marked spoons date no earlier than 1946, such spoons are well crafted and made in traditional methods.[8] The most common UITA mark found on Navajo spoons is from Borrego Pass, the mark of UITA 6—either Borrego Pass had a prolific spoonmaker or a prolific spoon stamper.

By the time the UITA began marking pieces, Mexican jewelry design coming out of the Taxco, Morelos, area had achieved notoriety. Although made in traditional Navajo methods, some UITA-stamped spoons reflect Mexican influence. Sets of UITA iced teaspoons found in several collections have dimensional deer heads atop the handle, their snouts protruding at a distance from their antlers, and resembling Mexican deer and antelope pins popular

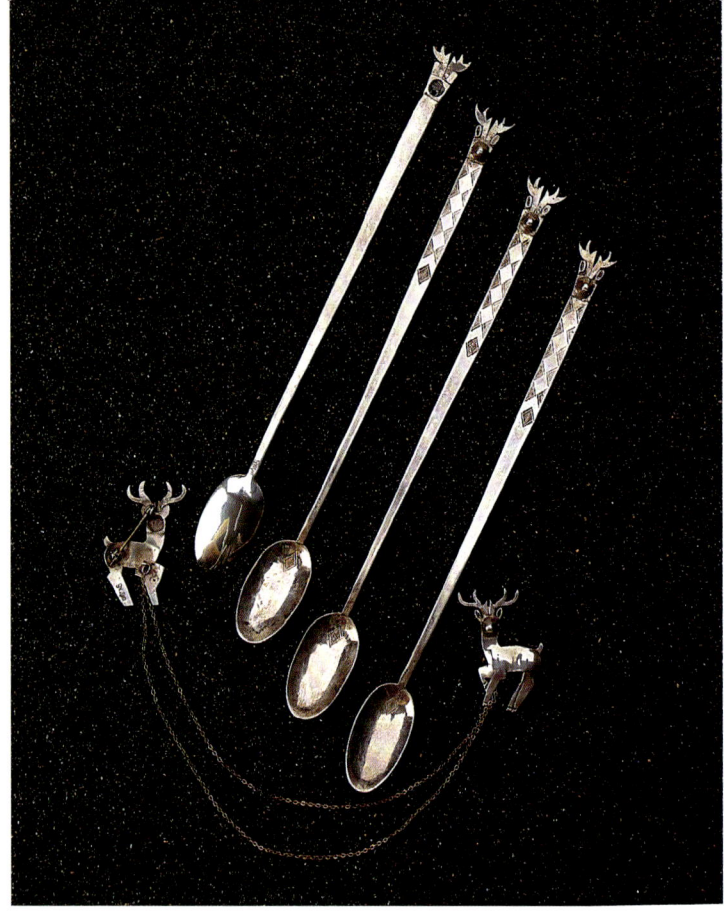

Iced tea spoons and a sweater pin set with similar deer heads, both stamped UITA 6 (Borrego Pass).

at that time. Despite the preponderance of animal motifs in Middle Phase Navajo spoons, dimension was never one of their characteristics.

Mexican jewelry was always signed or initialed. There was also a national trend toward marked "studio jewelry" since the G.I. Bill encouraged would-be artists to study jewelry design at colleges and universities. These influences, as well as the marks of such organizations as UITA and the IACB stamps of U.S. Navajo and U.S. Zuni, paved the way for Native silversmiths to hallmark their own pieces. Navajo spoons became signed "works of art."

The only profile handle included in the 1938 Fred Harvey Company catalog appears not on a Navajo spoon but on a "paper knife" (letter opener). If patient enough to hammer out and hallmark a spoon, a Native artisan was not going to create an outdated image he found personally demeaning. After World War II, artists chose to work with nonrepresentational decorative designs or to explore motifs that did not disrespect their own culture. In postwar America, profile spoons vanished completely.

Anonymity also vanishes. Because First Phase and Middle Phase Navajo spoons predate the era of hallmarking, most makers remain "anonymous." However, signing silver pieces with a personal hallmark ended the dilemma of distinguishing "Navajo" spoons from spoons made by smiths from other pueblos, such as Joe H. Quintana of Cochiti Pueblo. Working anonymously in the bench shops of Santa Fe and Albuquerque in the 1930s and 1940s Quintana, like so many others, produced Navajo-style jewelry. Only after hallmarking his pieces did Quintana gain renown for his work, which included spoons.

Navajo spoons at last had come full circle: from isolated silversmiths anonymously producing imaginative, one-of-a-kind spoons to factory operations haphazardly cranking out "Indian design" spoons by the hundreds to hallmarked spoons produced by Native craftspeople now regarded as artist-jewelers.

epilogue
Every Spoon Tells a Story

Now that Navajo spoons are known to be First Phase and early-twentieth-century objects, a new area of focus exists for collectors, dealers, and museums. Previously dismissed as "oddities," they are, oddly enough, one of our last links to early Southwest silverwork. Navajo spoons offer museums a visually exciting starting point for discussions of many aspects of life in the changing Southwest.

It is nearly impossible today to find Navajo silver made before 1900, even in museums, because the Navajo traditionally buried their dead with their best silver pieces. For that reason, many Navajo today do not "trust" old jewelry—the appearance of an exemplary early piece raises suspicion. Navajo spoons, fortunately, are above such suspicion. While intertwined in technique with jewelry, they are not items that held any personal meaning to the Navajo. Made exclusively for sale to others, they offer a fresh foray into the beginnings of silversmithing, from which so much personal jewelry is lost. A spoon's simple, consistent form provides an excellent canvas from which to study the evolution and perfection of skills.

Throughout this book, the word "common" has been used to describe certain motifs or engraved dates. This should not be taken as an implication that Navajo spoons are common. They're not. The heyday of old-style Indian traders and the fad of souvenir spoon collecting were both long past by 1920. The ensuing Great Depression and World War II kept production of utilitarian Navajo spoons to a minimum, and the

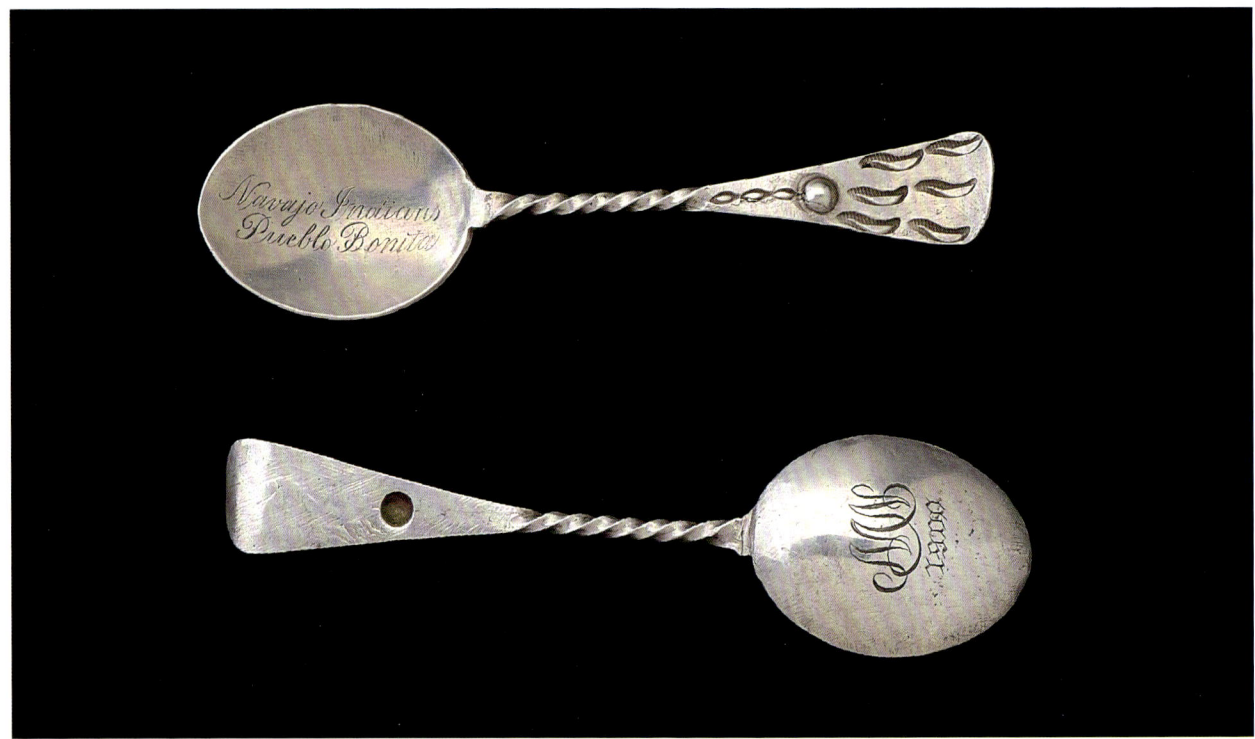

The misspelling of Bonita, which is the feminine form of "pretty" in Spanish, was likely an error on the part of the Anglo engraver. Richard and Marietta Wetherill's location was known as Pueblo Bonito.

spoons made after the war were very different from the styles that had been wrought before. Navajo spoons underwent three significant but brief periods within sixty years: exploratory and decorative utilitarian spoons (for Victorian tables) to souvenir spoons (whimsical motifs to tantalize tourists) to artists' spoons, often sets of spoons, intended for actual use.

The engraved details found on turn-of-the-twentieth-century Navajo spoons provide information valuable to the dating and evaluation of other early jewelry, and such engraving can be trusted because of the absence of comparable engraving skills in today's marketplace. Not even fakery, a serious problem plaguing even the most reputable and knowledgeable dealers of Native American art, is of concern with spoons. Having been previously ignored in books and being so labor-intensive to make in the traditional methods, no one has bothered with Navajo spoon knockoffs. In order for fakery to be fruitful, objects must command a high enough price to warrant production. Given their resale value, spoons have not, at least until now, been deemed worthy of the effort.

Beyond their monetary value, for those willing to go to the trouble of investigating their details, Navajo spoons can reward collectors with a peek into the past. Stories

unfold. The story behind this Anglo-engraved Navajo spoon touches upon most every topic presented in this book, with an ill-fated Buick and even murder thrown into a tragic ending.

Richard Wetherill, the oldest of six children, was raised on a ranch in Mancos, Colorado. After his parents settled in the Four Corners region in 1880, he and a brother discovered Cliff Palace, within what is now Mesa Verde National Park, in 1888. When the boys returned home with a collection of relics, their excited father wrote to the Smithsonian Institution. The Smithsonian officials replied that they had no money to buy the boys' findings and would only accept it as a donation. After being exhibited in Denver and Durango, Colorado, the collection was purchased by the Denver Historical Society. Shortly thereafter, the boys began collecting artifacts from cliff houses at Mancos Canyon. This new grouping was exhibited at the World's Columbian Exposition in Chicago in 1893.

Having now earned a reputation for their archaeological pursuits, the Wetherills were approached by Talbot and Fred Hyde, heirs to their grandfather Benjamin Babbit's BaBo soap fortune, and were offered financial support from the Hyde Exploring Expedition (HEE) for the American Museum of Natural History in New York. A few years later, Richard married Marietta Palmer, and the newlyweds settled at Pueblo Bonito, located in New Mexico's staggeringly beautiful Chaco Canyon.

Richard and Marietta operated a trading post at Pueblo Bonito, with their homestead often serving as a gathering place for Navajo events. By 1899, Richard's brother, John, and his wife, Louisa, had visited Pueblo Bonito once or twice, getting a feel for the life-style. When the Hyde brothers requested that John and Louisa Wetherill run their newly purchased trading post at Ojo Alamo for them, the couple accepted the offer; it would be the first of their several trading posts and locations.

Richard filed his first homestead claim on May 14, 1900, but accidentally forgot to include Pueblo Bonito. He filed again a few months later, correcting the mistake, but his vigorous removal of artifacts and his plans to lay railroad tracks through Chaco had begun to raise eyebrows with federal authorities. Richard's second claim triggered accusations of vandalism, and he was ordered to cease excavations. Nevertheless, he was allowed to remain living at Pueblo Bonito with Marietta.

His digging halted, Richard focused his attentions on the distribution of Navajo crafts. He started a rug-weaving enterprise for the Navajo women at Pueblo Bonito and began selling merchandise through many locations across the country. His New York

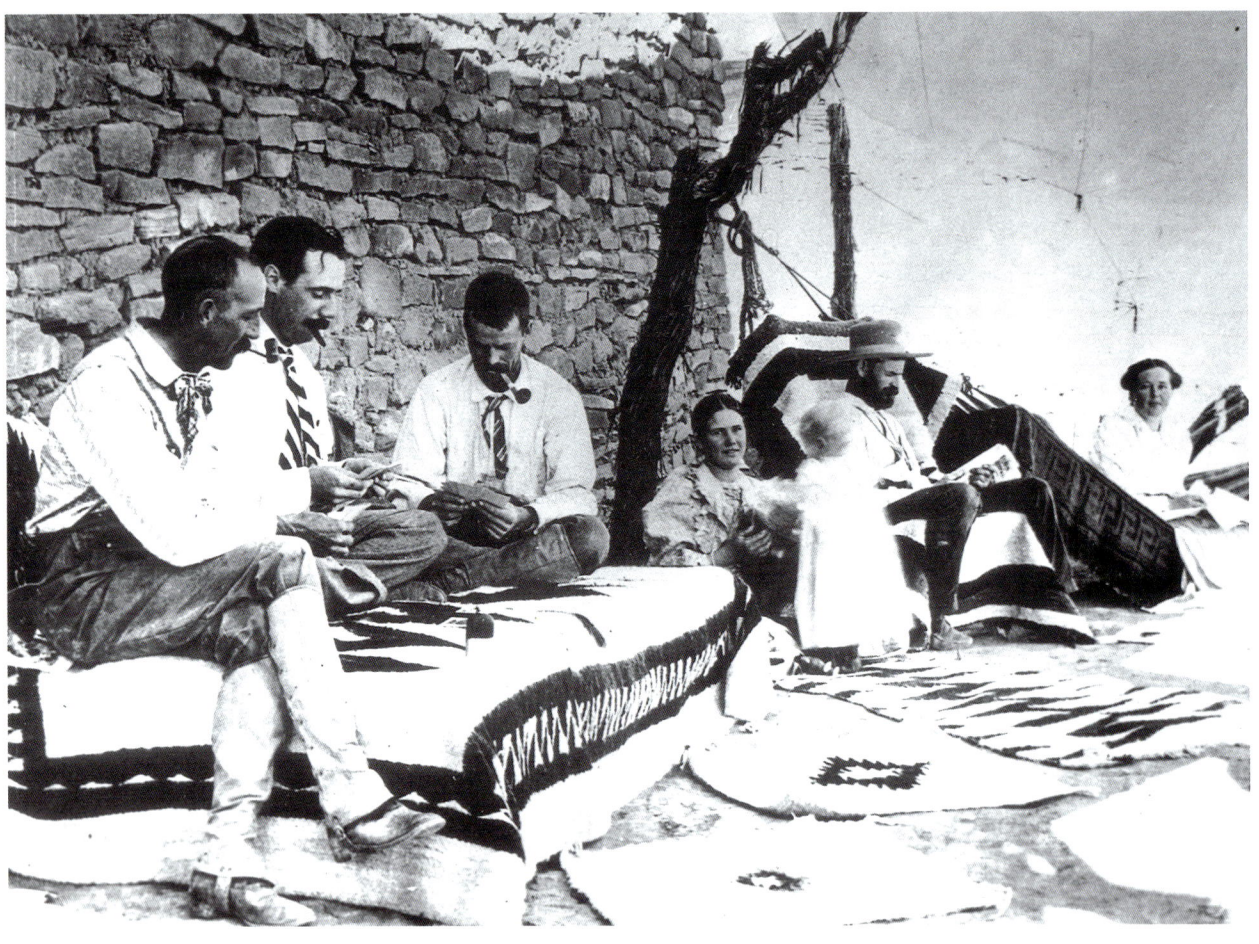

Richard and Marietta Wetherill, shown with Richard Jr., and their friends and family at Pueblo Bonito in 1900, the date engraved on the spoon shown on page 104. Frank McNitt Collection, State Records Center and Archives 6564.

City connections reputedly brought Navajo textiles to Times Square as early as 1901.

The year 1902 was not a good one for Richard and Marietta. Richard was permanently forbidden from excavating, and his homestead claim was suspended. He continued to operate the store at Pueblo Bonito, however, and the couple spent the next year preparing for their exhibit at the Louisiana Purchase Exposition held from May to December of 1904 in St. Louis. Richard took sixteen Navajos, most of whom had never ridden on or even laid eyes on a train, ahead of Marietta to get things set up and to help the Navajo men and women become accustomed to the crowds and the alien environment. Theirs was a large corner concession located in the Manufacturing Building—Marietta estimated its size at about fifty feet by a hundred fifty feet—containing a replica of a cliff dwelling at one end. Plans to include authentic Native

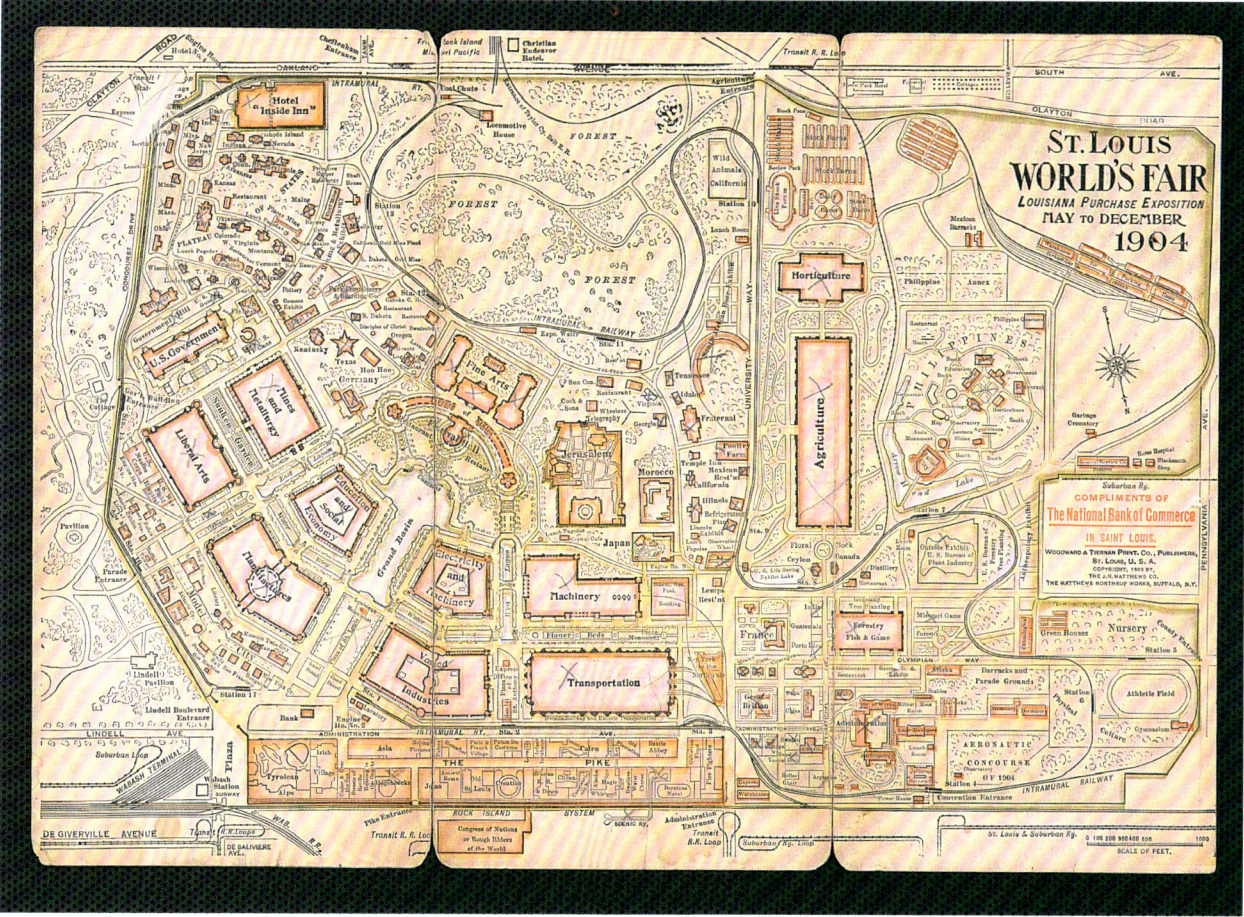

World's fairs and expositions were enormous undertakings. At the Louisiana Purchase Exposition held in St. Louis in 1904, the Wetherill booth was located in the Manufacturing Building, and the Fred Harvey Company's display was in the Anthropology Building at the lower right. The pencil marks on the map are leftovers from the original attendees, who must have X'd off the buildings as they toured the premises. Note the presence of the New Mexico building at the upper left, although New Mexico would not become a recognized state for another eight years, in 1912.

dancing, with the Navajo men wearing only breechcloths, were thwarted by the law and by modesty: the dancers performed in overalls.

Regarding their sales inventory, Marietta recalls: "We'd been around enough to know we needed to have a lot of small items for people to buy" (Gabriel 1992, 183). Most of their inventory was made ahead of time, including moccasins and textiles; Marietta recalled that Navajo rugs were already

draped around their booth—"There wasn't one that was more beautifully arranged and colorful than ours" (Gabriel 1992, 186)—when she arrived. Navajo spoons are not specifically mentioned in her recollections of their offerings, but given that their silversmiths did create rings, necklaces, earrings, and bracelets, with such an ambitious endeavor it's unlikely that the Wetherills would have missed an opportunity to sell "real" Navajo spoons. The souvenir spoon movement was at its peak, with the Robbins Company producing its commercial "Navajo Spoons" for the 1904 exposition.

The Southwest was a prominent feature that year in St. Louis. Although New Mexico would not become a recognized state until 1912, it had its own building in the northwest corner of the grounds. In the Anthropology Building, far removed from the Wetherills' booth, the Fred Harvey Company received glowing media attention for its extensive "scientific" displays. Outshining even the Smithsonian Institution's collections, the Harvey Company received the "grand prize for the best ethnological exhibit . . . and the grand prize for the Navajo blanket exhibit" (Howard and Pardue 1996, 63). Despite being overshadowed by their competition, the Wetherills fared well enough with their sales that they rather impulsively purchased an automobile upon their return home.

Marietta recounted the following tale to Silver City, New Mexico, newspaperman Lou Blachly: "After we came back from the World's Fair in St. Louis, Mr. [Fred] Hyde and Mr. Wetherill bought a Buick in Albuquerque and they thought they could just drive it to Pueblo Bonito. They got as far as Corrales just outside Albuquerque and from there they pulled it with a team of mules . . . it never moved from where it was drawn in there with the mules. That was the first automobile that came to Chaco and the last while I lived there. There wasn't a place where an automobile could go. The Navajo called the car 'get-there-I-guess'" (Gabriel 1992, 109).

Richard surrendered his claim on Pueblo Bonito proper three years later, in 1907, at the time of the national park designation. Controversy continued to accompany him to his death, by bullet wound, on June 22, 1910, while out driving cattle. The shot was fired by a Navajo man, and speculation on motive ran the gamut from a land dispute to a jealous paramour. A Navajo runner carried the news of Wetherill's death to his brother, two hundred miles away. Marietta, finding herself a financially strapped widow with five children, contacted the venerable Fred Harvey Company to purchase Pueblo Bonito's textiles, baskets, and her beloved personal collections.

This is a remarkable spoon, but others, equally remarkable, await our discovery. Forgotten in drawers or buried deep in auction box lots, Navajo spoons are still very findable and their secrets and stories accessi-

ble, even for the casual antiques enthusiast. Being mere spoons, they don't call attention to themselves as do squash blossom necklaces or heavy ingot bracelets laden with turquoise. They'll turn up where you least expect them, often mixed carelessly into piles of commercial flatware.

"I think that one's handmade," said a flannel-shirted fellow perched on the back of his pickup truck, his farm tools and chipped ceramics and piles of children's clothing spread out on a card table at a Midwest flea market, when I held up a profile spoon to ask the price.

When you find a Navajo spoon of your own, take a moment to imagine the journey it took to end up in your hands. Turn it over, and think of the Native silversmith hammering out the handle and bowl from a Mexican peso or ingot of melted coins. Envision for a moment the dusty time and place from whence it came, and imagine the person and the circumstances under which it might have been first purchased. And as you brighten it with a bit of polish, see if it's engraved with a date or a name.

It just may tell you how many chapters of history are reflected in its silver surface.

notes

1. Charles F. Lummis, an innovative writer, researcher, and Southwest personality, founded the museum in 1911. A photo of one of his scrapbook pages, never before published, is included on page 33.

2. The liberty shield was featured on the chest of federal eagles used on silver half-dollars and on other nineteenth-century coins, including three-cent silvers. Introduced in 1851 and commonly referred to as "trimes," three-cent silvers were the tiniest coin ever produced.

3. As discussed in chapter 3, Indian trader J. L. Hubbell's 1902 pamphlet would include Navajo spoons set with turquoise. However, this was only because Hubbell took it upon himself to order turquoise from Persia in the 1890s.

4. The Certificate of Incorporation, never before published, has been acquired by the author.

5. At the time of statehood, Oklahoma was commonly referred to as "Indian Territory." The name "Oklahoma" comes from the Choctaw Indian words *okla* for "people" and *humma* for "red" because of the government's use of the state for the relocation of Native peoples beginning in 1834. Many commercial souvenir spoons with Indian motifs are engraved with the state name of Oklahoma. The mad dash for real estate known as the Oklahoma Land Rush of 1893, occurring during the initial craze of souvenir spoon collecting, may also be partly responsible.

6. Such discrepancies are a frustrating reality for researchers because Native languages are oral, not written. Spellings don't translate consistently to the English alphabet; therefore, spoken names and words are subject to the ear, aptitude, and personal interpretation of the person recording the information.

7. The two spoons were donated by "Consul Paul." No further accession information was available.

8. For a listing of UITA numbers and locations, see the appendix

appendix

This list is intended to assist dealers and collectors with the identification of United Indian Traders Association (UITA) spoon origins as well as other UITA items. The numbers listed below correspond to the numbers that were stamped alongside the UITA mark on silverwork: "UITA 6," for example, means that a spoon met the strict UITA silverwork requirements and was then sold at the Borrego Pass Trading Post by the owner at that time, Don Smouse. Some numbers list only the name of the UITA member and not the name of a specific post or location. The Fred Harvey Company, for instance (UITA 4), would have sold their UITA items at diverse locations.

The passage of time has contributed to the loss of many assigned UITA numbers, but detective work by Native American art and jewelry dealers has tentatively matched the following members and numbers. Some names have been taken directly from UITA membership lists, and others have been compiled from oral recollections, handwritten notes, or loose UITA paper sale tags that were attached to nonjewelry items stating, "Guarantees this to be a genuine Indian Handmade Article." Later research may therefore yield some discrepancies, but in the interest of supplying a starting point for future connections or confirmations, here is the best available information to date:

1: Gallup Mercantile, New Mexico
2: C.G. Wallace, Zuni New Mexico
3: Toadlena (Two Grey Hills) Bert Staples & Dean Kirk,
4: The Fred Harvey Company
5: Kirk (?)
6: Don Smouse (Borrego Pass Trading Post)
8: Claude Bowlin, Blue Water, New Mexico
12: Packard or Lippincott
13: Shiprock Trading
16: Lobe
17: Hubbell: Ganado, Oraibi, Moencopi locations
18: Bob Cousins—Gallup, New Mexico or Cousins Bros. in Pine Springs
21: Bob Cousins–Al Packard
22: Kirk, Manuelito New Mexico
26: Russell Fouly (?)
27: Russell Fouly
29: Hubbell: Winslow, Arizona

selected references

Adair, John. *The Navajo and Pueblo Silversmiths*. Norman: University of Oklahoma Press, 1944.

Bailey, Garrick and Roberta Glenn Bailey. *A History of the Navajos—The Reservation Years*. Santa Fe, N. Mex.: School of American Research Press, 1986.

Bedinger, Margery. *Indian Silver Navajo and Pueblo Jewelers*. Albuquerque, N. Mex.: University of New Mexico Press, 1973.

Bednersh, Wayne. *Collectible Souvenir Spoons: Identification and Values*. Paducah, Ky.: Collector Books, 1998.

Bennett, Edna Mae. *Turquoise and the Indian*. 3rd ed. Chicago: The Swallow Press, 1970.

Bernstein, Alison R. *American Indians and World War II, Toward a New Era in Indian Affairs*. Norman and London: University of Oklahoma Press, 1991.

Bishop, Robert and Patricia Coblentz. *The World of Antiques, Art, and Architecture in Victorian America*. New York: E. P. Dutton, 1979.

Bourke, John G. *The Snake-Dance of the Moquis of Arizona*. New York: Charles Scribner's Sons, 1884. Reprint. Chicago: The Rio Grande Press, 1962.

Bridwell, Margaret M. "Tea Caddy Spoons." *Antiques* 87 (1965): 528–531.

Bynner, Witter. "Designs for Beauty." *New Mexico Magazine* (reprint) 75, No. 8 (1997): 30–33.

Byrkit, James W. *Charles Lummis Letters from the Southwest*. Tucson, Ariz.: The University of Arizona Press, 1989.

Frank, Larry with the assistance of Millard J. Holbrook II. *Indian Silver Jewelry of the Southwest, 1868–1930*. West Chester, Pa.: Schiffer Publishing, Ltd., 1990.

Gabriel, Kathryn. *Marietta Wetherill, Life with the Navajos in Chaco Canyon*. Boulder, Colorado: Johnson Books, 1992. Reprint. Albuquerque: University of New Mexico Press, 1997.

Gillmore, Frances and Louisa Wade Wetherill. *Traders to the Navajos*. Albuquerque: University of New Mexico Press, 1953.

Howard, Kathleen L. and Diana Pardue. *Inventing the Southwest, the Fred Harvey Company and Native American Art.* Flagstaff, Ariz.: Northland Publishing Company, for the Heard Museum, 1996.

Kline, Cindra. "Indian Ways, Charles (Ruling Hissun) Eaves." *Rocky Mountain Spirit 7* (Winter 2000)7: 9–14.

Laboratory of Anthropology. "Southwestern Indian Jewelry," by Nancy Fox, in *I Am Here. Two Thousand Years of Southwest Indian Arts and Culture.* Santa Fe: Museum of New Mexico Press, 1989.

Lockwood, Charles. "Baedeker's United States." *United Airlines' Hemispheres* (November 1999): 82–87.

Logsdon, Paul. *Ancient Land, Ancestral Places: Paul Logsdon in the Pueblo Southwest.* Santa Fe: Museum of New Mexico Press, 1993.

Lummis, Charles F. *Manuscript Collection, Scrapbook 1 – "The Land of Poco Tiempo, Vol. 1, Illustrated."* Los Angeles, Calif.: Southwest Museum, Braun Research Library permanent collections, 1888: 41–45.

———."The Southwestern Wonderland: Our First American Jewelers." *The Land of Sunshine 2* (1896): 54–57.

Moore, J. B. *United States Indian Trader, A Collection of Catalogs Published at Crystal Trading Post 1903–1911.* Albuquerque, N. Mex.: Avanyu Publishing Inc., 1987.

McNitt, Frank. *The Indian Traders.* Norman: University of Oklahoma Press, 1972.

Newcomb, Franc Johnson. *Navajo Omens and Taboos.* Santa Fe, N. Mex.: The Rydal Press, 1940.

Rainwater, Dorothy T. and Donna H. Felger. *American Spoons Souvenir and Historical.* Camden, N.J. and Hanover, Pa.: published jointly by Thomas Nelson Inc., and Everybody's Press, 1968.

Rushing, W. Jackson. *Native American Art and the New York Avant-Garde: A History of Cultural Primitivism.* Austin: University of Texas Press, 1995.

Stutzenberger, Albert. *The American Story in Spoons with an Historical Sketch of the Spoon through the Ages.* Louisville, Ky.: Gibbs-Inman Co., 1953.

Washington, William DeHertburn. *Progress and Prosperity.* New York: The National Educational Publishing Company, 1911.

Winchester, Alice. "Editor's note." *Antiques* 87 (1965): 477.

Witmer, Linda F. *The Indian Industrial School Carlisle, Pennsylvania 1879–1918.* 2nd ed. Camp Hill, Pa.: Plank's Suburban Press, Inc., for the Cumberland County Historical Society, 2000.

Young, M. Ada. "Editor's note." *Antiques* 87 (1965): 477.

AUTHOR'S PAPERS

The author's personal papers comprise a collection of original and photocopied catalogs, circulars, inventories, meeting minutes and member lists, exhibition notes, personal correspondence, and archival advertisements. This material is referenced as follows:

ANC: Arrow Novelty Company
CIS: Carlisle Indian School
CR: Candelario's Original Old Curio Store records
DL: Daniel Low, silversmith
FHC: Fred Harvey Company
FL: Francis Lester, curio dealer
IACB: Indian Arts & Crafts Board
ISC: International Silver Company
JBW: Jonathan Batkin, Director, Wheelwright Museum of the American Indian
KH: Kathleen L. Howard, co-author *Inventing the Southwest, the Fred Harvey Company and Native American Art*
NASM: National Air and Space Museum, Smithsonian Institution
TLIS: The Little Indian Shop
UITA: United Indian Trader's Association
UITAS: United Indian Trader's Association Silver Standards
VIACS: Vaughn's Indian and Curio Store

ANC catalog, n.d.
ANC Certificate of Incorporation, 1917
ANC amendment to list of officers, 1931
CIS promotional brochure, n.d.
CR loose page inventory list, 1908
CR sales brochure, 1908
DL print ad, 1891
FL mail order catalog, 1906
FHC mail order catalog, 1938
IACB letter, 1938
ISC: ad, 1927
JBW: e-mail, 1999
KH: e-mail, 2001
NASM personal notes from visit to exhibits, 2000
UITA minutes, 1945
UITA minutes, September 1945–November 1946
UITAS jewelry requirements, 1946

index

Note: References to figures and captions appear in **bold**.

Acoma Pueblo, 16, **35**
Alaska Yukon Pacific Exposition of 1909, 56, **56**
Albuquerque Indian School, 98
Albuquerque, New Mexico, 52
All American Indian spoons, 79
almond scoops, **20**
Alvarado Hotel, **61**, **62**
amateurs versus experts, 17–18
animal ingot spoons, **19**
appliqué decoration, 40
arrow motif, **53**; notched arrowhead handle, **89**
Arrow Novelty Company, 54-55, 59, 68, 97; Depression era, 94
art, crafts as, 101–02
arts and crafts, 20
Atchison, Topeka and Santa Fe Railway, 22
automobile age, 60
Autry Museum, 18, **30**

baby spoons, 97
basket-star design, 50, **50**
Bearer of Happiness, thunderbird as, 68
bear motif, 74, **75**
bench operations, 97, 104
Bernisches Historical Museum (Switzerland), 96
berry or nut spoons, 33, **34**
bird motif, 69; compilation stampwork, **80–81**; handles, **21**; owls, 59, **170–71**
boarding schools, 57-59
bonbon spoons (bonbonieres), **20**, 34
Borrego Pass, 103, **104**
Bosque Redondo, 40
Bourke, John G., 69
bracelets: Carlisle Indian School, **57**; embossed, 85; stamps for, 98
Bright Angel Lodge, 66
buckles, 85
bug motif, **75**
butterfly motif, **75**
butter knives, **32**, 76
buttons, 23, 34-35, **34**
Bynner, Wittner, 97

Candelario, Jesús Sito, 52
Candelarios' Original Old Curio Store, 51–52, **52**
candy cane design, **48**
Carlisle Indian School, 57, **57**, 58

Cartier, 95
cast spoons, 87–88, **88**
catalogs: Clarke, 52, **53**; Depression era, 94–95; Francis E. Lester Co., 68–69; mail order, 48-51; Maisel's Indian Trading Post, 97; trading post, 45, 46, 47, 48
cat on handle with chicken, 16, **16**
Chaco Canyon National Monument, 64
Chapman, Kenneth M., 98
Charles M. Robbins Company, 27, 100, 110
cheese scoops, **31**, 34
Chicago World's Columbian Exposition, 26–27; Mancos Canyon artifacts, 107; souvenir spoons, 64; Tiffany and Company, 30
Chit-chi, 15; described, 16; jewelry, 22; snake bracelet; ostracized, 74; sugar shell, 22, 23; sugar spoon, 16; table silver set, 23
Christmas tree design, **48**
Clarke, John Lee, 52, **53**
classic period, 19, 40
cloud-and-rain design, **73**
Cochiti Pueblo, 86, 104

cocktail spoons, 92, 97
Cody, Buffalo Bill, 82
coffee spoons, 30, 47
coinage: coin motifs as design, 16; hammering progression, **77**; Indian head pennies, 82; Mexican, 86, **87**, **88**; Morgan silver dollars, 86; shield nickels, 86–87; slugs of coin silver, 88, **88**, 90; U.S., 86
Colter, Mary, 62
commemorative spoons, 64; Victorian flatware, 19
"common", use of word, 105
compilation stampwork, 79, **80–81**; bird motif, 80-81
Comstock Lode, 86
corn motif, **24**
Cotton, Clinton N., 46
cream ladles, 34
Crystal, New Mexico, 46
Crystal rugs, 47
cucumber server, **90**
curio crafts: tourism, 20
curio traders, 51–52, **52**, 55
cutout handle designs, 88, **89**

dating silver objects, 63–64, 106
DeCora, Angel, 58-59
deer head motif, 103–04
demitasse spoons, 97

Index 115

Department of the Interior, 97
dies, 41, 43
Dietz, William ("Lone Star"), 57–59
double eagle motif, 89
double-headed spoon, 21

eagle-and-snake motif, 16; initials on spoons, 36
Eaves, Debra ("Ruling Hissun"), 83
elephant motif, 74, 75
embossing technique, 84, 85
engraving, 36–37, 61–65; dating silver objects, 63–64, 106; decline, 76; initials on spoons, 36, 37; lettering, 63; ornate "A," 25; styles from early 20th century, 27
enthusiasts, 17–18
experts versus amateurs, 17–18
eyestrain, 78

fakery issue, 106
First Phase silverwork, 40; early techniques, 93; stampwork, 31
fish symbol (Christian), 55
fluting, 23, 34, 34
Fort Defiance, 45
Four Directions, 100
Francis E. Lester Company, 48, 68–69; swastika motif, 50, 50; teaspoon, 50; thunderbird motif, 51, 51
Fred Harvey Company: Alvarado Hotel store, 62; booth at St. Louis Exposition, 109, 110; Candelario shop, 52;

Depression era, 96, 96, 97; hiring Native smiths, 46; logos, 66, 68; Pueblo Bonito collections, 110; silver-plated nickel, 92; swastikas dropped, 99; Thunderbird salt spoons, 38, 39; see also Thunderbird motif
frog motif, 89

Gallup Inter-Tribal ceremonials, 95, 95
Germany: Third Reich, 100
G.I. Bill of Rights, 102, 104
goat stamp, 79
Goodman, Charles, 12
Grand Canyon National Park, 64
gravy ladles, 34
Great Depression, 94–96
Grey Moustache, 59
Grossjean, Charles T., 30

hallmarking, 104
handles: cutout designs, 88, 89; with upturned tips, 78
Harvey Thunderbirds. see Thunderbird motif, Fred Harvey Company
Heard Museum, 18
H. H. Tammen Company, 52–54; Depression era, 94, 95, 97
Hitler, Adolf Hitler, 98, 99
Hopi House, 62
Hopi motifs, 73
hozho concept, 90, 90
Hubbell, J. L. (Juan Lorenzo), 45–46; arrow spoons, 53; decline, 60, 94; pamphlet, 46, 52–53; profile spoons, 26

Hubbell, Lorenzo, Jr., 94
Hubbell, Roman, 94
Hyde Exploring Expedition (HEE), 107
Hyde, Fred, 107, 110
Hyde, Talbot, 107

IACB. see Indian Arts and Crafts Board
ice cream servers, 30, 33, 34
iced beverage spoons, 92, 97
iced tea spoons: deer head motif, 104; sets, 76; snake motif, 74; with turquoise, 40
imitation Indian designs, 54; Arrow Novelty Company, 54–55; Depression era, 97; H. H. Tammen, 52–54
Indian Arts and Crafts Board (IACB), 97
Indian Design machine-manufactured spoons, 94
Indian-head handle, 47
Indian head pennies, 82
Indian head spoons, 79, 82; Depression era, 94–95, 95
Indian profile spoons, 79
Indian schools, 57–59, 64–65
ingot bracelets, 54; profile, 82
International Silver Company, 36

Jello-O gelatin commercials, 17–18
jelly or aspic servers, 33
jeweler-silverplate connection, 35–36
jewelry, 23; commercialization of Indian, 46; early, 39–40; old early pieces, 105

ketohs, 87

labor costs, 22
La Fonda Hotel, 62
lemonade spoons, 92
lettering, engraved, 63
letter openers, 31, 104
Leupp Art Studio, 58
liberty shield motif, 16
life-forms on spoons, 90
Lindbergh, Charles, 100
lithography, 61
Little Indian Shop, The, 52
Litzenberger, Rudolf, 54
Louisiana Purchase Exposition (St. Louis, 1904), 27, 55
love of spoons, innate, 19
Low, Daniel, 20
Lummis, Charles F.: Chit-chi, 16, 22–23; early spoon making, 24, 26; fear of snakes, 74; native workmanship, 35; Navajo items, 22; photograph, 22, 23; scrapbooks, 15, 35; tourist dollars, 22

Maisel's Indian Trading Post, 97
making of Navajo spoons, 77–92
Mancos Canyon, 107
Mansfield spoon (imposter), 64–65, 64
Mesa Verde National Park, 64, 107
Mesilla Park, New Mexico, 48
Mexican jewelry design, 103–04, 104
Mexican pesos, 16; buttons,

34; Indian schools, 58; silver content, 86–87
Middle Phase spoons, 90, 93; animal motifs, 104
Montezuma's Castle, 64
Moore, J. B. (John), 46–48; Indian head spoons, 79, 82; twisted handles, 30
Moqui, 69
Morgan silver dollars, 86
Mountain Chant, 100
Mussolini, Benito, 99
mustard spoons, 34

naja pendant: design origin, 86; interpretations on spoon, **85**, **89**
national parks, 102
Navajo: spelling, **82**; stamping of word, **82**, **83**, 83, **84**, **85**; traditional headdress, 82
Navajo Code Talkers, 99
Navajo National Monument, Betatakin and Tsegi, 64
Nevada, 40
New Mexico, **109**, 110
New York City, 54
nickel, silver-plated, **92**
Night Chant, 100
nonrepresentational spoons, 90, 104
Northwest Coast motifs, 39, **56**
novelty companies, 52–55
nut or berry scoops, 33, 34

Ojo Alamo, 107
olive spoons, **32**, 34
orange spoons, 20, 30, **31**
origins, 13–14, 15, 22–26
owl motif, 59, **24–25**, **170–71**
owners and collections, 18

Pacific Northwest, 39, **56**
pamphlets: Candelario Curio Shop, 52; Cotton, 46; Hubbell, 46, 52–53
Panama-California Exposition (San Diego, 1915–16), 26
Panama-Pacific International Exposition (San Francisco, 1915), 64
Pan-American Exposition (Buffalo, New York, 1901), 26, **26**, 64
paper knife, 104
pastry servers, **33**
Pattison, Thomas, 42
Petrified Forest National Monument, 64
pickle forks, **32**
pins, salt spoons converted, **38**, **39**
Plains Indians: as dominant design, 79, 82; influences, 86
Portland, Oregon's, Louis and Clark Exposition (1905), 64
prestige growing, 96
production. *see* making of Navajo spoons
profile spoons: Alaska Yukon Pacific Exposition, **56**; commemorative, 64–65; compilation stampwork, 79; disappearance, 104; full-profile, **76**; Indian profile, 79; Navajo headdress, 82; Pan-American Exposition (Buffalo), **26**; paper knife, 104; prevalence, 74; snake with eagle, **87**; squash blossom on handle, **85**

Pueblo baskets, 50, **50**
Pueblo Bonito, **106**, 107–10
Pueblo motifs, 86
Pueblo silversmiths, 74, 85–86
punch, 41

Quillayute, 68
Quintana, Joe H., 104

railroads, 19–20; extent, 26; tourism, 22, 26; *See also individual railroads*; tourism
rattlesnake motif, 74; *see also* snake motif
reasons for spoon production, overview, 14–15
repoussé technique, **84**
Revere, Paul, 37
Roaring Twenties, 76
Robbins, Charles M., 27
Robbins Company (Charles M.), 27, 100, 110
rocker-engraving, 41, **43**, 43; coin designs, 87; First Phase silverwork, 40; late 19th century, **25**
Roger Bros. Silverplate, 36, **36**
rug-weaving enterprise, 107, 109–10

St. Louis Louisiana Purchase Exposition (1904), 27, 55, 64; Fred Harvey Co. booth, **109**, 110; Wetherill booth, 108–10, **109**
salad sets: of 1920s, 92, **93**, **93**; Maisel catalog, 97; stampwork on, 92; thunderbird motif, 68, 97
salt shovel, 103
salt spoons, 34, 38, 39, 97;

owl motif, **70-71**
sandcast technique, 87–88, **88**
Sani, Atsidi, 40
Santa Fe, New Mexico, 51, 52
Santa Fe Railroad, **68**
Santo Domingo silver, 86
Schweizer, Herman, 66
Scott, Julian, **34**
Seattle (Chief), **56**
Seattle, Washington, 56
Seward, William H., 56
sheet silver, 88, 96
shield nickels, 86–87
significance of designs, 86
silver content, 14, 55, 86–87
silver-plated nickel spoons, **92**
silversmiths: anonymity vanishes, 104; Carlisle curriculum, 57–59; Depression era, **95**; development, late 19th century, **24–25**; early, 40; identifying work of, 85–86; identity of, 48, 104; late 19th century, 20; Mexican instructor, 46; traditional headdress, 82, **82**
silverware chests, 36, **36**
silverwork: classic period, 40; two types, 22
slugs, silver, 88, **88**, 90
Smithsonian Institution, 107, 110
snake motif, 49, 69, **72–73**, 74; turquoise eyes, **72–73**
soldering, early, 40
soup spoons, 30, 34; types of, 35
souvenir spoons: Albuquerque spoon described, 62; attractions

Index 117

of, 21–22; decline, 76, 93–104; early 20th century, **44**; first commercially produced, 20; Gallup ceremonial, **95**; as jewelry, 25–26; mail order, 47; Navajo (Mansfield Co.), **64**; reasons for collecting, 19; St. Louis Exposition, 110; swastika's popularity, 100

spelling, Navajo, **82**

Spirit of St. Louis, 100

spooners, 34

spoon rests, 34

spoon sets, 101–02, **102**; iced tea, **76**

squash blossom motif, **32**; *najahe* origins, 86

stamping, 77–79; categories, 78; compilation stampwork, 79; making stamps, 41, 43; plain spoon bowls, **102**; precarious nature, 78; star-shaped, **25**; of word "Navajo," 82, **83**, **83**, **84**, 85

Standard Railway Time, 22

Stilton cheese scoops, **31**, 34

sugar bowls, covered, 34

sugar shells, 34, **34**; early, **41**

sugar spoons: Chit-chi, 16; Moore's catalog, 47

sugar tongs, **33**

swastika motif, 50–51; early pieces, 27, **55**; eradicated, 96, 98–99, **98**; good or bad meanings, 100, **101**; Harvey Thunderbirds, 66; jewelry, 50; Lester Company catalog, 50, **50**; Mansfield spoon, 64, **64**; prevalence, 74; rugs, 51; serving spoons, **98**; whirling log symbol, 27, 99–100; in world culture, 99

sweater pin set, **104**

table silver, origins, 22–26

Tammen. *see* H. H. Tammen Company

Taxco, Morelos, 013

tea caddy spoons, **35**, 37; owl motif, **70–71**

teaspoons, **31**; Lester Company, 50

techniques, 43; embossing, **84**, **85**; repoussé technique, **84**; sandcast, 87–88; *see also* dies; engraving; rocker-engraving; stamping

textiles, 47

Thunder Bird Design, 69

Thunderbird motif: appearance, 66; Fred Harvey Company, 51, **51**, 66, **67**, **68**; catalog, **96**; progression of, **77**; Harvey Thunderbirds, 66–68; Lester Company, 51, **51**; Lester Thunder Birds, 68–69; origins in myth, 58; prevalence, 74; salad set, **68**; salt spoons, **38**, **39**; tourist "bearer of happiness" thunderbirds, 68

Tiffany & Company, 30; Depression era, 95; Indian motifs, 30; silverware, 36

time, 22; spoon eras, overview, 106

tomato servers: *hozho* concept, **90**; pierced, 34

tools: UITA standards, 103; World War II era, 96

totem pole motif, **56**

tourism, 19–20; train travel, 22, 37; *see also* railroads

traders: coins for smiths, 86; early, 40; spoons appearing, 45; *see also* Cotton, Clinton N.; Hubbell, J. L.; Moore, J. B.; Wetherill, Louisa Wade

training: Indian schools, 57–59

triangular (carinated) spoons, 88

Trifari, 95

tufa, 87

turquoise, 40–41, **40**; iced tea spoons, 92

turtle motif, **41**

twisted handles, **15**; late 19th century, **25**, 27; Moore's catalog, 47; popularity, 27, **28–29**, 30; Pueblo Bonito, 106; Robbins Company, 27; souvenir spoons, 26; as surface slash marks, 90, **91**, 92; Victorian spoons, **28–29**

United Indian Trader's Association (UITA), 97; promoting veterans, 102; stamping system, 102–04, **103**

uses and types, 30, 34

U.S. Navajo stamps, 97–98; U.S. Navajo 4, 98

U.S. Zuni stamps, 97–98; U.S. Zuni 4, 98

Utkitly, Peshlakai, 65

vandalism, 107

Vaughn's Indian and Curio Store, 55

veterans, 101

Victorian flatware, **15**; commemorative spoons, 19; uses for spoons, 30

Wallace, C. G., 98

Warren Mansfield Company, 64, **64**

watch fobs, **67**

weight, selling by, 47, **47**

Wetherill, John, 107

Wetherill, Louisa Wade, 60, 107

Wetherill, Marietta Palmer, 107, **108**, 110

Wetherill, Richard, 107–10, **108**

whirling logs motif: early pieces, 27; in world culture, 99–100; *see also* swastika motif

Wild West shows, 82

Witch Spoon, 20, 26, **26**, 52

World War II era: Native American involvement, 99; Navajo involvement, 100–101; tools, 96

Yei figure, **89**

Young, M. Ada, 17

Zuni silversmiths, 74, 86